REDEFINING GENDER IN AMERICAN IMPRESSIONIST STUDIO PAINTINGS

Were late nineteenth-century gender boundaries as restrictive as is generally held? In *Redefining Gender in American Impressionist Studio Paintings: Work Place/Domestic Space*, Kirstin Ringelberg argues that it is time to bring the current re-evaluation of the notion of separate spheres to these images. Focusing on studio paintings by American artists William Merritt Chase and Mary Fairchild MacMonnies Low, she explores how the home-based painting studio existed outside of entrenched gendered divisions of public and private space and argues that representations of these studios are at odds with standard perceptions of the images, their creators, and the concept of gender in the nineteenth century.

Unlike most of their bourgeois contemporaries, Gilded Age artists, whether male or female, often melded the worlds of work and home. Through analysis of both paintings and literature of the time, Ringelberg reveals how art history continues to support a false dichotomy; that, in fact, paintings that show women negotiating a complex combination of professionalism and domesticity are still overlooked in favor of those that emphasize women as decorative objects. *Redefining Gender in American Impressionist Studio Paintings* challenges the dominant interpretation of American (and European) Impressionism, and considers both men and women artists as active performers of multivalent identities.

Kirstin Ringelberg is an Associate Professor of Art History at Elon University, USA, where she also contributes to the Women's and Gender Studies, American Studies, and Asian Studies programs.

Redefining Gender in American Impressionist Studio Paintings

Work Place/Domestic Space

Kirstin Ringelberg

ASHGATE

Published by
Ashgate Publishing Limited
Wey Court East
Union Road
Farnham
Surrey, GU9 7PT
England

Ashgate Publishing Company
Suite 420
101 Cherry Street
Burlington, VT 05401-4405
USA

www.ashgate.com

British Library Cataloguing in Publication Data
Ringelberg, Kirstin.
 Redefining gender in American Impressionist studio
 paintings : work place/domestic space.
 1. Chase, William Merritt, 1849-1916--Criticism and
 interpretation. 2. MacMonnies, Mary Fairchild, 1858-1946--
 Criticism and interpretation. 3. Artists' studios in art.
 4. Sex role in art. 5. Painting, American--19th century--
 Themes, motives. 6. Impressionism (Art)--United States.
 I. Title
 759.1'3'09034-dc22

Library of Congress Cataloging-in-Publication Data
Ringelberg, Kirstin.
 Redefining gender in American impressionist studio paintings : work place/
 domestic space / Kirstin Ringelberg.
 p. cm.
 Includes bibliographical references and index.
 ISBN 978-0-7546-6921-0 (hardcover : alk. paper)
 1. Artists' studios in art. 2. Sex role in art. 3. Painting, American--19th
 century--Themes, motives. 4. Impressionism (Art)--United States. I. Title.
 ND1460.A7R56 2009
 759.13--dc22

 2009045501

ISBN 9780754669210

Mixed Sources
Product group from well-managed
forests and other controlled sources
www.fsc.org Cert no. SA-COC-1565
© 1996 Forest Stewardship Council
FSC

Printed and bound in Great Britain by MPG
Books Group, UK

Contents

List of Illustrations

H × 55⅛" W (115 × 140 cm). Photo: Fine Art Photographic Library, London/Art Resource, New York

1.3 Alfred G. Stevens (Belgian, 1823–1906), *In the Studio*, 1888. Oil on canvas, 42" H × 53½" W (106.7 × 135.9 cm). The Metropolitan Museum of Art, New York. Gift of Mrs. Charles Wrightsman, 1986. 1986.339.2. Image: © The Metropolitan Museum of Art/Art Resource, New York

1.4 Jean-Frédéric Bazille (French, 1841–1870), *The Artist's Studio, rue Visconti, Paris*, 1867. Oil on canvas, 25½" H × 19" W (64.8 cm × 48.3 cm). Virginia Museum of Fine Arts, Richmond. Collection of Mr. and Mrs. Paul Mellon. Photo: Katherine Wetzel © Virginia Museum of Fine Arts

1.5 Jean-Frédéric Bazille (French, 1841–1870), *The Painter's Atelier in the rue de la Condamine (L'Atelier d'artiste, 9 rue de la Condamine)*, 1870. Oil on canvas, 38⅝" H × 50⅝" W (98.1 × 128.6 cm). Musée d'Orsay, Paris, France. Photo: Erich Lessing/Art Resource, New York

1.6 William Merritt Chase (American, 1849–1916), *Studio Interior (In the Studio)*, c. 1882. Oil on canvas, 28" H × 40⅛" W (71.2 × 101.9 cm). Brooklyn Museum, New York. 13.50. Gift of Mrs. Carll H. de Silver in memory of her husband

2 'The Prince of the Atelier': Negotiating Effeminacy in *A Friendly Call* by William Merritt Chase

2.1 *William Merritt Chase in his Studio, Shinnecock Hills*, photographer unknown, c. 1896. Albumen print, 4⅝" H × 6⅛" W (11.8 × 15.5 cm). The William Merritt Chase Archives, The Parrish Art Museum, Southampton, New York. Gift of Jackson Chase Storm, 83.Stm.21

2.2 Alfred G. Stevens (Belgian, 1823–1906), *The Painter's Salon*, c. 1880. Oil on canvas, 34¼" H × 45¾" W (87 × 116.2 cm). Private collection. Photo: Art Resource, New York

2.3 Alfred G. Stevens (Belgian, 1823–1906), *L'Atelier (The Studio)*, 1869. Oil on wood, 37" H × 28" W (94 × 71 cm). Royal Museums of Fine Arts of Belgium, Brussels. Photo: Ro Scan, J. Geleyns; © KMSKB-MRBAB

2.4 William Merritt Chase (American, 1849–1916), *A Corner of My Studio*, c. 1895. Oil on canvas, 24⅛" H × 36" W (61.3 × 91.4 cm). Fine Arts Museums of San Francisco. Gift of Mr. and Mrs. John D. Rockefeller III. 1979.7.29

2.5 Edgar Degas (French, 1834–1913), *Un Artiste dans son atelier (Portrait of Henri Michel-Lévy)*, c. 1878. Oil on canvas, 16⅜" H × 10¾" W (41.5 × 27.3 cm). Museu Calouste Gulbenkian, Lisbon, Portugal. © 2009 Fundaçao Calouste Gulbenkian

2.6 Thomas Wilmer Dewing (American, 1851–1938), *A Reading*, 1897. Oil on canvas, 20¼" H × 30¼" W (51.3 × 76.8 cm). Smithsonian American Art Museum, Washington DC. Bequest of Henry Ward Ranger through the National Academy of Design. Photo: Smithsonian American Art Museum, Washington DC/Art Resource, New York

3 'The Painter will not Sink into the Mother': Mary Fairchild's Nursery/Studio

3.1 Photograph of Mary Fairchild MacMonnies's painting studio in the grounds of her Giverny home, *Le Prieure*. Photo courtesy of the Raymond Inbona family

4 Rendering Invisible by Display: Representations of Late Nineteenth-Century American Women

4.4 William McGregor Paxton (American, 1869–1941), *The House Maid*, 1910. Oil on canvas, 30¼" H × 25⅛" W (76.9 × 63.8 cm). Corcoran Gallery of Art, Washington DC. Museum Purchase, Gallery Fund, 16.9

4.5 Childe Hassam (American, 1859–1935), *Tanagra (The Builders, New York)*, 1918. Oil on canvas, 58¾" H × 58¾" W (149.2 × 149 cm). Smithsonian American Art Museum, Washington DC. Photo: Smithsonian American Art Museum, Washington DC/Art Resource, New York

Acknowledgments

I am deeply indebted to David M. Lubin, Joy S. Kasson, Jaroslav T. Folda, Helen Hills, Mary D. Sheriff, and Kimberly Abels for their feedback and support of this project at its various stages. David Lubin was especially generous in reading the entire penultimate draft and giving me valuable final revision ideas and a better title. A brief correspondence with Griselda Pollock early on also encouraged me to continue and expand upon the project, as did exchanges with Carol Duncan, Sarah Burns, William Gerdts, Mary Smart, Linda Docherty, Derrick Cartwright, and Rachael Ziady DeLue. Naturally its omissions and weaknesses are my own. My many other intellectual debts are well documented throughout the text, and my historiographically oriented approach has, I think rightfully, highlighted the dialogic and accumulated nature of my (and all our) scholarship. Every scholar whose work I discuss in the pages that follow is someone to whom I am grateful.

Special thanks are reserved for Mme. Inbona and Mme. Isabelle de Reimpré who allowed me to scour the former MacMonnies home in Giverny for various clues (while the delightful Thibault de Reimpré reminded me that painting was still being created), as well as for Katie Bourguignon who continues to patiently answer my questions via email from the Museé d'Art Americain at Giverny. A fellowship from Elon University and my writing group there, Evan A. Gatti and Lynn Huber, helped me through many revisions, and of course the unfailingly generous staff of the Carol Grotnes Belk Library at Elon made sure I had all the resources I needed, as did Assistant Vice President of Academic Affairs Mary Wise, Provost (then Dean) Steven D. House, and Associate Dean Tim Peeples. Marta Fodor and Ann Handler at Art Resource helped me through the last-minute attribution issues with great professionalism. And of course this book has thrived under the guidance and wise counsel of Meredith Norwich, my editor at Ashgate, as well as Erika Gaffney before Meredith came on board.

I learned how to get the manuscript from my laptop to Ashgate at the elbow of my most important and helpful mentor and colleague, Thomas

Fahy; from our dissertation writing team nearly a decade ago to just last week, I have learned to turn to him when I need to know anything about writing and publishing. My father, Thomas Ringelberg, provided food and shelter when it was most needed in the early stages of the project and frequent supportive communiqués after that.

This project was born long ago from a graduate methodologies class in which I was only introduced to the work of a single feminist art historian (and no historians of race or sexuality). The marginalization of that material in the class, compounded by my classmates' angry reactions against the feminist author, put me on the path that led to my current scholarship and teaching goals, which are profoundly intertwined; I have been fortunate to have students who have given me energy and a sense of responsibility to keep working to change the system for them. Nichole Rawlings, one of these wonderful students, helped me with the images, alumna Sara Davis helped me with auction house information, and the 'Art History Mafia' at Elon kept my spirits up throughout with their important blend of playfulness and commitment to challenging the canon.

Anna Arellanes Wirth helped me get over my bigger self-doubts and crises of opportunity, which were annoyingly many; without her there would be no time or place for writing at all, and no joy in either.

Introduction: The Studio, the Domestic Interior, and the Ideology of Separate Spheres

Both feminist and non-feminist scholars alike have maintained a view of gender in late nineteenth-century paintings that claims women painted interiors and families while downplaying their own professional aspirations, and men painted their activities in the broader world around them. Although each camp views (and values) this dichotomy quite differently, both groups maintain it firmly. However, two significant American paintings from the late nineteenth century defy this dichotomy: *A Friendly Call* (1895, National Gallery of Art, Washington DC) by William Merritt Chase (Plate 1), and *Dans la Nursery (Painting Atelier at Giverny)* (1896–97, Daniel J. Terra Collection), by Mary Fairchild MacMonnies Low (Plate 2). The Chase painting lacks the most overt studio symbols and seems merely to represent two women conversing in a parlor. Nonetheless, critical explorations of the work usually minimize the image's domestic associations and consider it primarily a depiction of Chase's Shinnecock Hills studio. The Fairchild[1] painting is more evidently a merging of studio and domestic spaces, depicting a baby in a high chair, two servants, and an easel holding a work in progress.

These paintings refute a simplistic, bifurcated reading of gender in late nineteenth-century art and raise new questions about the role of art and the artist in America. How did artists portray the confluence of work and home lives in an age of dichotomized class and gender constructs? Why did nineteenth-century professional women artists generally fail to paint their own studios? A re-examination of the interpretive significance of the artist's studio in light of gender construction theories nuances our understanding of the art world of the late nineteenth century and illuminates how artists fitted into that world and perceived themselves within it. Although the situation of the artist is in many ways unique, if we can rethink their negotiation of societal roles and norms, we can also rethink the more simplistic representations of gender in nineteenth-century culture more generally.

In this book, I explore the relationships among gender, the studio, and the domestic interior. I use Chase's and Fairchild's paintings as springboards to a discussion that transcends simple distinctions between the work of male and female artists. Fairchild's and Chase's paintings show the artists uniting studio and domestic spaces in a deliberate manner, and thereby problematizing the social dicta of separate spheres. Their paintings are simultaneously reflective and subversive of bourgeois nineteenth-century ideals.

Perhaps because these paintings do not have the clear didacticism of more traditional studio representations, they remain relatively uncharted territories among art historians. In fact, it may be the very ambiguity present in these images that has kept art historians from thoroughly analyzing them from a gender perspective. Why would Chase want to emphasize his studio's domesticity? Why would he highlight his wife's presence in this workspace and downplay his own? Why would Fairchild place equal emphasis on her domestic and professional lives if doing so would call her femininity into question? These questions need to be answered by an analysis that considers such depictions suggestive of deeper meanings rather than simply anomalous to the otherwise clear trajectory of our current understanding of nineteenth-century art. I believe that this book will thus explicate a range of issues central not only to art history but also to broader historical and gender studies.

I intend to prove the value of an interpretation that takes into account the variations *within* gender and class groups rather than corralling them into inflexible and definitive categories. This approach will prove particularly valuable in understanding the identity of artists, whose practices often put them in the unique position of being able to cross over and convolute such categories. The studio was a site wherein male and female models from the lowest classes, in various states of undress, mingled with wealthy patrons, including 'respectable' upper- and middle-class women who would ordinarily eschew such company. Artists were at the center of this otherwise unusual potential for deviation from societal norms.

This project will redress the marginalization of the female artist in at least one case, that of Mary Fairchild MacMonnies Low. Her current obscurity reveals all-too-familiar sexist, nationalist, and formalist biases in art history.[2] Fairchild was a well-known and respected artist at the turn of the century, winning accolades at major national and international competitions in which men predominated. Her marriages to two prominent male artists, Frederick MacMonnies and Will Hicok Low, allowed her to live as a 'proper' bourgeois woman within the art milieu – a relatively uncommon role. Despite these accomplishments, Fairchild's wall painting for the Women's Pavilion at the 1893 World Columbian Exposition is her only work that receives any significant scholarly attention today, and inevitably it is discussed parenthetically in comparison to its pendant painting by Mary Cassatt. In fact, only thirteen scholarly works address Fairchild's work for more than a sentence or two, and

all but seven (an unpublished master's thesis monograph, a six-page article in the *Woman's Art Journal*, an article by Judy Sund on the 1893 World's Columbian Exposition, an essay by Derrick Cartwright for an exhibition catalogue, an essay by Kathleen Pyne for an exhibition catalogue, my PhD dissertation, and an article I wrote for *Prospects: An Annual of American Cultural Studies*) refer to her as the minor player in each of these pairs of artists (Fairchild and MacMonnies, Fairchild and Cassatt, Fairchild and Low).[3] My book will be the first to discuss Fairchild's work in depth and on its own merits without focusing on a purely or largely biographical perspective. As the focus of my thesis is a rethinking of the paintings of late nineteenth-century artists from a less gender-dichotomized perspective, I will attempt to rescue Fairchild not only from obscurity, but also from simplistic categorization as a marginalized American Impressionist female artist. Only by re-evaluating her painting can we understand the gender complexities negotiated by male and female artists of the time who worked to define and redefine the gender associations of the spaces in which they created their art. Studying Fairchild is thus vital to understanding the impact of gender on late nineteenth-century American art.

The careful reader already may have noticed that the cover image and plate provided in this book give Fairchild's *Dans la nursery* a different title and attribution – to her first husband, Frederick MacMonnies. Unfortunately, as this book was going to press, the Terra Foundation for American Art decided to re-reattribute this painting and Fairchild's *C'est la fête à bébé (Baby's Birthday)* (Plate 3) to her husband. Both of these images had been sold to the Terra in 1987 as the work of MacMonnies, who was of course at that time (and today) much more well-known than Fairchild. But this attribution was successfully challenged in the late 1980s by Mary Smart and supported in the early 1990s by William Gerdts (the two most prominent scholars to have studied these works at the time). The Terra accepted the reattribution, and you will see evidence of this in every publication and exhibition of the painting after 1988, including an exhibition organized by the Terra itself in 2008 ('Impressionist Giverny: American Painters in France, 1885–1913; Selections from the Terra Foundation for American Art') and its accompanying publications.[4] In the summer of 2009, as I was gathering together images and permissions for my August 2009 editorial deadline, I contracted with Art Resource, the licensing body for works owned by the Terra Foundation. They had *Dans la nursery* in their databases, listed as such and attributed to Fairchild. I purchased the right to publish the work as well as a digital image of it. I also asked the staff of Art Resource if they could do the same for me with *C'est la fête à bébé (Baby's Birthday)*, which did not appear in their database. In the later process of securing the permissions for the cover (which naturally required a submitted layout proof, as is often the case) and the second image, I was told by Art Resource staff that the Terra was changing the attributions listed with these

images and, furthermore, had new requirements for licensing – *all* images used would now have to be mocked up in a proof and submitted before the Terra would give permission, even if these works were for interior, black-and white use (something no other organization required for this publication). It is clear that the Terra is extremely concerned about this new/old reattribution, since such complications delay or dissuade the scholar who might work on their collection, and obviously it is my professional duty to follow their demand for captioning the works, even if that demand was made after I purchased *Dans la nursery* publication rights as a work by Fairchild. Nonetheless, I disagree with their attribution, and I will provide my arguments for my belief in Chapter 3, both in the text and in the endnotes. I would like to point out that, as of this writing, the Terra's staff have not contributed one new piece of evidence to support their attribution; in fact, the support their website provides is either cited incorrectly, edited to a point which challenges the source's accuracy in this context, or inconclusive at best.[5] I am eager to hear a scholarly argument that proves the re-reattribution conclusively – in some ways it might actually make my thesis in this book stronger, because it would take away the one exception that proves the rule, Fairchild's depiction of her studio, and leave us only with the rule (Impressionist women artists did not depict their studios). Or perhaps, given there is no conclusive proof either way, the Terra could attribute the work to *either* Fairchild or MacMonnies – although they are suggesting some ambiguity by requiring that the caption for the image read 'Attributed to' rather than just giving MacMonnies's name. However, I can be forgiven my concern that this sudden, unsupported move merely fits in with a long historical trend this book aims to challenge: when in doubt about a high-quality work of art's authorship, assume a man.

Throughout the pages that follow, I will make comparisons between Chase's and Fairchild's paintings and other contemporary works of art, literature, and criticism in order to show how these paintings fit into their historical context. My goal is to provide a more nuanced and historically accurate interpretation of these paintings, and hence a more complex and accurate view of the artist in society at the time. I will show the artist not as a victim of social norms but as a sometimes-resistant actor within them.

The Studio

Nikolai Cikovsky, in the exhibition catalogue *The Artist's Studio in American Painting*, states that 'the artist's studio is a special subject, quite unlike any other. Most of all, it is special because it is a depiction of that personal, usually private place where art is made, a subject that allows a privileged experience of where artistic creativity occurs.'[6] Nonetheless, the majority of books that address the studio as a theme in painted representations are exhibition

catalogues rather than independent scholarly texts.[7] Studio representations can be found throughout art history, but the popularity of the subject grew tremendously in the aftermath of Giorgio Vasari's sixteenth-century emphasis on the artist as a figure of singular importance.[8] The nineteenth century signaled a particularly dramatic increase in such images, as the exhibition catalogues invariably show.[9] Most significant to this study is the concomitant codification of such images into nearly standardized rhetorical categories (the garret, the show studio, and the representation of the artist's ideological and artistic influences) that can then be used to interpret the artist's self-image.

Studios occupied an interesting place in the French Impressionist movement, which followed the Barbizon School in its eschewing of rigorously controlled environments in which to produce art. Emphasizing instead the importance of painting what the artist encountered as s/he saw it, Impressionists were less likely than other artists to work solely from a studio. Thus, their studios have not been the focus of art-historical interest in the era. However, Robert Herbert and others have long since given the lie to the notion that Impressionists such as Claude Monet always worked immediately and only outdoors, with none of the careful reworking of canvases and use of studios of more academic artists.[10] So it would appear that art historians have neglected Impressionist studios more than did the Impressionists themselves. Although the relative paucity of studio images by these artists accounts for the limited number of French Impressionist canvases fitting the parameters of my study, it does not explain how these artists might have perceived the studio as a site of self-representation. Certainly we know that setting and subject were important to the Impressionists, both French and American; Edmond Duranty, one of the critics whose defense of French Impressionism in the nineteenth century framed our understanding of it, spoke more than once of the necessity of the environment of the subject to a more accurate presentation of the person within it:

An atmosphere is created thus in each interior, likewise as a certain personal resemblance develops among the objects that fill it. The frequency, massing, and arrangement of mirrors that decorate the apartments, the number of objects that are hung on the walls, all these things have brought something to our homes ... And since we are closely observing nature, we will not separate the person from the background either of the apartment or the street. Never in life do we see him appear against backgrounds that are neutral, empty, and vague. But surrounding him and behind him are the furniture, the fireplaces, the hangings, a wall that expresses his fortune, his class, his profession.[11]

If the painter were to notice and remark upon his/her human subjects' surroundings as contributory to constructing or revealing their identity, surely a consideration of the painter's own surroundings and how they defined the artist would be a part of that process.

In considering any topic that subsumes both France and America as loci of Impressionist art, one encounters the tradition of viewing the latter as necessarily inferior to the former. Yet Impressionism encompassed a broad number of artists and styles, even in France and even within each exhibition by the Société Anonyme.[12] The majority of successful American artists of the nineteenth century were trained in France, including Chase and Fairchild.[13] This would suggest a greater continuity between the subject matter of American and French Impressionists. Yet American Impressionists regularly painted images of their studios, while the French did not. Hence, although I will discuss the studio paintings of French artists in Chapter 1 and documentation of French women's studios in Chapter 3, my study will focus on American artists and their images. I will suggest some reasons for the greater number of such paintings by American artists, but I will not focus on this national difference.

Recent re-evaluations of the art of the American Impressionists and Tonalists have also begun to redress longtime disinterest in images such as these, showing that they are not merely derivative of European art (which was seen as more progressive and intellectual). European artists rarely merged studio and domestic spaces in quite the same manner as these and other American artists did.[14] Instead, European studio images follow a more codified standard in which the space is defined as either a struggling worker's garret, a gathering for like-minded aesthetes, or a glittering showplace for the grandeur of Great Art. Because European artists did not emphasize studio domesticity, this subject matter reveals a uniquely American vision. Russell Lynes, Neil Harris, and others long ago established that the relative recentness of an organized and accepted American art world created an important distinction between the self-images of American and European artists and how they presented themselves to society.[15] The Chase and Fairchild paintings offer an opportunity to understand the particularity of the American artists and their work without subsuming them under the influence of European practices and iconographies.

The Domestic Interior and the Ideology of Separate Spheres

Another important site of self-representation in the late nineteenth century for artists and non-artists alike was the domestic interior. A number of primary and secondary sources inform us that among the changes wrought by urbanization and industrialization was a stricter division between the home and the place of work, at least for men.[16] Particularly in the ever-growing middle and upper-middle classes, this relegation of men's work outside of the home and women's work within the home defined the family's class status and success. In 1899, Thorstein Veblen traced the connection

between economic theory and social constructs of gender and class in his *Theory of the Leisure Class*. Veblen pointed out that to raise or maintain their standing in the middle and upper-middle classes, families had to display their acquired wealth in both material possessions and apparent leisure time. Giving the appearance of leisure became the role of the increasingly homebound woman, while her husband put in a stressful day at the office earning that wealth. The domestic interior had become a space that was both public and private, functioning as the inevitably male breadwinner's safe haven from the harrying world of business and industry and as the family display case of both material goods and leisure, created by and forming a backdrop for the female. This study questions what occurs when these two significant spaces, the artist's studio and the domestic interior, are combined.

The ever-expanding reach of gender studies has allowed a more thorough understanding of the way in which public and private spaces are gendered, and particular attention has been paid to this issue in the nineteenth century. The accepted but increasingly embattled stance of the moment is that private spaces were largely gendered feminine and public spaces were largely gendered masculine, at least in the middle and upper classes. Chapter 1 outlines the normative social constructs that led to the general acceptance of this dichotomized gendering of the middle classes, both in the late nineteenth century and in most scholarship on the time period.

The home-based art studio, which is both a professional workspace and a domestic room, inhabits both of the gendered worlds typically discussed, thereby complicating this polarized view. According to the traditional understanding of late nineteenth-century social norms, a man does hard work outside the home and a woman decorates that home using his income. What happens when, as in the case of Chase, a man does his own decorating, and has a 'feminine' parlor for a workspace? What happens when a female artist like Fairchild earns her living as a professional and runs an apparently bourgeois home from the same room?

William Merritt Chase and the Masculine Ideal

William Merritt Chase was born on 1 November 1849 in Nineveh, Indiana.[17] The descendant of prosperous general store owners and farmers, Chase moved with his family to Indianapolis in 1861, where he worked for his father as a shoe salesman. As a teenager, Chase exhibited an unflagging interest in art that led to his enrollment in a small art school, interrupted in 1867 by a brief stint in the Navy. In 1869, Chase left Indianapolis for the National Academy of Design in New York. By 1870, his father's business had failed and Chase rejoined his family in St. Louis, where he opened a studio and

took commissions for paintings. After numerous small prizes proved Chase's talent, several local businessmen paid for him to travel to study in Europe in return for both original paintings and help with European art acquisitions.

Chase arrived in Munich in 1872, after brief trips to London and Paris. There he studied at the Royal Academy with Wilhelm Diez and Karl von Piloty, learning the dark palette, historical subject matter, and bold realism popular there while developing his signature bravura brushstroke. In 1878, Chase returned to the US to take a teaching position at the Art Students League; his fame had begun to grow even before his arrival, due to several popular submissions to both the National Academy of Design's exhibitions and those of its new splinter organization, the Society of American Artists. In 1886, Chase married 20-year-old Alice Gerson, with whom he later had eight children, living with them primarily in New York at a number of addresses until his death in 1916.

Chase's role as a teacher was one he would continue throughout his life, and it gained him as much fame and success as his painting. He taught at every major art school on the east coast, sometimes simultaneously. For example, in the 1890s he taught at his own Chase School (later the New York School of Art), the Pennsylvania Academy of the Fine Arts, and the Shinnecock summer art school, commuting to each in turn. He also led classes in various locations in Europe, returning there regularly throughout his life.

One result of Chase's teaching was that he became proficient and enthusiastic in his use of a wide variety of media in addition to oil, particularly pastel and watercolor. By founding or joining in organizations such as the Tile Club and Painters in Pastel, Chase lent his considerable social and artistic cachet to media that had previously been considered the province of amateur and women artists. Similarly, he did not restrict himself in terms of subject matter, painting portraits, still lifes, interiors, and landscapes at all points in his career. Some time after his departure from Munich and possibly in response to criticism of his 'muddy' canvases, Chase began to lighten his palette to a more Impressionistic emphasis on light and bright colors, although he never totally gave up the darker tones of his youth when the painting's subject seemed to demand them.[18] Chase's versatility and skill garnered him the status of a master technician, able to paint a beautiful image quickly and to general satisfaction. This quality was occasionally used against him, however, as he was sometimes criticized for being merely an exceptional manual worker of sorts with little in the way of deep thinking to recommend his paintings – a criticism often directed at women artists by critics from the Renaissance to the present.[19]

Viewing Europe as the center of the artistic world, Chase appointed himself a sort of cultural ambassador for Americans, insisting that his students travel to Europe if at all possible. Chase was particularly enamored of European openness to all things aesthetic as well as European artists' more bohemian

way of life, and he did his best to represent these perspectives when at home. Notorious for his omnivorous collecting mania, Chase brought back as many European souvenirs as he could manage, including paintings by contemporary artists as well as the bric-a-brac he felt should fill his studios with the correct atmosphere for making and showing his art.

Fortunately, Chase had plenty of studios to fill. Gallati points out that one can follow Chase's fortunes by the number of studios he kept at any given time: in 1909, for example, she notes three.[20] Chase's studios, particularly the Tenth Street studio, served not merely as workspaces but as showplaces where he could promote both his own art and art in general to an increasingly enthusiastic American audience.[21] Filled with every kind of decorative object imaginable, as well as visitors of divergent origins, Chase's studios were a significant part of his self-construction as an artist.

A Friendly Call (Plate 1), painted in 1896 and now hanging in the National Gallery in Washington DC, depicts two women sitting on a banquette, engaged in conversation. They are in a room that appears to be a parlor decorated in a typical, late nineteenth-century style. A study of Chase's other works of this period reveals that the setting is actually specific: Chase's studio in his summer home in Shinnecock, Long Island. How Chase, as a man, could negotiate such 'feminine' territory – the domestic interior, women's lives, their etiquette and conversation, the purportedly superficial attractiveness of Chase's depiction – without losing his masculinity and that of his workspace, is the subject of Chapter 2. I begin with the case study of a male artist because, although few scholars have noted the potential for a feminized reading of his studio images, the images themselves have been rather thoroughly discussed, providing a way to see how such images were framed (both at the time and now). I will follow with a case study of a female artist who has, perhaps unsurprisingly, received almost no scholarly notice for her studio image. This comparison might begin to balance such a one-sided view of the history of late nineteenth-century studio paintings, one that gives preference to both male artists and masculinity. I am most interested throughout the book in the tricky positioning of gender characteristics associated with the feminine (for both men and women) in a field (art making) and spaces (the studio and domestic interior) whose makeup was largely determined and delimited by men with a stake in maintaining their own definitions of both sex and gender, however much those might shift. The art world, both in the nineteenth century and today, is dominated by a patriarchal canon and patriarchal perspectives that are thoroughly documented and form the basis of much of the discipline of art history, and my desire is to challenge rather than reify these. For those wishing an even greater emphasis on masculinity than that presented here, excellent work on the masculinity of the late nineteenth-century male American artist exists in the work of Sarah Burns, Martin Berger, and James C. Boyles. I take the stance here and in general

that masculinity is as fully multiple as femininity, and that masculinity and femininity are not tied to specific genders, sexes, or sexualities. In the late nineteenth century, the prevailing cultural view was that men should be masculine and heterosexual and women should be feminine and largely asexual. Throughout this book, I will be focusing on the norms of the time and how these artists negotiated those norms and performed, in their work, the expected identities – and how both male and female artists did in fact need to perform and negotiate those identities (and others), and how the identities they depicted in their works (both of their studios and of domestic interiors more generally) were gendered. However, like Abigail Solomon-Godeau, I worry that certain representations (both visual and textual, including the art-historical scholarship that discusses both) that emphasize the multiplicity of masculinity 'suggest a colonization of femininity, so that what has been rendered peripheral and marginal in the social and cultural realm, or actively devalued, is effectively incorporated within the compass of masculinity' and that such colonization/devaluation/incorporation only serves to reaffirm the masculinity of the spectator and my reader (male or female).[22] I certainly hope I have not fallen into that trap here by including lengthy discussions of William Merritt Chase's potentially feminine performance in Chapter 2 and the use of the female body by male artists in Chapter 4.

Mary Fairchild MacMonnies Low and the Feminine Ideal

Mary Fairchild was born in 1858 in New Haven, Connecticut.[23] Shortly thereafter, her family moved to St. Louis, Missouri, where Fairchild eventually began a career as a third-grade teacher. Dissatisfied with her vocation, Fairchild began taking classes in 1885 at the St. Louis School of Fine Arts, then under the direction of Halsey C. Ives. There she edited an art journal, *Palette Scrapings,* and petitioned Ives for the right of the women's classes to draw from the nude. Impressed by her drive, Ives created a scholarship for Fairchild to travel to Paris and study at the Académie Julian for three years. At Julian's, Fairchild studied under William Bouguereau, Jules Lefebvre, and Tony Robert-Fleury. As soon as 1886, Fairchild was exhibiting in the Paris Salons and finding support for her work among both mentors and peers. In 1887, Fairchild began working with Carolus-Duran, whose technique and palette were more light and loose than those of her previous instructors. That fall, she met Frederick MacMonnies at an expatriate Thanksgiving dinner. They became engaged within months, but were unable to marry until Fairchild's scholarship (which stipulated that she could not marry during its course) ended in September of 1888. During this time, Fairchild spent some of her scholarship money on a bigger studio that she shared with MacMonnies, who saved money by sleeping there.

Like Chase, Fairchild sent works to the US as well, exhibiting both in St. Louis and at the Pennsylvania Academy of the Fine Arts and the Art Institute of Chicago. Fairchild painted in a variety of styles during the 1880s and 1890s, producing plein air Impressionist works, decorative panels, neoclassical murals, and copies of Renaissance works at the Louvre. She took commissions for these copies, and combined these with her numerous awards for her original works to support both herself and her husband, whose sculptures were beginning to garner popularity and financial rewards. Their fortunes permanently improved when they both won commissions to create major pieces for the 1893 World's Columbian Exposition. Fairchild's mural depicting *Primitive Woman* (1892–93, whereabouts unknown), to be placed high above the floor of the Women's Pavilion in one of the two tympana of the main exhibition space, was a great success. Popular magazines lauded the mural's design and content, and Fairchild returned to Paris a celebrity. MacMonnies had received similar praise for his sculptural group in the Great Basin, so the couple was able to invest in more commodious housing, purchasing both a townhouse in Paris at 44, rue des Sèvres and renting, and later purchasing, housing in Giverny. While she continued to exhibit both at the Salon of the Société des Artistes Français and the newer, secessionist Salon of the Société Nationale des Beaux-Arts, Fairchild also gave birth to three children: Berthe Hélène in 1895, Marjorie Eudora in 1897, and Ronald, born in 1899 and surviving only for a year.

While rearing her children, Fairchild served as president of the American Woman's Art Association of Paris from 1900 to 1903. During those years, Fairchild was particularly successful, winning a gold medal at the Exposition Universelle in Paris in 1900 for *Roses and Lilies (Roses et lys)* (1897, Musée des Beaux-Arts de Rouen) (Fig. I.1); garnering praise as one of the finest contributors to the Chicago Art Institute's fourteenth annual exhibition; capturing the bronze medal at the Pan-American Exposition in Buffalo, New York; earning the gold medal at Dresden's International Exhibition in 1901; and winning the Julia A. Shaw prize for the most meritorious work by an American woman artist at the annual exhibition of the Society of American Artists in 1902.

In 1909, Fairchild's husband Frederick sued for divorce in a provincial French court, winning custody of the children, but allowing Fairchild to take them with her to a new apartment in Paris. Less than a year later, Fairchild remarried the recently widowed artist and writer Will Hicok Low. They left France with Fairchild's daughters and moved to Lawrence Park (a suburb of Bronxville), New York, where they lived for the rest of Fairchild's life. Fairchild continued to exhibit, albeit almost exclusively in the US, until shortly before her death. The majority of her works after about 1915 were portraits and, with the exception of a few works (primarily landscapes) Fairchild's palette and style became gradually less Impressionistic and more

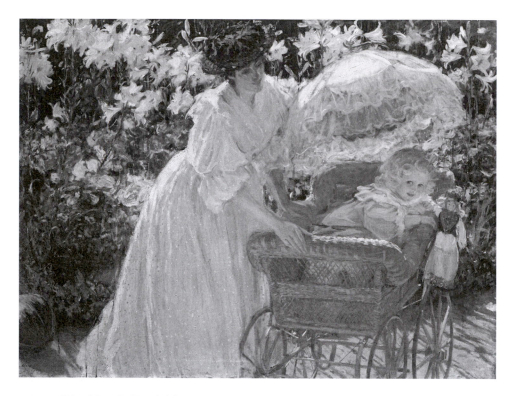

I.1 Mary L. Fairchild MacMonnies (later Low) (American, 1858–1946), *Roses and Lilies (Roses et Lys)*, 1897. Oil on canvas, 52⅜" H × 69¼" W (133 × 176 cm). Musée des Beaux-Arts de Rouen, France. Photo: Erich Lessing/Art Resource, New York

Academic. She died in 1946 in Bronxville, considerably less famous than she had been at the peak of her career, from 1886 to 1915.

Chapter 3 begins with an analysis of Mary Fairchild MacMonnies Low's *Dans la nursery*, painted in 1896–97 (Terra Foundation for American Art, Daniel J. Terra Collection) (Plate 2). This image shares with Chase's *A Friendly Call* the conjoining of studio and domestic spaces. The title, given by Fairchild when she exhibited the painting at the Salon National des Beaux Arts in 1899, seems to emphasize the domestic aspects of the image, much like Chase's painting. However, despite the title, Fairchild seems to have given equal emphasis within the scene to the domestic and studio aspects of the setting. By 'failing' to disguise her own professional status in the image, Fairchild makes a radical move – creating the only painting of a female artist's studio as a site of artistic creation by a prominent woman artist of the late nineteenth century.

Fairchild and Chase share some obvious similarities. Both studied and worked in both the US and Europe, showing their paintings with equal regularity at European salons and American exhibitions. Hence they were

active in the international art scene and represented the transcontinental nature of the Western art world in the late nineteenth century. Yet neither artist relinquished his or her deepest ties to the US, through either citizenship or artistic style, as many other Americans did. Additionally, both artists were actively involved in their family lives and used their children as models in a majority of their paintings; both also actively labored to maintain a certain status in society through their appearance and acquaintances.[24] Thus, both artists reflect the bourgeois family life that appears to fit the normative standards of their time and class.

Gendering Artists and Their Subjects

Previously, art historians have articulated a gendered division of subject matter between male and female artists. Griselda Pollock's landmark essay, 'Modernity and the Spaces of Femininity,' serves as both the first and fullest discussion of this issue from a feminist perspective. Pollock argues that instead of viewing women Impressionists as outside the development and rhetoric of modernity because of their failure to depict its most representative sites (cafés, bars, and other 'public' spaces where bourgeois women dared not enter), we should note their restricted, chiefly domestic realm as another, significant and thus equally representative, space of modernity that these women were particularly adept at analyzing.[25] This argument opened the door to a desperately needed reconsideration of the art of female Impressionists as well as the appropriate demand that the domestic life of women in this period be understood as itself modern and the women living it as conscious, active agents in their experience of it. One unfortunate legacy of the article has been, however, that its followers occasionally oversimplify Pollock's reading into a biologically binary approach. According to Robert Herbert, works by women Impressionists are 'easily distinguished' from those of their male counterparts, who tended to highlight the figures over their surroundings and fail to note the expressive capabilities of household furnishings.[26] Although both Pollock and Herbert have given critical and aesthetic value to the paintings of women Impressionists in their analyses, they still maintained the sharp gendered distinction of paintings once used to devalue those works by women. As a result, the division of subject matter between male and female Impressionists has often seemed unquestionable, and it has certainly become the 'new canonical' reading of their images. Yet neither of the two paintings under consideration in this study exactly fit that division. Photographs of Chase's studio clearly indicate his omission of elements that would have made the work setting of *A Friendly Call* more evident; he obviously chose to emphasize his studio's domestic qualities in the painting. Fairchild's inclusion of both domestic and art-making elements in her painting of a room that did not

need to contain both keeps the image from contributing to her effacement as a professional artist in favor of her socially predicated domestic role. The melding of domestic and studio spaces served to reinforce the linkage between women and artists – both were relegated the duty of maintaining society's creativity and beauty. Yet Chase's painting emphasizes the domestic and societal elements in his workspace over his own masculine labor, while Fairchild emphasizes both her labor and the labor of the other women of her household in equal proportion to the domestic and artistic elements. Therefore Chase's image seems to confirm feminine associations even more than Fairchild's.

As both Chase and Fairchild were successful, well-known artists whose works were widely considered typical of the prevailing styles and subject matter of their time, one cannot locate these two paintings in the margins of dominant cultural modes. Thus it seems that a more considered accounting of the domestic home studio or its absence is needed, and the most fruitful avenue for study of the complex images that represent it is from a gender and queer studies perspective.

The methodology I use, a melding of social history, contemporary feminist theory, queer theory, and formal analysis, is useful in moving past the tendency all scholars struggle with to see a time period or artifact as in some way hermetic and cleanly representative of a historical 'truth.' By looking through more than one lens, I try to avoid letting any one structure my view. New methodologies in academia can be powerfully controlling, and they can also be used inappropriately. While absolute care is required to avoid wildly speculative or erroneous conclusions, scholars should consider the usefulness of new approaches, particularly those that broaden, rather than narrow, the scope of study. Rather than link each time period with a constituent methodology, we should share our research and critical perspectives across materials and fields of study.

In the past three decades, queer theory has been particularly useful in finding a new entry into the assignation of particular qualities to gender categories. Traditionally, both societal norms and gender theorists promoted fixed essential gender identifications based on sexual binaries. Rather than accept the consequent status of marginalized 'Other,' queer theorists such as Judith Butler and Eve Kosofsky Sedgwick have articulated more flexible and fluid definitions of gender. In *Gender Trouble: Feminism and the Subversion of Identity*, Butler argues that feminists who attempt to locate universal commonalities among women end up forcing them into the same rigid gender bifurcations that allow for sexist valuations of women.[27] Further, these strictly defined categories are not inclusive of all women's lives, practices, and self-images. As Butler points out, there are times when one (male or female) might say that s/he is acting, feeling or living more or less 'like a woman' or 'like a man.' Butler thus recommends that we risk the incoherence of gender identity,

acknowledging our own and others' identities as being performed along a continuum of potential identities rather than being coherently fixed to a certain essential set of qualities based on biological or socialized difference.[28] Butler uses the term 'performance' to emphasize that she is not just casting gender and sex against each other, in the sense that one's gender and one's sex might not coincide. Instead, she sees individuals as performing a variety of constantly changing, imitative selves, with the string of performances 'constitut[ing] and contest[ing] the coherence of that "I."'[29] Adopting, imitating, and performing a role or a set of behaviors or identifications often results in making the dominant conventions (of gender, sexuality, or any identity category) obvious as conventions, rather than inherent, predestined facts.

Although the late nineteenth century certainly seems to be a time in which polarized roles were dictated by social norms in an extreme manner, attention to the actual people who lived with those norms suggests room for a more performative reading of their gendered identities. After all, the strictness of the boundaries for gendered behavior in the nineteenth century certainly stemmed not merely from the changing division of labor in the industrial era but also from concerns that the greater social freedom brought on by increased wealth and leisure time was carrying with it a greater threat to such divisions. If middle-class women could buy garments that imitated those of the upper classes in department stores and men like Oscar Wilde could find generally appreciative audiences for their feminized personas, those who wished to maintain societal divisions would have to work much more diligently at defining them.[30] Thinking of the late nineteenth century's normative standards for gendered behavior as open to performative play, parody, and subversion by those who experienced them, whether subconsciously or consciously, expands our understanding of those moments, such as certain painted representations, in which the normative standards do not appear to be met coherently. Support for such an interpretation is found in the period itself, not just with the examples of Wilde and Rosa Bonheur, but in the words of Fairchild herself, defending her use of nude figures in her mural for the Women's Pavilion of the 1893 World's Columbian Exhibition: 'I think that one of the objects of the Woman's Building is surely to show what I may call our "virility", which has always been conspicuous in its absence.'[31] While at first Fairchild's conflation of virility with depiction of the nude seems binaristic and normative, her desire to display virility in her own work suggests that even this seemingly über-'feminine' nineteenth-century woman could imagine performing a complex self.

Late nineteenth-century American artists provide a challenging but relevant focus for studying these broader social constructions and their subversion. By this time in the US, artists had achieved a modicum of respectability and influence, with well-known male artists belonging to prestigious and exclusive social clubs like New York's Century Club. As

both Sarah Burns and Russell Lynes show, artists of the 1880s and 1890s were a confident bunch, believing in their specific worth to society 'apart from the fusty men of merchandise.'[32] In many ways it could be argued that they represented the Gilded Age itself – the period of American history between the Civil War and the Progressive Era, roughly 1865–1900 – through their emphasis on the aesthetic (which could be read both positively and negatively as artifice, (re)creating the lily or merely gilding it), their need for and association with wealthy donors made wealthier by the period's rapid economic growth, and their status as both a sign of change and a sign of its potential corruptions – of gender norms, class hierarchies, and what constituted labor. These artists were also quite diverse, providing the ever-informed public with a variety of personalities and aesthetic interests rather than a united front. Burns notes that although the American artist's standing as a celebrity developed gradually throughout the course of the nineteenth century, the last decades (with 'the machinery of American publicity … in high gear' and artists one of its favorite subjects) saw a more significant shift in public attention from the art to the artist, and particularly the artist's personality. 'Whether courting publicity or shunning it, the artist of the period had to confront an unavoidable fact of modern life: in addition to being a producer of aesthetic commodities, he (or she) had to become a commodity as well,' and artists' responses to that fact varied significantly, from James Abbott McNeill Whistler's studied aesthetic intellectualism to Winslow Homer's hermit-like retreat to the rugged landscape of Maine.[33]

Thus, to come to a single, coherent image of the American artist in late nineteenth-century society is impossible. But certain anxieties come through in the literature, paintings, and popular culture of the time to give a sense of the grounds artists negotiated. As Burns argues, one of the first problems male artists had to face was the tendency of others to link their work, so associated with leisure and dependent upon the earning power of businessmen for success, with women and femininity. Although male artists certainly had greater freedom, mobility, and political and social power than women, they had to engage in what Burns has called 'outselling the feminine,' associating their extravagant studios with sales strategies and asserting biological differences in critical analyses of art to avoid their being connected with women's spheres.[34] Female artists had to face the same possibility of being unsexed or seen as manly for their efforts in a masculine realm. The most successful American women artists usually dealt with this problem by emphasizing their femininity, as Burns has argued Cecilia Beaux did.[35] American periodicals at the end of the century painted both female and male artists with a broad, critical brush, depicting them as trivial, faddish, and entertaining in their abnormality.[36] Contemporary author Kate Chopin captured similar feelings through the various social responses to Edna Pontellier's studio in *The Awakening* (1899). As Edna sacrifices her

marriage and family for art, moving from her home to her studio, society condemns her for being frivolous, irrational, and even insane. How do we reckon with these conflicting views of the late nineteenth-century artist, a figure of adulation and mockery, influence and questionable status?

One way to pay tribute to this complexity is to address the work of these artists in a manner that avoids the pitfalls of categorization that would make such a conversation simpler but less meaningful. As both William Merritt Chase and Mary Fairchild MacMonnies Low steer their images away, even briefly, from the normative gender identifications and associations of the late nineteenth century, they form the ideal focus of a study that seeks to allow for greater play in the representation of the artist's identity.

By conflating their domestic and working spaces, Chase and Fairchild gave that location and themselves a complexity that the contemporary view of gendered bourgeois space would not otherwise have allowed. William Merritt Chase and Mary Fairchild MacMonnies Low, by combining work and home lives in the most extreme manner, raise a specter of gender performativity that should not be restricted to the twentieth century. Chase was the aesthetic director of his home as well as the one who financed its fittings, and, at least at his Shinnecock Hills home, worked in the same place as he rested. Fairchild was painter, mother, and society wife simultaneously, and occasionally supported her first husband with her art making and student funding. Both artists crossed the physical borders of gendered spaces and the invisible borders of societal constructs to present an image of the artist's studio as a more complex site, not so easily divided into poles of masculinity and femininity as is so often asserted.

Notes

1. I will refer to Mary Fairchild MacMonnies Low as Fairchild throughout the book, to avoid confusion with her first husband (who will be referred to as MacMonnies) or her second husband (who will be referred to as Low). It is tempting to reverse the standard in literature on Fairchild and her contemporaries and refer to her as MacMonnies or Low and to her husbands as Frederick and Will.

2. I believe Fairchild suffers not just from the usual lack of documentation that accompanies women artists, so well described by Linda Nochlin, Tamar Garb, Roszika Parker, and Griselda Pollock among others, but also from the devaluation of American art before abstraction generally, and the devaluation of American Impressionism in particular. Only since the 1990s have art historians begun to redress the bias that favored the European avant-garde until Abstract Expressionism's advent, and even since then the focus has continued to remain almost exclusively on the work of male painters.

3. See Kirstin Ringelberg, 'No Room of One's Own: Mary Fairchild MacMonnies Low, Berthe Morisot, and *The Awakening*,' in *Prospects: An Annual of American Cultural Studies*, vol. 28 (2004), 127–54; and Ringelberg, 'Risking the Incoherence of Identity: Locating Gender in the Late Nineteenth-Century Paintings of the Artist's Home Studio' (PhD diss., University of North Carolina at Chapel Hill, 2000). Most useful for those interested in Fairchild from a biographical perspective are two works by Mary Smart: 'Sunshine and Shade: Mary Fairchild MacMonnies Low,' *Woman's Art Journal*, vol. 4 (Fall 1983/Winter 1984), 20–25; and *A Flight with Fame: The Life and Art of Frederick MacMonnies (1863–1937)* (Madison CT: Sound View Press, 1996). Fairchild is

most often discussed critically in terms of her mural for the 1893 World's Columbian Exposition in Chicago – see especially Judy Sund, 'Columbus and Columbia in Chicago, 1893: Man of Genius Meets Generic Woman,' *The Art Bulletin*, vol. 65, no. 3 (September 1993), 443–66. For the most recent information on the whereabouts of the mural, see Sally Webster, *Eve's Daughter/ Modern Woman: A Mural by Mary Cassatt* (Urbana IL: University of Illinois Press, 2004); see also Carolyn Kinder Carr and Sally Webster, 'Mary Cassatt and Mary Fairchild MacMonnies: The Search for Their 1893 Murals,' in *American Art*, vol. 8, no.1 (Winter 1994), 53–70. More typical in mentioning Fairchild is David Sellin's *Americans in Brittany and Normandy 1860–1910* (exhibition catalogue, Phoenix AZ: Phoenix Art Museum, 1982), in which Cassatt figures extensively in the section on Giverny, even though she did not paint there. Fairchild, who lived and painted there for more than ten years, is briefly described as 'his wife, the painter Mary Fairchild' (p. 73). For contemporary (and hence more laudatory) accounts of Fairchild and her work, the Mary Smart/ Frederick MacMonnies Papers at the Archives of American Art are invaluable. Fairchild collected a scrapbook of articles on both her husband and herself that can be found there, including the article on Fairchild by Eleanor E. Greatorex in *Godey's Magazine* (May 1893), 630. A number of recent exhibition catalogues show Fairchild's *Dans la nursery* (attributed as such); Cartwright's textual contribution within one of these is the lengthiest (and is discussed further in the footnotes to Chapter 4), followed by Kathleen Pyne's 'Americans in Giverny: The Meaning of a Place,' in Katherine M. Bourguignon, ed., *Impressionist Giverny: A Colony of Artists, 1885–1915* (Giverny (France): Musée d'Art Américain Giverny, 2007), pp. 45–55. Pyne, transitioning from a discussion of how MacMonnies's role as teacher drew female students to Giverny, begins her treatment of both Fairchild's painting and her contributions to life in Giverny with 'Now family figures – the wife, Mary Fairchild MacMonnies, herself a painter, and the children – or a professional model imported from Paris …' (p. 49), but the text that follows is appropriately even-handed. There is a brief entry on Fairchild, with a reproduction and short discussion of *Dans la nursery*, in *Americans in Paris 1860–1900*, a catalogue for the major exhibition which traveled to the National Gallery in London, the Boston Museum of Fine Arts, and the Metropolitan Museum of Art in New York. In neither the exhibition nor the catalogue was Fairchild forced to play second fiddle, and this exhibition probably resulted in the largest audience this work has had since the turn of the previous century (there remains a link to the work on the Metropolitan Museum of Art's website, again, still crediting the work to Fairchild, at least as of August 2009). Nonetheless, the textual discussions of her work that accompanied the show were brief and based wholly on existing scholarship.

4. See, for example, Katherine M. Bourguignon, 'Impressionist Giverny: American Painters in France,' in *American Art Review*, vol. 20, no. 3 (2008), 100–13.

5. On their collections pages for each of the images (the only published sources making the re-reattribution argument at the time this book went to press), it is stated that the attribution has been debated. On the page for *'Painting Atelier at Giverny'* (*Dans la nursery*), an 1896 edition of the *Chicago Evening Post* is cited as supporting the change back to MacMonnies, stating that the reviewer in that text describes *Dans la nursery* differently than what appears in our painting. This is not necessarily the case as the reviewer states clearly that the described work is as yet untitled; additionally, the reviewer describes *a* work depicting a nursery scene by Fairchild – who submitted two differently titled 'nursery' works to various exhibitions, so this may in fact be describing the other or even an unknown third, as the work matching this description is at present lost or missing. It is also important to note that MacMonnies *never* submitted or documented any works with a similar title or setting, so there is no reason to believe that if one work by Fairchild is not the same as that described, that we must be seeing an entirely undocumented work by MacMonnies. See <http://www.terraamericanart.org/collections/code/emuseum.asp?style=single ¤trecord=1&page=seealso&profile=objects&searchdesc=Baby%20Berthe%20in%20a%20Hi gh%20Chair...&searchstring=id/,/is/,/2/,/false/,/true&newvalues=1&rawsearch=id/,/is/,/537/,/false/,/ true&newstyle=single&newprofile=objects&newsearchdesc=Atelier%20at%20Giverny&newcurr entrecord=1&module=objects>. On their page for *Baby Berthe in a High Chair with Toys* (*C'est la fête à bébé*), they cite a source they claim states that that painting was 'a large and 'elaborate' painting, not like this intimately scaled canvas' (<http://www.terraamericanart.org/collections/code/ emuseum.asp?style=single¤trecord=1&page=seealso&profile=objects&searchdesc=Atelier %20at%20Giverny...&searchstring=id/,/is/,/537/,/false/,/true&newvalues=1&rawsearch=id/,/is/,/2/,/ false/,/true&newstyle=single&newprofile=objects&newsearchdesc=Baby%20Berthe%20in%20a%2 0High%20Chair%20with%20Toys&newcurrentrecord=1&module=objects>). However, the source cited in the footnote below that interpretation is cited incorrectly (Helen Cole never wrote an essay entitled 'A Western Art Collection' – rather, this citation should have the title of 'American Artists in Paris'). Unlike the Terra, I give this quote in full in Chapter 3 (and also did so in my dissertation, which the Terra staff have been aware of since 2000). I will cite the relevant sentence here, with my own added emphasis: '*All these* are of a size and elaborateness of composition that prove that the painter will not sink into the mother.' Cole is clearly talking about more than one work, not this specific one, and also is not so specific about the size and elaborateness to be conclusive in any

way. What is the size and elaborateness that proves one is a professional, not a dabbler? It should be kept in mind that one of Fairchild's many professional artistic successes involved the painting of miniatures (see Fig. 3.2). See Helen Cole, 'American Artists in Paris,' in *Brush and Pencil*, vol. 4, no. 4 (July 1899), 199–202; esp. 201.

6. 'Introduction,' n.p.

7. There are books that cover in greater detail specific studios or sites for studios, such as Annette Blaugrund's *The Tenth Street Studio Building: Artist-Entrepreneurs from the Hudson River School to the American Impressionists* (exhibition catalogue, Southampton NY: Parrish Art Museum, 1997); and John Milner's *The Studios of Paris: The Capital of Art in the Late Nineteenth Century* (New Haven CT: Yale University Press, 1988). However, both books emphasize the actual studios and their features over their representation in painting, as does the more general and helpful *Imagination's Chamber: Artists and Their Studios* by Alice Bellony-Rewald and Michael Peppiatt (Boston MA: Little, Brown, 1982) and the more recent but brief *Artists in Their Studios: Images from the Smithsonian's Archives of American Art* by Liza Kirwin with Joan Lord (New York NY: Collins Design, 2007). The studio as a painted subject has been pursued exclusively in either articles or exhibition catalogues such as: David B. Cass, *In the Studio: The Making of Art in Nineteenth-Century France* (Williamstown MA: Sterling and Francine Clark Art Institute, 1981); Ronnie L. Zakon, *The Artist and the Studio in the Eighteenth and Nineteenth Centuries* (Cleveland OH: Cleveland Museum of Art, 1978); and *The Artist's Studio in American Painting 1840–1983* (Allentown PA: Allentown Art Museum, 1983). By contrast, the artist's self-portrait is more widely and deeply considered.

8. See particularly Bellony-Rewald and Peppiatt, *Imagination's Chamber*, for a history of the studio.

9. Bellony-Rewald and Peppiatt's text, which is the most comprehensive on the subject, has three chapters on pre-nineteenth-century studios and seven that cover the nineteenth and twentieth centuries. Zakon's catalogue (*The Artist and the Studio*) focuses on the eighteenth and nineteenth centuries exclusively, describing them as the most significant for such depictions due to the changing position and status of the artist in society. Cass states that the nineteenth century produced more pictures of artists' studios 'than the art of any previous century' (*In the Studio*, p. 7), also linking it to the changing status of artists and the changes in the art market that I discuss in Chapter 2.

10. Robert L. Herbert, 'Method and Meaning in Monet,' in *Art in America*, vol. 67, no. 5 (September 1979), 90–108.

11. My own translation, from the following: '… *une atmosphère se crée ainsi dans chaque intérieur, de meme qu'un air de famille entre tous les meubles et les objets qui le remplissent. La fréquence, la multiplicité et la disposition des glaces dont on orne les appartements, le number des objets qu'on accroche aux murs, toutes ces choses ont amené dans nos demeures … Et puisque nous accolons étroitement la nature, nous ne séparerons plus le personage du fond d'appartement ni du fond de rue. Il ne nous apparaît jamais, dans l'existence, sur des fonds neutres, vides et vagues. Mais autour de lui et derrière lui sont des meubles, des cheminées, des tentures de murailles, une paroi qui exprime sa fortune, sa classe, son métier …*' See Louis Emile Edmond Duranty, *La Nouvelle peinture à propos du groupe d'artistes qui expose dans les galeries du Durand-Ruel* (Paris: E. Dentu, 1876); reproduced in *The New Painting: Impressionism 1874–1886* (San Francisco CA: Fine Arts Museum of San Francisco, 1986), pp. 477–84, with an English translation by Charles S. Moffett on pp. 37–49. Moffett's translation can also be found excerpted in *Art in Theory 1815–1900: An Anthology of Changing Ideas*, ed. Charles Harrison and Paul Wood with Jason Gaiger (Oxford: Blackwell, 1998), pp. 576–85. The phrase '*et puisque nous accolons étroitement la nature*' is translated by Moffett as 'And, as we are solidly embracing nature,' but I believe Duranty is here referring to his previous paragraph, in which he discusses the way that Academic artists were combining various distinct details to create images that were not true to the subject as we might encounter it in lived experience. Duranty thus uses *accoler* to signal instead a close joining or uniting of things normally found together or existing in the same atmosphere, rather than a unity of dislocated parts; this is slightly different than the mere (yet 'solid') embracing of nature that Moffett's translation suggests. It is the close, direct observation of nature and its truthful visual re-presentation that Duranty finds missing if one ignores context or separates context from subject.

12. All the members of the Société Anonyme, the Anonymous Society of artists who came to be known as Impressionists, have at some point or another been considered Impressionists, yet one struggles to locate stylistic and other similarities between the works of Edgar Degas, Berthe Morisot, and Camille Pissarro.

13. Training in France or somewhere in Europe was considered vital to the development of the American artist, whose homeland was often viewed as indifferent if not hostile to art making as a career. When naming the most famous American artists of the late nineteenth century, this

paradigm is evident: James Abbott McNeill Whistler, John Singer Sargent, Mary Cassatt, Lilla Cabot Perry, Frederick MacMonnies, and Mary Fairchild MacMonnies Low were all expatriates for most or all of their artistic careers. Winslow Homer, Thomas Eakins, William Merritt Chase, Cecilia Beaux, and all of the members of The Ten spent years in European academies and schools.

14. Two notable exceptions are Swedish artist Carl Larsson (*Ateljé-idyll*, 1885, Nationalmuseum Stockholm) and Alfred Stevens, whose studio paintings will be discussed in later chapters. Their studio images differ significantly from the type discussed in my book (Larsson's barely evokes the room and could depict any interior; Stevens's are highly fantastical paintings that are clearly not intended to depict his own studio as it actually existed). The standard European studio images will be discussed in greater detail in Chapter 1.

15. See particularly Russell Lynes, *The Art-Makers of Nineteenth-Century America* (New York NY: Atheneum, 1970) and Lynes, *The Tastemakers* (New York NY: Harper, 1954); and Neil Harris, *The Artist in American Society: The Formative Years 1790–1860* (New York NY: George Braziller, 1966). Also useful are J. Meredith Neil, *Toward a National Taste: America's Quest for Aesthetic Independence* (Honolulu HI: University Press of Hawaii, 1975); and James Thomas Flexner et al., *The Shaping of Art and Architecture in Nineteenth-Century America* (New York NY: Metropolitan Museum of Art, 1972). Neil, whose focus is more strictly upon literature, puts the shift to increasing acceptance of a national interest in aesthetics and the arts earlier, at the turn of the eighteenth century.

16. The growth of cities and the gradual development of the suburbs often placed a new physical distance between some men's work and their homes, eventually aided by transportation developments like the streetcar and subway, which then allowed some families to live even farther from the businessman's work. This time also marked the growing geographical separation between business and residential areas within the urban core.

17. For information about Chase, see the following biographies: Katherine Metcalf Roof, *The Life and Art of William Merritt Chase* [1917] (New York NY: Hacker Art Books, 1975); and Keith L. Bryant, Jr., *William Merritt Chase: A Genteel Bohemian* (Columbia MO: University of Missouri Press, 1991). See also Ronald G. Pisano, *A Leading Spirit in American Art: William Merritt Chase 1849–1916* (Seattle WA: Henry Gallery Association, 1983); Pisano's *William Merritt Chase* (New York NY: Watson-Guptill, 1979); and Barbara Dayer Gallati, *William Merritt Chase* (New York NY: Harry N. Abrams, 1995). There is a tremendous amount of literature on Chase both from his own time and now; however, he is relatively unknown to lay people today. Nonetheless, a glance at any art magazine of the late nineteenth century reveals his stature as one of the most influential and respected artists in American art.

18. Pisano notes that the quick and visible brushwork of the Munich years, combined with the lighter palette he believes Chase developed on plein air painting trips in Belgium, led to Chase's being seen as an Impressionist, despite his never having specifically studied under a French Impressionist artist. Pisano also notes that Chase was fond of the work of Eugène Boudin (Monet's mentor), was familiar with Manet before 1881, and probably saw the American Art Association's 1886 exhibition of Impressionist works from Durand-Ruel's collection. See Pisano, *A Leading Spirit*, pp. 149–50. Pisano thus argues that Chase's style is international, not having come from one particular source.

19. Giorgio Vasari used this type of criticism in writing about Sofonisba Anguissola in the sixteenth century, and its use was common in the nineteenth century as well: women, being of lesser intelligence (for whatever reason), fitted the patriarchal arguments of the time, and were capable of mimicry and manual skill but not invention of the type that showed intellect.

20. Gallati, *William Merritt Chase*, p. 50. Gallati also notes that none was as extravagant as the famed Tenth Street Studio in Manhattan, with the Shinnecock Hills studio on Long Island a close second in its fabulousness. Hence the relatively few representations of the others in his oeuvre.

21. See Gallati, *William Merritt Chase*, pp. 39–53; Celia Betsky, 'In the Artist's Studio,' *Portfolio* (January–February 1982), 32–9; and Sarah Burns, 'The Price of Beauty: Art, Commerce, and the Late Nineteenth-Century American Studio Interior,' in *American Iconology*, ed. David C. Miller (New Haven CT: Yale University Press, 1993), pp. 209–38. See also Lynes, *The Art-Makers*. Nearly every article ever written about Chase mentions this or one of his studios in some way.

22. Abigail Solomon-Godeau, 'Male Trouble,' in *Constructing Masculinity*, ed. Martin Berger, Brian Wallis, and Simon Watson (New York NY: Routledge, 1995), pp. 68–76; these quotations are from p. 73 (direct) and p. 75 (indirect). This part of my discussion is also indebted to Eve Kosofsky Sedgwick.

23. All biographical information on Fairchild comes from the sources mentioned in footnote 3.

24. There is not the same overwhelmingly universal consensus on Fairchild's concern with appearances and social standing that we find in Chase's literature, although as Mary Smart points

out, Fairchild's *Self-Portrait* (1889) clearly emphasizes her fashionable accoutrements, and in her memoirs 'reveals herself as very conscious of social position and appearance.' See both 'Sunshine and Shade' and *A Flight with Fame.*

25. Griselda Pollock, 'Modernity and the Spaces of Femininity,' in *Vision and Difference: Feminism, Femininity and the Histories of Art* (London: Routledge, 1988). For the gendering of subject matter in art, see also Pollock and Roszika Parker, *Old Mistresses: Women, Art, and Ideology* (New York NY: Pantheon, 1981). Pollock's more recent work, particularly *Differencing the Canon: Feminist Desire and the Writing of Art's Histories* (London: Routledge, 1999) takes a less essentialist stance, arguing, as I do, for a more comprehensive view of gender issues and the role of feminism in our understanding of art history. Even more relevantly, Pollock's newer reading of Alfred Stevens's 1888 *In the Studio* simultaneously considers the gender divisions of the times and their complexity in that image. See Griselda Pollock, 'Louise Abbéma's *Lunch* and Alfred Stevens's *Studio*: Theatricality, Feminine Subjectivity and Space around Sarah Bernhardt, Paris, 1877–1888,' in *Local/Global: Women Artists in the Nineteenth Century*, eds Deborah Cherry and Janice Helland (Burlington VT: Ashgate, 2006), pp. 99–119.

26. Robert L. Herbert, *Impressionism: Art, Leisure, and Parisian Society* (New Haven CT: Yale University Press), pp. 47–50.

27. Judith Butler, *Gender Trouble: Feminism and the Subversion of Identity* (New York NY: Routledge, 1990). See also Butler's *Bodies That Matter: On the Discursive Limits of 'Sex'* (New York NY: Routledge, 1993); and *Excitable Speech: A Politics of the Performative* (New York NY: Routledge, 1997).

28. I do not wish to enter the controversies over whether Butler originated these ideas or stole them from J.S. Mill or Nancy Chodorow or anyone else. Butler is, for better or worse, the most prominent voice in contemporary theory for this perspective. In any case, queer theory's resistance to essentialist theories allows for the separation of desire from a particular body, hence avoiding the compulsory heterosexuality of even the most progressive feminist or Freudian-based psychoanalytic views; the result is an opportunity to understand men and women as individuals, rather than wholly determined by their sex organs or societal constructions based on them.

29. Butler, 'Imitation and Gender Insubordination,' in *Inside/Out: Lesbian Theories, Gay Theories*, ed. Diana Fuss (New York NY: Routledge, 1991), p. 18.

30. See Mary W. Blanchard, 'The Soldier and the Aesthete: Homosexuality and Popular Culture in Gilded Age America,' in *Journal of American Studies*, vol. 30, no. 1 (1996), 25–46. Blanchard's article focuses almost exclusively on Wilde, and thus does little to convince the reader of just how widespread acceptance of male effeminacy was in the 1890s. Nonetheless, the public nature of Wilde's effeminacy, along with that of other aesthetes during the period, does suggest a more broad play with gender identities that I hope to contribute to readings of visual arts of the same time period. See also John Kasson's *Rudeness and Civility: Manners in Nineteenth-Century Urban America* (New York NY: Hill & Wang, 1990) for more on the continual refinement of manners with the encroachment of the middle class.

31. Fairchild in a letter to Bertha Potter Palmer quoted in Jeanne Madeline Weimann, *The Fair Women* (Chicago IL: Academy, 1982), p. 211.

32. Lynes, in Flexner et al., *The Shaping of Art and Architecture*, p. 114.

33. Burns, *Inventing the Modern Artist: Art and Culture in Gilded Age America* (New Haven CT: Yale University Press), pp. 4–5.

34. See Burns, *Inventing the Modern Artist*, pp. 159–86. Chase was a particular 'master' of these strategies, as I will discuss in more detail in Chapter 2.

35. See Burns, *Inventing the Modern Artist*, pp. 172–86. See also Pollock and Parker, *Old Mistresses*; they point out that this strategy may have been used by many women artists throughout art history, as for example Elisabeth Vigée-Lebrun, who 'was acceptable only in so far as her person, her public persona, conformed to the current notions of Woman, not artist' (p. 96).

36. Burns, *Inventing the Modern Artist*, pp. 277–99.

Working Men and Leisurely Ladies: Tropes of Gender and the Artist's Studio in the Late Nineteenth Century

To comprehend how artists resisted and/or subverted social norms in the late nineteenth century, we must first understand what those norms were. The considerable changes taking place from 1880 until the turn of the century make this task a challenge, and yet some generalizations are consistently made about the era. Scholars of the period, both in the US and Europe, have emphasized that relatively strict gender divisions as well as the significant growth of the middle class characterized the last two decades of the nineteenth century. In fact, these issues are closely related. As the Industrial Revolution changed the workplace forever, divisions of labor occurred even within the bourgeois family unit, and these divisions were decidedly gender-based. Whereas before industrialization, middle- and working-class families had tended to work together either inside or outside the home, the streamlining of production that accompanied the development of machines shifted emphasis in the middle classes more to white-collar work, which became a male province, leaving middle-class women to domestic labor and child-rearing at home. Enlightenment theorists both preceded and followed this shift, providing support for the dichotomization along philosophical lines; Jean-Jacques Rousseau, among others in the eighteenth century, outlined the new ideal family, in which the woman's goal was to submit to the male head of household and teach the male children to be good citizens – in both cases, from the 'safety' of the domestic space, which she would enliven with her unique feminine charms.[1] In this manner, justifications of the gendered division of labor suggested that to fight it was to, at best, live in the past and, at worst, side with the historical agents of oppression. At the same time, the genuine growth of the middle classes included an increase in leisure time and disposable income, enabling them to afford pursuits such as the acquiring of non-useful goods and services previously specific to the wealthiest strata of society.[2]

Accordingly, the concomitant growth of the art market seems predictable: more people were able to spend time developing an interest in art by visiting galleries and museums (both relatively new institutions whose development doubtless connected with these others) and displaying their appreciation by purchasing works. As more families moved out of agricultural and other labor-intensive economies and garnered more disposable income, subsequent generations began to feel greater freedom to choose their own careers, including art making. By extension, the gendered division of labor in bourgeois society had an impact upon perceptions of both artists and the spaces in which they created their works. In the chapter that follows, I will outline standard late nineteenth-century perceptions of the artist's studio and of gender divisions. Then I will link these two perceptions together to show how the artist's studio provides a particularly rich locus for understanding the role of gender in the identity of the late nineteenth-century artist.

Representing the Artist's Studio

The painted subject of the artist's studio was quite common in the nineteenth century, to such an extent that general subcategories of the genre developed.[3] In each case, but particularly when the work was meant for the public, the artist was obviously aware of the connotations of self-representation inherent in the image. After all, paintings of the studio have as their very subject matter artists and their artistic process. The early- to mid-nineteenth century artist often represented his or her studio as a place of artistic discovery or transformation, as in William Sidney Mount's *The Painter's Triumph* (1838, Pennsylvania Academy of the Fine Arts, Philadelphia). Mount's painter has a simple, plain studio interior, its only decoration a drawing of a Grecian sculpted head whose gaze is turned away from the art the painter produces. The painter, standing in a dramatic pose, displays his 'triumph' (unseen, like all the original works in the room, to our eyes) to the appreciative, wondering smile of a local type still gripping his riding crop and wearing his hat. Such studio images emphasized the artist's role as a creator able to bring the inanimate to life or at least to an amazed public eye.

Artists who might wish to be seen as capable of bringing an aesthetic atmosphere to everything they touched could depict their studios as dramatic, decorative showplaces; this was a popular choice in the later nineteenth century, particularly among artists like William Merritt Chase, Alfred Stevens, and Madeleine Lemaire, who felt that worldliness and art making went hand in hand. Chase's *Tenth Street Studio* (c. 1881–1910, Carnegie Museum of Art, Pittsburgh) shows that room in a wide view (Fig. 1.1), lavishing equal attention on the visitors leaning in to examine a work on the wall, the woman seated at the table at left looking through works

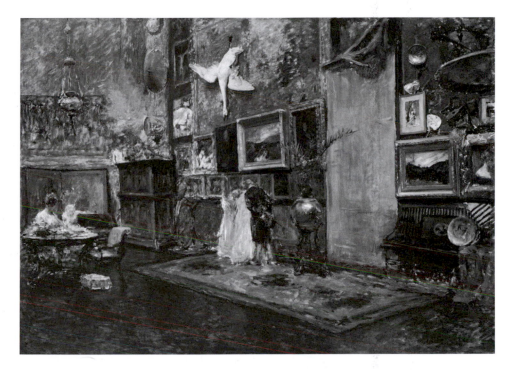

1.1 William Merritt Chase (American, 1849–1916), *Tenth Street Studio* (c. 1880–81 and c. 1910). Oil on canvas, 46⅞" H × 66" W (119 × 167.6 cm). Carnegie Museum of Art, Pittsburgh. 17.22. Photo: © 2009 Carnegie Museum of Art, Pittsburgh

or perhaps a book, and the furnishings, wall hangings, plates, pots, lamps, umbrellas, plants, rugs, stuffed (we hope!) swan, *live* peacock, drawings, paintings, and photographs that cover every inch of every visible surface. Here every element is equal in aesthetic value, and one presumes that the artist who assembled these objects must be the epitome of bold aesthetic taste. Madeleine Jeanne Lemaire's *An Elegant Tea Party in the Artist's Studio* (*Thé élégant dans l'atelier de l'artiste*) (1891) (Fig. 1.2) focuses on the activities of the studio's visitors, all richly dressed to match their surroundings. The artist is presumably either the woman seated on the couch on the far right, or the woman in the velvet gown attempting to serve tea to a gentleman. In such images, the female artist is typically depicted in more casual or intimate dress than her visitors (as in Alfred G. Stevens's *In the Studio*, 1888, Metropolitan Museum of Art) (Fig. 1.3), although as the artist would also be the hostess, one would expect her to serve the tea. The woman on the far right in Lemaire's painting is dressed in a relatively loose, light-colored tea gown that contrasts with the clothing of her visitors, who are attired more formally in day dresses and suits appropriate to making calls and being

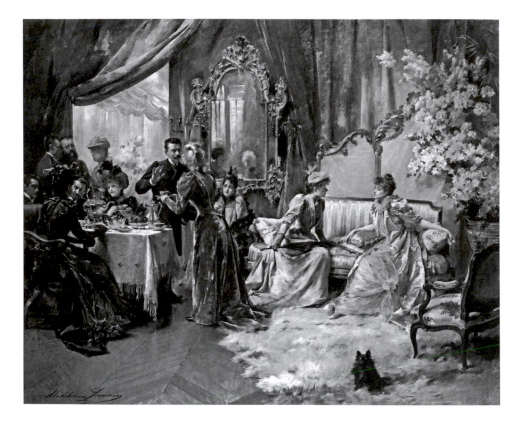

1.2 Madeleine Jeanne Lemaire (French, 1845–1928), *An Elegant Tea Party in the Artist's Studio (Thé élégant dans l'atelier de l'artiste)*, 1891. Oil on canvas, 45¼" H × 55⅛" W (115 × 140 cm). Photo: Fine Art Photographic Library, London/Art Resource, New York

seen out of doors on the way to social engagements.[4] The painting clearly emphasizes conversation between its human subjects, with only the small dog in the foreground addressing the viewer. As Lemaire states in her title, this does indeed seem to be an elegant tea party, and she has painted her studio as the perfect setting for such a gathering. In both Chase's and Lemaire's images, the studio recommends its owner as a social animal, skilled as much in entertaining and providing an artistic atmosphere through the careful display of furnishings as in creating works themselves – the Lemaire image does not include even a single painting, by Lemaire or anyone else.[5]

On the opposite side of the spectrum, the common conception of the romantically lonely artist suffering for art in a tiny garret was often encouraged by studio paintings that depicted a small room sparsely furnished with a cot for troubled sleep and a pot-bellied stove to keep away cold, while the artist

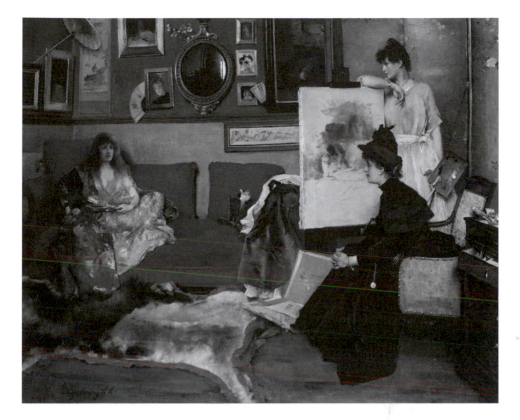

1.3 Alfred G. Stevens (Belgian, 1823–1906), *In the Studio*, 1888. Oil on canvas, 42" H
× 53½" W (106.7 × 135.9 cm). The Metropolitan Museum of Art, New York. Gift of
Mrs. Charles Wrightsman, 1986. 1986.339.2. Image: © The Metropolitan Museum
of Art/Art Resource, New York

lived only for the comfort of an artistic vision. Examples of this rhetoric can be
found in paintings by Henri Matisse, as in his *Studio Interior* (1902, Fitzwilliam
Museum, Cambridge, UK) or Jean-Frédéric Bazille's *The Artist's Studio, rue
Visconti, Paris* (1867, Virginia Museum of Fine Arts, Richmond) (Fig. 1.4). Both
of these paintings are composed to emphasize the cramped, dark, art-focused
corners of the artists' workspaces. Bazille's creation of a steep recession of the
dirty floor into the back of the room, amplified by his cropped placement of
an easel with its canvas and palette pressing into the viewer's space in the
left foreground, dramatizes the compression and claustrophobia of the room.
The studios are devoid of any extraneous furnishings and, in Matisse's image,
enlivening decoration, showing only bare walls and the barest necessities
of work. Bazille's small corner stove, with a bench pressed almost directly
against it, serves as a visual reminder that many artists worked in cold, damp

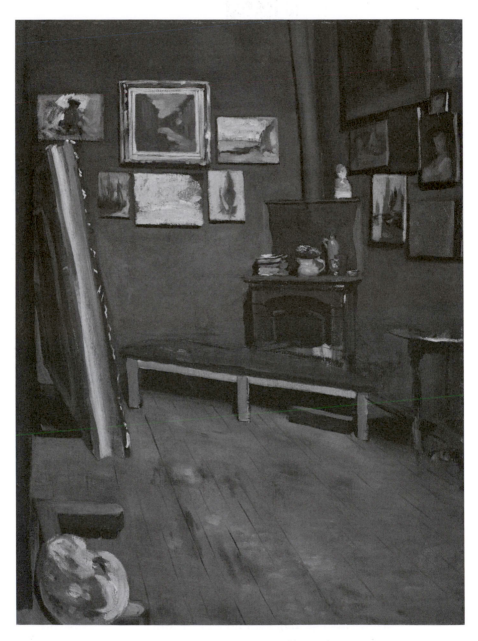

1.4 Jean-Frédéric Bazille (French, 1841–1870), *The Artist's Studio, rue Visconti, Paris*, 1867.
Oil on canvas, 25½" H × 19" W (64.8 cm × 48.3 cm). Virginia Museum of Fine
Arts, Richmond. Collection of Mr. and Mrs. Paul Mellon. Photo:
Katherine Wetzel © Virginia Museum of Fine Arts

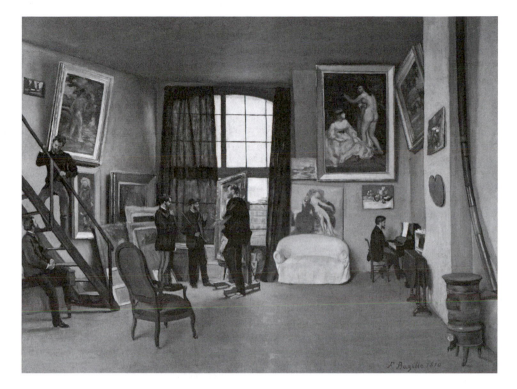

1.5 Jean-Frédéric Bazille (French, 1841–1870), *The Painter's Atelier in the rue de la Condamine (L'Atelier d'artiste, 9 rue de la Condamine)*, 1870. Oil on canvas, 38⅝" H × 50⅝" W (98.1 × 128.6 cm). Musée d'Orsay, Paris, France. Photo: Erich Lessing/Art Resource, New York

studios that were barely tolerable by middle-class standards – even though both Bazille and Matisse were middle-class and lived comfortably.

When artists like the Impressionists separated themselves from the Academies and began to form their own communities, their unity as like-minded innovators could be marked by a studio image depicting them gathering for discussion, as seen in Henri Fantin-Latour's *L'Atelier aux Batignolles* (1870, Musée d'Orsay, Paris) and Bazille's *The Painter's Atelier in the rue de la Condamine (L'Atelier d'artiste, 9 rue de la Condamine)* (1870, Musée d'Orsay, Paris) (Fig. 1.5). Fantin-Latour made more than one such image; here we see the 'masters' of Impressionism gathered around Edouard Manet, who seems to be leading the others in an impromptu painting lesson in his Batignolles quarter studio. The 'students,' among them Bazille, Claude Monet, and Pierre-Auguste Renoir, are rendered in recognizable portraits, suggesting Fantin-Latour's prescience in thinking his image might be used when defining the membership and innovation of

the avant-garde group. Bazille's painting, while still depicting identifiable characters (many of whom appear in both Fantin-Latour's painting and this one), seems a less posed, more snapshot-like representation of his own studio, where Monet, Manet, and Renoir among others take up informal positions around the studio, presumably discussing the latest ideas in representation. In both Fantin-Latour's and Bazille's images, the walls and tables hold works of art that are varied in style but suggest some of the influences upon the present artists.

Such a survey of contemporaneous studio paintings, although abbreviated, shows the developed and shared iconography of a popular subject matter. It is possible to locate one or more studio paintings by nearly every significant male European and American artist of the time – Chase alone made at least six finished and publicly shown paintings of his studios, Bazille at least three. The sheer number of paintings of the artist's studio produced during the latter half of the nineteenth century suggests that this space was one of great importance to artists of the time, both actually and metaphorically, and the manner in which the studio represented the artist was a significant issue.

This study will not address paintings of the garret studio wherein many a poor artist was forced to sleep in the same room in which he or she painted; rather, it will focus on depictions of the bourgeois artist's relatively more lavish surroundings. The garret studio representation typically invokes the concept of the unappreciated starving artist, pitting his or her skills, genius, or inspiration against a cold, unfeeling, materialistic world. I am more concerned with representations that bring the world in, rather than shutting it out, and with artists who were looking to fit at least marginally into their society, rather than seeing themselves as alienated from it. As bourgeois artists negotiated their class backgrounds and the classes of their patrons, their studios were increasingly sites of display, reflecting the new role of the artist in society. In fact, the more successful artists of the late nineteenth century usually had more than one studio – some common examples are the various studios of Chase, Ernst Meissonier, Albert Bierstadt, and Frederic Leighton. Each studio often differed from the others in use and perception, with a large showplace studio fulfilling the public role of display of the artist's works for possible purchase or accretion of fame and a smaller, more private studio providing space for the actual creation of paintings.[6] Growing numbers of artists even had homes specifically designed and built with their studios in mind, as is the case with Leighton.[7] This developing focus on the studio during the late nineteenth century had several causes: the shift away from Academies and toward the artist as an individual in terms of training, creation of works, and patronage; the increasing numbers of bourgeois artists and patrons; and, particularly in the US, the changing role and value accorded to the artist in society.

One of the most significant, if gradual, developments in nineteenth-century art was the erosion of the formalized Academy system in France.[8] Traditionally, those who wished to become professional painters studied at the Academy's schools (with some supplemental training, particularly in painting, at the ateliers of established 'masters' like Jacques-Louis David) and submitted finished works to the Academy's competitions and exhibitions, such as the Salons that were held once a year. Success in the Academy parlayed into commissions from the state and the development of private patronage from the highest classes of society. Artists established their reputations and honed their skills in the classrooms of either the Ecoles or the master ateliers and the Salon showings, where the state was a major purchaser of works. The academic institutions stressed and rewarded a particular hierarchy of subject matter, size, and format, as well as a strong degree of 'finish' and representational verisimilitude. As more artists began to create works that violated or subverted Academic principles,[9] private schools and independent exhibitions become increasingly commonplace. By the end of the century, it was a rare painter, American or French (or even Japanese) who did not study at the more informal Académie Julian or Colarossi's, where students had more freedom to produce non-Academic works and had only to pay in order to enroll. These changes were not solely the result of changing interests in representation among artists, however.

The dramatic growth of the middle class in France after 1830 created an altogether new audience for art – an audience that desired both affordable works that they could purchase and works that represented something more akin to their experiences. This new audience did not always hold the same expectations for a work that the jurors of the Salon did, and although the Salon continued to play an important role, so did a new and growing contingent of galleries and independent shows.[10] With more artists thus able to exhibit and sell their works outside of the Academy's purview, the Academy lost its economic stranglehold on the artistic profession.

The situation in the US was both similar and different. The American art world never included a single, fully entrenched state institution, although the development of the National Academy of Design in 1825 (in protest against the American Academy of Fine Arts and in contrast to the Pennsylvania Academy of Fine Arts and the Boston Athenaeum) seemed to signal a more unified organization. Yet from 1870 on, the NAD faced opposition similar to that faced by the French Academy. In response to both the relatively weaker support for the arts and American ideology, these organizations were necessarily more democratic and less restrictive than the European academies upon which they were modeled. Despite an inherent conservatism, they never achieved an equal level of control over the art world.[11] The US did share with Europe the dramatic increase in its middle class and the interest this class and the nouveaux riches

had in purchasing art and involving themselves more actively in the art world.

In both French and American society, the burgeoning middle classes and the development of a more capitalistic art market altered both the status and the sales techniques of artists. First of all, it was possible for a wider group of people to become professional artists – a larger bourgeoisie, constituting a much larger percentage of the total population than ever before, meant more people able to devote time and family (or better yet, speculative) resources to studying art and art making. Greater wealth allowed those who did not want to continue in the family business an opportunity to choose a less immediately lucrative career.[12]

Greater wealth and more leisure time also inevitably allowed the bourgeoisie to spend some of that wealth on leisure activities, including both appreciating and purchasing art. Hence many new artists met many new patrons, causing the development of new ways of marketing art. As Sarah Burns argues in *Inventing the Modern Artist: Art and Culture in Gilded Age America*, the creation of the mass media led to a more widespread familiarity with both artists and their works, with the personality as created by the media often being the chief path to an artist's success.[13]

I have mentioned the development of galleries and museums, but the studio also played an important role in new modes of marketing. As yet another site of display for both artworks and the person who made them, the studio of the late nineteenth century was no longer (if it ever had been) a private space, per se. Rather, it was one of many places in which the market operated. Furthermore, if the artist was no longer working primarily through an Academy, the studio was another way to emphasize the artist's individuality.[14] Additionally, the studio was one of the few sanctioned sites for the acceptable, if occasionally worrisome, mixing of classes. Much has been said about the new urban spaces of the Industrial Era and their potential for class admixture. Outdoor and other overtly public spaces are readily apparent sites for such discussion. Yet the studio, a simultaneously public and private space, is much more complex. Sarah Burns, both in her article 'The Price of Beauty: Art, Commerce, and the Late Nineteenth-Century American Studio Interior,' and in her book *Inventing the Modern Artist*, has looked closely at the nineteenth-century studio as a commercial venue, whose inhabitants, whether they purchase works or not, are cultural 'shoppers' displaying their enculturation and role in the market by their presence in the space. Through these kinds of social markers, we learn about the inherently commodified nature of the studio. However, we also need to think about the studio as a space in which the usual fairly extreme boundaries between the classes could be relaxed somewhat, if never totally, during the late nineteenth century. When Chase, at the request of John Singer Sargent, hosted a performance by the Spanish dancer Carmen Dauset ('La Carmencita') at his Tenth Street

studio for the enjoyment of patron Isabella Stewart Gardner and her friends, he was bringing together the highest, middle, and lower classes. He did not host this gathering at his home, but at his studio – a site appropriate not merely for its size and fabulous decor, but for its ability to contain such divergent groups without causing a scandal. Dora Wheeler later described the incident as 'wild and primitive,' and much is made of Chase and Sargent having to remove the dancer's overdone makeup and 'brush her frizzed hair back from her forehead' until she appeared more 'natural.'[15] An artist was expected to be a little bohemian, and was attractive to the upper classes for his (because the bohemianism was more acceptable in male artists) daring unconventionality.[16] A trip to his studio might cause one to 'stumble upon' a model (in some cases a prostitute, rag picker, or street urchin) posing for a picture, in a setting where encountering that 'type' would be picturesque rather than threatening. Burns has begun to focus our interest on the studio as a site for considering class and gender issues, and her work opens the door for the study developed here.[17]

As the private, home-based studio began to play a more significant role in the lives of increasing numbers of artists both in Europe and the US, so too did representations of it. Photographs or engravings of photographs of artists' studios were de rigueur in the many journals of the period that discussed art (for example, *The Studio* and *The Quarterly Illustrator*) as well as in newspaper articles about artists. These photographs confirm that many people were thinking about the studio and wanted to see it, and that interest in the space of artistic creation was not limited to its denizens. However, their paintings tell us more about how the artists themselves saw their spaces and their place in society than the photographs, which were usually taken by others.

The various types of studio images give clues to how the artists wished themselves and their art to be seen. For example, the dramatic difference between Winslow Homer's painting *The Artist's Studio in an Afternoon Fog* (1894, The Memorial Art Gallery of the University of Rochester) and Chase's *Studio Interior (In the Studio)* (c. 1882, Brooklyn Museum, New York) (Fig. 1.6) suggests a great deal about how these artists perceived their roles: Homer saw art as requiring solitude, simplicity, and natural surroundings. Our only depiction of his studio shows it from the outside, a silhouette of a building in an aggressive and untamed landscape. Chase, on the other hand, touted a sophisticated reverence for things urban and European, bric-a-bracomania, and public attention. Hence his depiction is an interior scene, in which the studio is also a room any visiting bourgeois woman would find comfortable and stimulating, enough that she would take a seat on a bench and peruse a book of reproductions. A visitor to Homer's studio might need a compass and galoshes, whereas Chase's guests would more likely don the latest fashions (as the young woman in this image does) and arrive in a carriage.

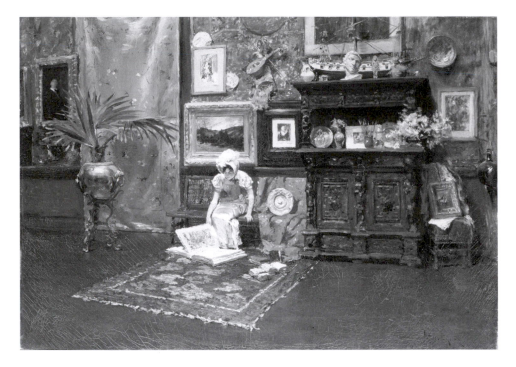

1.6 William Merritt Chase (American, 1849–1916), *Studio Interior (In the Studio)*, c. 1882. Oil on canvas, 28" H × 40⅛" W (71.2 × 101.9 cm). Brooklyn Museum, New York. 13.50. Gift of Mrs. Carll H. de Silver in memory of her husband

Many Impressionists, like Claude Monet and Pierre-Auguste Renoir, did not depict their studios as such but rather showed themselves and each other painting out of doors, to emphasize their interest in a direct connection to their natural subject matter over a heavily worked painting of a plaster cast you might find at any Academy studio. Renoir's *Monet Working in His Garden at Argenteuil* (1873, Wadsworth Atheneum, Hartford, Connecticut) shows Monet nearly subsumed by the outdoor scene of dahlias and country houses, wearing a farmer's or gardener's jacket, 'the very embodiment of the Impressionist ideology' of plein air painting.[18] John Singer Sargent 'commemorates the act of outdoor painting' in his painting *Paul Helleu Sketching with His Wife* (1889, The Brooklyn Museum, New York), originally titled *An Out-of-Doors Study* and not intended as a portrait.[19] This has caused the common misconception that Impressionists did not use or require indoor studios. As Robert Herbert pointed out in his 1979 essay 'Method and Meaning in Monet,' the effectiveness with which many Impressionists elided their studios resulted in the false perception that their works were completely spontaneous.[20] Equally important is the concomitant misperception that, if

Impressionists did not have studios, no study of their studios is necessary. The impact of this second misperception is largely gender-biased, as I will point out in my analysis of women's studios in Chapter 3.

Depicting one's studio, particularly in a painting meant to be shown publicly, was clearly a form of self-advertisement. All the above examples show artists choosing particular elements to emphasize in their studio paintings, depending on their expressive goals. The studio could assist an artist in appearing worldly, intellectual, avant-garde, as the member of a private club or as an 'honest American.' Therefore, we can look at paintings of the artist's studio during the late nineteenth century for cues to artists' perceptions of their role in society and their sense of their own identity. By taking this avenue, I hope to come closer to an accurate understanding of the artists of this time by moving beyond the more stereotyped roles relied upon in past scholarship. Of primary interest to me is a better understanding of the way that artists perceived gender as an element in their art making, as well as how society in general viewed gender.

Gender Tropes in the Late Nineteenth Century

The late nineteenth century was one of many crisis periods in the social construction of gender. The 1890s included both some of the most significant strides in altering earlier nineteenth-century definitions of appropriate gender identity and a seemingly unchangeable acceptance of delimited and separate spheres for men and women. As Peter Filene points out in *Him/Her/Self: Gender Identities in Modern America*, 'subjectively – in their cultural values – middle-class Americans of the 1890s remained eminently Victorian' in their view of women as 'ladies' who ruled the home and no other sphere, with grace, culture, moral fortitude, and utterly selfless devotion to husband and children.[21] Equally pervasive was the definition of masculinity: 'Ideally, a man was self-reliant, strong, resolute, courageous, honest,' a businessman whose commitment to work, and thus to supporting his family, defined him.[22] Although growing numbers of women and men were thinking and acting in ways that deviated from these established norms of separate spheres, there seemed to be predominantly two outcomes for such deviation: either one was seen as no longer truly a woman or man, or one had to defend such deviant behavior by linking it to the rhetoric of sexual difference. For example, suffragists, professional women, and young women who resisted Victorian ideals of genteel femininity at the turn of the century often had to withstand the criticism that they were either attempting to become men or had, in some way, become men in women's bodies. Filene argues that suffragettes were most successful in swaying the public when their rhetoric shifted from

suggestions of the destruction of separate spheres to co-optation of the terms of sexual difference.[23]

Although the 'New Woman' – athletic, short(er)-skirted, a smoker, ready to argue her opinion in conversation with men – did indeed debut in the 1890s, society's mores during that decade were shaped by a slightly older generation: those men and women in their thirties, forties, and fifties who grew up with more tightly defined gender roles based upon the standards of the Cult of True Womanhood and the ideology of separate spheres. In fact, even the growing number of women challenging inequities in education, voting, and public service often maintained a dual alliance to traditional domestic roles.[24] Carl Degler has pointed out that almost all white, native-born, middle-class American women did not work outside of the home after marriage.[25] This reinforces the classed and racialized aspect of the private/public division of the separate spheres construction, because obviously many non-white and working-class women were working outside the home – in other, middle- and upper-class white women's homes, or in public arenas elided by the separate spheres discussion.[26] Domestic work for both lower- and middle-class women alike was arduous and time-consuming, yet expected and hence not compensated financially. Furthermore, as the gendered division of labor increased over the last several decades of the century, housework became categorized as 'private' and thus in contradistinction to the public world outside the home. Hence women's lives, their perceived role in society, and their own self-identification were tightly bound to an unpaid domesticity.[27]

Although the enforced domestic arrangement for women in the late nineteenth century had many causes, the overarching ideal was consistent: a woman was responsible for keeping both home and family clean, pure, and stable physically and emotionally. The home, with the woman's careful diligence, was the repository for the morality and pleasure that were less frequently found in the public world that men inhabited. A proper, responsible, and reputable woman made her house a refuge from the outside world and thus it and she should have no marks of that outside world to sully the ideal. Several paradoxes occur in the segregation of these qualities and duties – how can a sweet, gentle, delicate 'angel of the house' also scrub her family's laundry by hand? How can she prepare male children for the less ethical, more competitive and violent outside world? How can a woman who must now purchase goods outside of the home that used to be made inside of the home both protect herself from the dangers of public life and maintain her status in the domestic arena?[28] Two responses to these paradoxes, available primarily to the upper-middle-class family, were domestic servants and an increased connection of women to consumerism.[29] By the end of the century, the Cult of True Womanhood was still a powerful notion, but the ideal no longer emphasized the woman doing the household work herself. Rather, her role began to focus more on managing the home's activities and purchasing the

goods, both vital and non-productive, that kept the household's status intact.[30] As the importance of non-productive goods to a family's status increased with the growth of the leisure class, women took on the custodianship, at least symbolically, of culture and education. Women were responsible for seeing that the family's culture and education, once gained, were also conspicuously displayed.[31] This 'feminization of culture,' as Alan Trachtenberg calls it, linked women, culture, and domesticity together, placing women at the apex of a passive, genteel, sheltering construct that they represented – but did not necessarily control. After all, the money women spent on consumer goods and cultural endeavors came predominantly from their husbands and fathers, and women's role in creating any of the things they were championing and selecting was forcibly limited by the same construct that made it their job to represent those things.[32] In any event, during the last decades of the nineteenth century, most women, even significant numbers of working-class women, were inextricably bound to the domestic arena. Middle- and upper-class women were also perceived as the keepers of society's morality, taste, and culture, and it was their duty to both personify and instruct their families in the highest ideals of these qualities – from within the confines of their rightful sphere. The arts were to be acquired as talents but not professions, and many popular journals of the late nineteenth century depicted the admixture of aesthetic interests with which the white bourgeois woman might edify herself and her family.[33] Of course to maintain this role, white bourgeois women had to distinguish themselves from other women by class, race, and careers, where possible. The same binaries that could be seen as either positive (because creating a space for them) or negative (because enabling their oppression) for white bourgeois women also essentially obfuscate the experience of women who worked in other women's houses or led actively public lives of labor in other contexts.[34]

Men of the late nineteenth century found themselves bound by less delimiting constraints than those that held women. For example, men were the theoretical rulers in both the home and the outside world of work, whereas women were usually conceded rule only in the home, and then only when their decisions did not interfere with the husband's. However, the dominance of men did not come without certain restrictions on what was expected of them by society as well. Aggressiveness, diligence, strength both mental and physical, and a fierce drive for success were all required traits for the truly 'manly.'[35] Doing battle in the world of work was supposed to be difficult, but men could not show weakness; rather, they were to hide their fears and doubts, even in the comforting refuge of the home maintained by a loving wife. As the physical separation of work and home, which coincided with the defining of home as feminine, aligned men and masculinity with the world of work, it also robbed men of interests and behaviors that were now more firmly classified as feminine. Filene notes that the previous acceptability of intimate male

friendships became more stigmatized, and the words 'homosexual' and 'fairy' became more commonplace pejoratives as the men of the 1880s and 1890s struggled to define gender identities more strictly. No longer comfortable with open displays of affection or emotionalism, 'middle-class Victorians [who] originally defined manliness in contrast to boyishness now … defin[ed] it in contrast to femininity.'[36] In other words, as more women were attempting, with mixed success, to challenge the boundaries of gender division, more men were struggling to maintain those boundaries with greater fervor than before. The result was a societally upheld norm of strict gender divisions that did not actually reflect the lived experience of many individuals.

The Studio as a Place to Locate and Read the Artist's Gender Identity

The bipolar construct of gender in the late nineteenth century is visibly complicated when one considers the home-based art studio, which is both a professional workspace and a domestic room, thus inhabiting both of the gendered worlds typically discussed. In previous eras, such a combination might not have seemed so surprising or subversive because the home was more directly linked to production and the family's income – often, the home was the base of operations for both the creation of necessary household goods and the creation or managing of the goods the family sold or bartered to provide for themselves.[37] However, in the late nineteenth century, societal proscriptions and industrialization's effects divided the home and the workplace more firmly than ever before, requiring a closer look at any occasion where this division was blurred. The artist's studio is a place where we can consider the codification of separate spheres differently, because the artist did not follow them as closely as others in the same social strata did. Although many artists in the late nineteenth century were bourgeois and, for the most part, 'fitted in' to society, their lives were significantly different from those of the average bourgeois man and woman. Whether male or female, a professional artist generally melded the worlds of work and home at some point in a way that few other bourgeois people did at this time. Artists had more flexible work schedules that gave them more conspicuously leisured time, and they could work from their homes as well as in more communal settings. New questions are raised by the artist's home studio: what happens when a man has a 'feminine' parlor for a workspace and spends a large portion of his day with women and children rather than other businessmen? What happens when a woman earns her living as a professional artist and runs a bourgeois home ostensibly from the same room? In the following chapters, I will turn these questions on specific male and female artists and the paintings of their studios that begin to answer those questions. First, I will read a studio painting by William Merritt Chase, and then I will read a studio painting

by Mary Fairchild MacMonnies Low, to see how their self-representations respond to these normative gender divisions of the late nineteenth century.

Notes

1. See, for example, Rousseau's *The Social Contract* (trans. Maurice Cranston, New York NY: Penguin, 1968) or *Emile, or, Treatise on Education* (trans. William H. Payne, New York NY: Prometheus, 2003).

2. This is not to say that the theory of separate spheres is unique or limited to the nineteenth century; Greek and Roman writings, both general and explicitly architectural, emphasized a gendered distinction between the home and the world outside it, and Leon Battista Alberti's architectural treatises in the fifteenth century continued and extended this proposal. Mark Wigley ties Alberti back to fifth-century writer Xenophon, who claimed that not only must women and men be kept to their respective spaces, but that any attempt to subvert those placements would confuse one's gender identity. See Wigley, 'Untitled: The Housing of Gender,' in *Sexuality and Space*, ed. Beatriz Colomina (Princeton NJ: Princeton Architectural Press, 1992), pp. 337–89.

3. See Alice Bellony-Rewald and Michael Peppiatt, *Imagination's Chamber: Artists and Their Studios* (Boston MA: Little, Brown, 1982). See also Annette Blaugrund, *The Tenth Street Studio Building: Artist-Entrepreneurs from the Hudson River School to the American Impressionists* (Southampton NY: Parrish Art Museum, 1997); Albert Boime, *The Academy and French Painting in the Nineteenth Century* (New Haven CT: Yale University Press, 1986); Francis Kelly, *The Studio and the Artist* (Newton Abbot: David & Charles, 1974); and Jacques Lethève, *Daily Life of French Artists in the Nineteenth Century* (New York NY: Praeger, 1972).

4. A useful reading on women's clothing in late nineteenth-century painting can be found in Anne Schirrmeister's 'La Dernière Mode: Berthe Morisot and Costume,' in *Perspectives on Morisot*, ed. T.J. Edelstein (New York NY: Hudson Hills Press, 1990), pp. 91–115.

5. Lemaire was herself a renowned hostess, immortalized by friend Marcel Proust, whose book *Les Plaisirs et les jours* (1896) she illustrated, as Mme. Verdurin in his *A la recherche du temps perdu* (1913–27). The bearded male guest being served tea in Lemaire's painting is almost certainly Proust, as the figure bears more than a passing resemblance. She also garnered an entire chapter of Fanny Reed's *Reminiscences Musical and Other* (Boston MA: Knight & Millet, 1903), pp. 85–90. In Reed's description, Lemaire's studio is a separate building in the courtyard of her house filled with flowers, important visitors, and 'numerous sketches by Mme. Lemaire herself' as well as 'precious souvenirs from artist friends' (p. 86). A full and adulatory discussion of Lemaire's studio as the perfect setting for fabulous soirées also appeared in *Le Figaro* on 11 May 1903, written by 'Dominique.'

6. See Sarah Burns, 'The Price of Beauty: Art, Commerce, and the Late Nineteenth-Century American Studio Interior,' in *American Iconology: New Approaches to Nineteenth-Century Art and Literature*, ed. David C. Miller (New Haven CT: Yale University Press, 1993); and Celia Betsky, 'In the Artist's Studio,' *Portfolio* (January–February 1982), 32–9.

7. See Louise Campbell, 'Decoration, Display, Disguise: Leighton House Reconsidered,' in *Frederic Leighton: Antiquity, Renaissance, Modernity*, eds Tim Barringer and Elizabeth Prettejohn (Studies In British Art 5) (New Haven CT: Yale University Press, 1999). Campbell argues that Leighton's house was a reflection of his desire to improve his status (and that of artists in general) by hosting lavish gatherings in a setting that simultaneously emulated the upper class's own homes and emphasized the arts.

8. I am using the word 'Academy' as a broad term that encompasses the Académie des Beaux Arts, the Ecole des Beaux Arts, and the Salon. For a more detailed account of the history and changing role of these institutions, see Boime, *The Academy and French Painting*; June Hargrove, ed., *The French Academy: Classicism and Its Antagonists* (Newark DE: University of Delaware Press, 1990); and Nikolaus Pevsner, *Academies of Art Past and Present* (London: Cambridge University Press, 1940). Hargrove's collection of texts is particularly instructive in showing a less all-or-nothing view of the differences between the Academy and the growing numbers of artists and instructors who rejected the institutions in the late nineteenth century. I shall not enter into that discussion here, where my focus is less on why or how artists rejected the Academy but simply that growing numbers did.

9. Two of the most famous examples are Gustave Courbet's large-scale genre paintings such as *Burial at Ornans* (1849–50), thought far too grandiose in scale for its subject matter, and Edouard Manet's *Le Dejeuner sur l'herbe* (1863), which was seen as unfinished because of his atypical use of perspective and paint application.

10. For a thorough discussion of this, from the success of *juste-milieu* art through to the popularity of the Salon des Réfusés of 1863, 1864, and 1873 and the Impressionist exhibitions, see Nigel Blake and Francis Frascina, 'Modern Practices of Art and Modernity,' in Frascina et al., *Modernity and Modernism: French Painting in the Nineteenth Century* (New Haven CT: Yale University Press, 1993), pp. 50–140. Blake and Frascina point out that 'by 1861 there were 104 picture dealers in Paris, which indicates the large increase in the number of paintings produced outside the Salon or direct commissioning system' (p. 110).

11. For more on American academies, see Lois Marie Fink and Joshua C. Taylor, *Academy: The Academic Tradition in American Art* (exhibition catalogue, Washington DC: National Collection of Fine Arts, 1975). See also Ulrich W. Hiesinger, *Impressionism in America: The Ten American Painters* (Munich: Prestel, 1991).

12. In some cases, a much less lucrative career than they suspected. Lynes and Harris both argue that, although public interest in and acceptance of both art and artists increased dramatically in the nineteenth century, financial recompense did not keep pace. The more conservative artists of the first half of the century, fighting for respectability, struggled even to keep their careers (Samuel F.B. Morse being the most famous example of an artist who found a second career far more profitable). By the 1860s, American artists like Thomas Cole and Albert Bierstadt were doing quite well financially and socially, and it seemed the tide had permanently shifted for artists. However, the growth in interest and education of the buying public led to their acceptance and purchase of European art as superior. More American money in the 1880s and 1890s went to European and Asian art works, and popularity in Europe was one of the key factors in an American artist's popularity back home. So, paradoxically, after working to gain acceptance, American artists found themselves viewed as the weaker exponents of their craft. See Russell Lynes, 'How a Few Artists Wormed Their Way in the Course of a Century into Confidence of a Small Percentage of Their Compatriots,' in J.T. Flexner et al., *The Shaping of Art and Architecture in Nineteenth-Century America* (New York NY: Metropolitan Museum of Art, 1972), pp. 104–16. Harris points out that American artists also contributed to this backlash by 'feel[ing] embarrassment and guilt for the awe-inspiring naiveté of this [pre-Gilded Age] native school.' No longer viewing art as inherently immoral, the public came, by the turn of the century, to view it as 'the object of suspicion by masses not fortunate enough to enjoy the luxury of such idealizing.' See Neil Harris, *The Artist in American Society: The Formative Years 1790–1860* (New York NY: George Braziller, 1966), pp. 315–16.

13. New Haven CT: Yale University Press, 1996.

14. Pevsner locates the development of anti-Academicism in the post-1800 artist's self-image as 'the bearer of a message superior to that of State and society. Independence was consequently his sacred privilege' (Pevsner, *Academies of Art*, p. 240). I believe that this independence was not just expressed through a rejection of the Academy, but also through an elevation of importance of each artist's studio. Burns and Betsky would seem to concur.

15. Katherine Metcalf Roof, *The Life and Art of William Merritt Chase* [1917] (New York NY: Hacker Art Books, 1975), pp. 155–8; and Barbara Dayer Gallati, *William Merritt Chase* (New York NY: Harry N. Abrams), pp. 46–7. Two other anecdotes related to this incident are compelling: in their excitement at the performance, women in the audience tore off their jewels and tossed them at Dauset, and when one went later to retrieve hers, the dancer refused to return them. This anecdote reinforces the class difference between the two women. In Roof's text, an aside involves the dancer sending a slipper to Chase's wife, 'who was unable to be present' at presumably all three performances. I wonder if these performances were like some of the balls and club meetings frequented by artists on both sides of the Atlantic, at which wives' attendance was considered improper due to the presence of prostitutes. All the more strange that they should be fine for 'Mrs. Jack' (Gardner) – doubtless a privilege of her great wealth.

16. See Sarah Burns, 'Performing Bohemia,' in *Inventing the Modern Artist: Art and Culture in Gilded Age America* ((New Haven CT: Yale University Press), pp. 247–73.

17. Susan Waller has raised some similar and pertinent issues in French painting in *The Invention of the Model: Artists and Models in Paris, 1830–1870* (Burlington VT: Ashgate, 2006). Discussing Gustave Courbet's *The Studio of the Painter: A Real Allegory Summing Up Seven Years of My Artistic Life* (1854–55, Musée d'Orsay, Paris), Waller shows his use of several female types, particularly that of the *lorette* (a fashionably dressed woman who earned a living through modeling or otherwise gleaning money from men, as embodied here in the figure of Apolonie Sabatier wearing an embroidered shawl, just to the right of center) to establish the studio as a unique and significant place for modern culture: 'Courbet's incorporation of the *modèle* (*lorette*), on the other hand, made explicit the social realities of the artist/model/viewer triangle and contributed to establishing the transgressive sexuality of the bohemian *atelier*' (p. 77).

18. *Faces of Impressionism: Portraits from American Collections* (exhibition catalogue, Baltimore MD: Baltimore Museum of Art, 1999), pp. 148–9.

19. Patricia Hills, *John Singer Sargent* (exhibition catalogue, New York NY: Whitney Museum of American Art, 1987), p. 134.

20. Robert Herbert, 'Method and Meaning in Monet,' *Art in America*, vol. 67, no. 5 (September 1979), 90–108.

21. Peter Filene, *Him/Her/Self: Gender Identities in Modern America* (Baltimore MD: Johns Hopkins University Press, 1998), p. 7.

22. Filene, *Him/Her/Self*, pp. 75–85. The model of manliness I am using is specific to the North. The construction of masculinity in the South was often quite different. Filene addresses both genders; for a treatment that focuses on men, see Michael Kimmel, *Manhood in America: A Cultural History* (New York NY: Free Press, 1996). For the relationship between domesticity and masculinity in England, which case is both similar and different from that I discuss here, see John Tosh, *A Man's Place: Masculinity and the Middle-Class Home in Victorian England* (New Haven CT: Yale University Press, 1999).

23. On the idea of ambitious women as unsexed or men in women's bodies, see Filene, *Him/Her/Self*, pp. 6–41, esp. p. 24. See also Ann Uhry Abrams, 'Frozen Goddess: The Image of Woman in Turn-of-the-Century American Art,' in *Woman's Being, Woman's Place: Female Identity and Vocation in American History*, ed. Mary Kelley (Boston MA: G.K. Hall, 1977). Abrams points out that artists responded to the pervasive belief that a woman could not be beautiful and independent by depicting nostalgically idealized women as passive, aloof, and inhabiting a separate realm. The implication is that not only would one not choose to represent contemporary, newly independent females, but if one did, their appearance would sharply contrast with the 'beauties' of late nineteenth century painting. Michael Kimmel notes the use of biological arguments in attempting to keep women from higher education and the public sphere, where they would 'develop larger brains while their wombs atrophied, hence becoming masculinized (*Manhood in America*, p. 96). Filene's argument about the softening of suffragist appeals for change is more complex than I can suggest here – see *Him/Her/Self*, pp. 39–41. See also Gillian Brown, *Domestic Individualism: Imagining Self in Nineteenth-Century America* (Berkeley CA: University of California Press, 1990). Brown argues that suffragists were caught in a double bind of wanting to inhabit a world (of independence and self-definition) they already inhabited ideologically but could never inhabit in actuality; the alignment of prized individualism with the domestic realm (first posited in Tocqueville's observations of American culture) suggested that the most ideal and powerful space for women to occupy and control was already theirs – the separate sphere of domesticity.

24. Filene, *Him/Her/Self*, pp. 32–3.

25. Carl Degler, *At Odds: Women and the Family in America from the Revolution to the Present* (New York NY: Oxford University Press, 1980), pp. 155 and 362–77.

26. For more on the way the separate spheres argument ignores or reinforces class and race distinctions, see *No More Separate Spheres! A Next Wave American Studies Reader*, ed. Cathy N. Davidson and Jessamyn Hatcher (Durham NC: Duke University Press, 2002). Especially relevant to my conversation here and elsewhere in this book, see You-Me Park and Gayle Wald, 'Native Daughters in the Promised Land: Gender, Race, and the Question of Separate Spheres,' in Davidson and Hatcher, pp. 261–87.

27. See Carroll Smith-Rosenberg, *Disorderly Conduct: Visions of Gender in Victorian America* (New York NY: Alfred A. Knopf, 1985); and Cara Mertes, 'There's No Place Like Home: Women and Domestic Labor,' in *Dirt and Domesticity: Constructions of the Feminine* (exhibition catalogue, New York NY: Whitney Museum of American Art, 1992). Mertes' article discusses both middle and lower classes as well as the significant role race played in the cult of domesticity, both in forming its rhetoric and in the exploitation of non-white women as domestic servants. See Susan Strasser, *Never Done: A History of American Housework* (New York NY: Pantheon, 1982); Nancy F. Cott, ed., *Domestic Ideology and Domestic Work*, vol. 4 of *History of Women in the United States: Historical Articles on Women's Lives and Activities* (Munich: K.G. Saur, 1992), esp. Linda K. Kerber, 'Separate Spheres, Female Worlds, Woman's Place: The Rhetoric of Women's History,' pp. 173–203, and Jean Gordon and Jan McArthur, 'American Women and Domestic Consumption, 1800–1920: Four Interpretive Themes,' pp. 215–30. (Note that Kerber's essay can also be found in Davidson and Hatcher, *No More Separate Spheres!*) The doctrine of separate spheres was more flexibly applied in rural areas and in the lives of doctors and lawyers, who often kept offices in their homes where clients visited. My study focuses on urban areas, where the majority of middle-class men worked outside of the home.

28. For more on the battle between emancipation from household duties and defense of women's particular control over and skills in the household arena, see Strasser, 'Redeeming Woman's Profession,' in her *Never Done*, pp. 180–201.

29. See Strasser, 'Mistress and Maid,' pp. 162–79, and 'Selling Mrs. Consumer,' pp. 242–62, both in *Never Done.*

30. As Gordon and McArthur point out, recent historians suggest that women lost significant status when their role shifted from producers to consumers during the Victorian era. Additionally, women with more 'leisure' time, because they were no longer producing but were expected to represent the family's status and adherence to the code of separate spheres, raised fears of the loss of health, piety, and moral strength associated with hard work in the Puritan-Jacksonian era. Gordon and McArthur note that even conspicuous consumption 'can be as labor intensive as the earlier domestic production,' and most '"labor saving" innovation brought with it higher expectations for the housewife.' See Gordon and McArthur, 'American Women and Domestic Consumption,' in Cott, ed., *Domestic Ideology*, pp. 226–9. The ideal of true womanhood never actually required that the female head of the house do the work herself, as even earlier in the century, many middle-class homes had servants. Nonetheless, there is a shift in representation, visually and through language, from the housewife as household worker to the housewife as household manager.

31. See Thorstein Veblen, *The Theory of the Leisure Class: An Economic Study of Institutions* [1899] (New York NY: Modern Library, 1934); and Alan Trachtenberg, *The Incorporation of America: Culture and Society in the Gilded Age* (New York NY: Hill & Wang, 1982).

32. For an art-historical example, see Judy Sund's comparison of actual male cultural/ideological exponents to symbolically representational female exponents at the World's Columbian Exposition in 1893: 'Columbus and Columbia in Chicago, 1893: Man of Genius Meets Generic Woman,' in *The Art Bulletin*, vol. 75, no. 3 (September 1993), 443–66.

33. Tamar Garb notes that there were some exceptions to this type of depiction in two French journals: *La Famille* and *L'Art français*. Both journals represented professional women artists on their covers, linking these women and their inherently 'feminine' art to conservative politics – in contrast to the more 'extremist' feminists both in art and society generally. Berthe Morisot and Rosa Bonheur, as avant-garde or 'masculine' in their art, were not included in the journals' notion of appropriate artistic endeavors. See Garb, '"L'Art Féminin": The Formation of a Critical Category in Late Nineteenth-Century France,' in *Art History*, vol. 12, no. 1 (March 1989), 39–65.

34. See Park and Wald, 'Native Daughters,' in Davidson and Hatcher, *No More Separate Spheres!*, pp. 261–87.

35. Filene, *Him/Her/Self*, p. 75.

36. Filene, *Him/Her/Self*, p. 83. Kimmel notes that some heterosexual men did not feel threatened by increasingly visible gay men at the turn of the century, because the gay men's effeminacy reinforced their own more traditional masculinity (*Manhood in America*, p. 99). In 1988, Margaret Marsh argued that suburban men at the turn of the century seemed to take on more domestic involvements and emphasize their home lives over other, more masculine diversions during non-working hours. Interestingly, both she and others have noted that this turn often served to reinforce the limitation of women to the domestic sphere by highlighting the home's importance over that of public life. Kimmel's discussion of men's fears of women's domination of the home and therefore of young boys, teaching them to become more feminine by example, also seems relevant here (*Manhood in America*, p. 121). The majority of Marsh's evidence highlights women's demands for more male involvement at the home in the late nineteenth century (as, for example, the demands of Catherine Beecher, who was hoping to restore value to domesticity by involving men) and men's comments in advice columns and other sources from the early twentieth century; in other words, calls for such changes rather than signs that such changes were occurring. Furthermore, as Michael Kimmel points out, one third of all Americans lived in cities of 8,000 or more – not suburbs – by 1900 (*Manhood in America*, p. 82). This suggests to me that the 1890s can still be spoken of as predominantly gender-divisive, although I agree with Marsh's call to broaden our studies of the entire period to allow for a more full account of both women and men breaking the traditional boundaries established in the early and middle part of the nineteenth century. See Margaret Marsh, 'Suburban Men and Masculine Domesticity, 1870–1915,' in *American Quarterly*, vol. 40, no. 1 (March 1988), 165–86.

37. As late as the mid-nineteenth century, housewives still created the majority of their household goods, from making soap, candles, and rugs to raising animals for meat, milk, and eggs. By the 1880s and 1890s, the tide had shifted toward purchasing many of these goods in the marketplace. This shift devalued both women's ability to be useful and evidently productive members of the economy and their sense of connection to that world. See Strasser, *Never Done.*

'The Prince of the Atelier': Negotiating Effeminacy in *A Friendly Call* by William Merritt Chase

William Merritt Chase's painting *A Friendly Call* (1895, National Gallery of Art, Washington DC) (Plate 1) depicts two women sitting on a banquette, engaged in conversation.[1] They are in a room adorned with pillows, hanging silks and tapestries, and framed artworks. A large mirror reflects the opposite side of the room, showing a door, many windows, and still more artworks. The floor appears to tilt up slightly, causing the space to recede gradually. The composition emphasizes horizontal and vertical lines, contrasted with a few striking diagonals provided by the hands, veil, and parasol of the woman in white, the pillow in the center of the floor, and a bamboo chair at the right. The painting is colored in golden hues, seen in the gilt mirror, bamboo chair, tan floor covering, and one woman's bright yellow dress. These dominant tones are offset by bright flashes of carnation red, lavender, pink, and black on the pillows, in the images on the walls, and on both women's clothing. The paint appears loosely handled and impressionistic, with large areas of the floor, wall, and banquette just barely resolved, although close inspection of the work reveals a fairly smooth, glassy surface with little evident texture.

On a purely compositional level, Chase sets up what seem to be extremely ordered devices and then sabotages them with slight but effective alterations. The few diagonals in an otherwise strongly horizontal composition and the dashes of sharp color that offset the overall golden tonality energize the image, causing the viewer's eyes to focus in on the space between the two women at the center of the image, despite the many distractions of detail throughout the rest of the painting. The room depicted is difficult to name. Although the scattered pillows and banquette suggest an informal private setting, the gilt mirror, the women's clothing and the overt decorativeness of the room suggest a more formal space for entertaining.

A Friendly Call raises many questions of subject matter. The title suggests that the subject is the visit between the two women, and the rules of behavior

well established for such visits in the late nineteenth century. A study of Chase's other works of this period actually reveals that the setting is specific: Chase's studio in his summer home in Shinnecock, Long Island. This context raises important questions: is the painting a documentary of or commentary on codes of etiquette in the late nineteenth century, a studio painting that defines in some respect the artist's role in society, or a visual attempt to define the domestic realm in terms of gender? I will begin with a discussion of the manner in which Chase's studios aided in and reflected the changing definition of the artist's studio in the US, to examine how anxieties about gender and class roles were played out there. In particular, I shall be concerned with the way in which William Merritt Chase combined his professional work and domestic life and thereby blurred the established gender distinctions of his time.

The Artist's Studio?

Chase titled his work *A Friendly Call*, which would lead one to believe that the intended subject of the painting is the meeting of the two women. However, most critics (both during Chase's lifetime and since) have remarked chiefly on the situating of the subject in the artist's studio specifically, and the world of the nineteenth-century artist more generally.[2] Chase's own preoccupation with the studio as a representational setting no doubt encouraged this trend. He is known for the multitude of paintings he made of his several studios, particularly those in his Shinnecock summer home on Long Island and in the Tenth Street studio building in New York City. As I have argued in the previous chapter, the artist's studio as an image carries connotations of self-portraiture: the type of studio shown symbolizes the artist and how he wishes to be seen by others. Chase's development as an artist coincided with the radical growth of American interest in art and its possibility as a career, so it should not be surprising that he, and most of his contemporaries, painted the studio often. It was, in a sense, a new space for Americans.

Before Chase's heyday, the average American artist was considered more of a craftsman than a talented creator. An elaborate studio would have been both expensive and pretentious in what was then a developing profession. Over time, the American studio evolved from a simple working space (as seen in such works as William Sidney Mount's *The Painter's Triumph*, 1838) into the grander affair of the late nineteenth century, when Americans who had studied abroad returned with more European notions.[3] European artists had a long tradition of patronage and elevated status that made them more comfortable with the idea of an elaborate studio in which to showcase their work. American artists were slower to adopt this practice, but in the late nineteenth century artists envious or admiring of their European counterparts began to create such studios at home.

Chase was among these, and 'vowed he would make his Manhattan studio as exotically impressive as anything he had seen during his six years of study and travel in Europe.'[4] Years of collecting various artifacts paid off for Chase, and on his return to the US after six years abroad, he rented the largest space in New York's Tenth Street Studio Building, originally intended as an exhibition space for all the artists in the building, and made it his own.[5] The Tenth Street studio was renowned in New York as the premier show studio of the city. Neil Harris, writing about the American artist and his or her social role, notes that the studio building on West Tenth Street was the first building in America planned exclusively for studio use:

The Crayon observed approvingly in 1858 that those who knew the New York studios of earlier times would be amazed at the changes. ... It was another mark of social advancement for artists to receive their guests in an elegant style; he 'who can induce people of refinement to resort to his studio is in the fairest way to be appreciated.'[6]

Clearly the definition of what constituted an artist's studio underwent a change in the second half of the century, with a new focus on attracting patrons and creating an appropriate artistic persona for that pursuit. Harris logically ties the development of more formal and public studios to the improved image of the American artist in the years between 1830 and 1860.

Chase's Tenth Street studio, the subject of many paintings by both Chase and other artists (including Reynolds Beal, Henry Grinnell Thomson, and Irving Ramsey Wiles), became perhaps the most talked-about studio of the time, enhancing and occasionally overtaking Chase's own growing fame (see Figs 1.1 and 1.6). There Chase held receptions, sold his works, and established his reputation as a 'society favorite.'[7] The studio developed a nearly mythical status: 'it did everything that such studios were intended to do – it enshrined the dignity of the profession, was a sanctuary of the creative process, and generated "art-atmosphere."'[8] In this way it thus simultaneously defined and was used as an exemplar for the art world itself.

Chase's studio was the product of extensive decorative effort on his part; the appropriate elements had to be located (often in the foreign lands they were intended to signify), purchased, and placed for the greatest aesthetic impact. One would think that maintaining such an extravagant studio would require immense personal wealth, but Katherine Metcalf Roof, a student of Chase and his first biographer, argues that in Chase's case it was more a matter of will than wealth:

With nothing but his salary at The League to be depended upon for a certain income, he took his large studio, and there, surrounded by much beauty, he started his artistic career in America in the grand manner. This scheme of grace and dignity he maintained without concession to the last, for Chase would not accept small quarters or poverty.[9]

Chase apparently lacked the financial savvy one would hope would go along with having a collector's tastes on a teacher's budget. Although she concedes that he nonetheless was skillful in arranging these pieces for the best effect, Roof in her otherwise adoring biography finds Chase's extravagant collecting of questionable wisdom, stating that '[he] seemed often to lose sight of the value of simple spaces in his love of ornamentation and bric-a-brac.'[10] The financial cost of his horror vacui was offset at least in part by its benefit to both his image and his work. Keith L. Bryant, Jr., another, later Chase biographer, argues sensibly that Chase's studio was not merely an affectation, but also a gallery of 'props' for his many paintings, whether of the studio or not.[11]

While Chase's Tenth Street studio was the scene of constant activity and even functioned as the site of many formal parties, his studio in Shinnecock Hills, Long Island, was appropriately more peaceful. However, Chase did not entirely follow the typical habit of having a summer studio far simpler and more workmanlike than the city show studios. The Shinnecock Hills studio was in a house designed by Stanford White and purchased for the Chase family by local women benefactors interested in having Chase teach summer art classes there.[12] Although most sources suggest otherwise, the house was not in fact built for Chase, but for Charles L. Atterbury in 1888. White remodeled it in the early 1890s for Chase.[13] David Garrard Lowe, in his book on Stanford White, claims that:

White consciously made this summer residence a complete contrast to Chase's vast Tenth Street studio, which was celebrated for its intoxicating mix of carved highbacked Spanish chairs, Turkish brass lamps, Japanese prints, painted silk fans, and heavy, bright-colored stuffs. The house, on property between Shinnecock and Peconic bays, given to him by a group of Southampton residents who hoped Chase would establish an art school on Long Island, is uncompromisingly American ...'[14]

The studio was a tall room at the west end of the house, with many large windows in the west and north walls. Opinions on its original purpose differ, with Nicolai Cikovsky providing the most convincing argument that the room was not designed specifically as a studio:

It was Chase's decorations, not architectural changes, that decisively transformed the room into a studio. He covered the walls [and some of the windows] with hangings, and filled the room with furniture, bric-a-brac, art objects, reproductions, and paintings, chiefly his own, that gave him things to paint and the inspirational 'atmosphere' in which to work.[15]

Other than large windows, it would seem that decor, rather than architectural features, often identified a room as a studio at this time, and Chase had already set the standard for the kind of decor required to complete such a transformation.

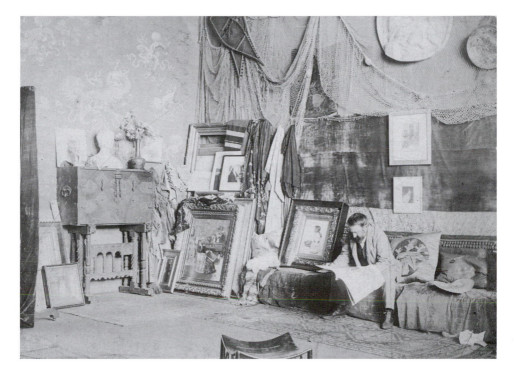

2.1 *William Merritt Chase in his Studio, Shinnecock Hills*, photographer unknown,
c. 1896. Albumen print, 4⅝" H × 6⅛" W (11.8 × 15.5 cm). The William Merritt Chase
Archives, The Parrish Art Museum, Southampton, New York. Gift of Jackson Chase
Storm, 83.Stm.21

In this studio, Chase painted a great number of interior scenes, many of
which are titled simply *In the Studio*. The overwhelming majority of these
interiors also feature Alice Gerson Chase, William Merritt Chase's wife. *A
Friendly Call* is no exception – she and her unidentified guest sit on a banquette
against the west wall of the studio, a placement which can be verified from
both photographs and other paintings of the time, such as *In the Studio (Interior:
Young Woman at Table)* (1892 or 1893, Smithsonian Institution, Washington DC).
It is important to emphasize that the Shinnecock studio was nearly as filled
with exotic paraphernalia as the Tenth Street studio, and in decor perhaps a
bit more informal – Chase's cropping of the room in *A Friendly Call* is what
gives it a more formal and ordered appearance, as can be seen by comparing
it to contemporary photographs of the room (Fig. 2.1). Had Chase opened
up the scene, the room's function as an artist's studio would have been more
apparent. He usually went to extremes with his studio scenes: either he pulled
back and showed large spaces in which the setting was clearly defined (as in
The Tenth Street Studio, Fig. 1.1), or he focused on a single figure and produced

2.2 Alfred G. Stevens (Belgian, 1823–1906), *The Painter's Salon*, c. 1880. Oil on canvas, 34¼" H × 45¾" W (87 × 116.2 cm). Private collection. Photo: Art Resource, New York

more of a portrait effect (as in *In the Studio*, 1892, private collection). *A Friendly Call* stands out in Chase's oeuvre for the indeterminacy of its setting – too formal and decorative for a working studio, but too disordered for a parlor.

It is possible that Chase turned away from his usual motifs in reference to or homage to another artist's work.[16] Cikovsky cites Diego Velázquez (particularly *Las Meninas*, 1656, Museo del Prado, Madrid) and Alfred Stevens as the primary influences on Chase's Shinnecock interiors.[17] Velázquez' interest in presenting many types of representation simultaneously is certainly seen in *A Friendly Call* – for instance, in the mirror and many paintings. It has elsewhere been argued that Stevens was influential for Chase in terms of artistic style and interest in studio decoration.[18] More significantly, *A Friendly Call* may have been directly influenced by Stevens's painting, *The Painter's Salon* (c. 1880, private collection) (Fig. 2.2), which shares a similar setting (Stevens's home studio) and compositional devices (figures in conversation, seated on a couch before a mirror).[19]

Stevens's *L'Atelier (The Studio)* (1869, Royal Museums of Fine Arts of Belgium, Brussels) (Fig. 2.3) also strengthens this connection. In this image

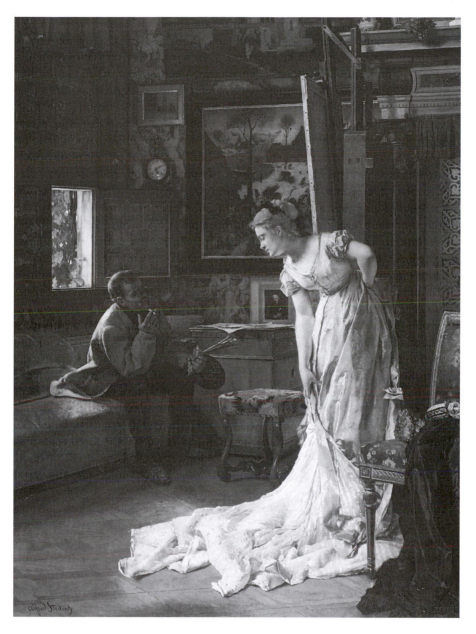

2.3 Alfred G. Stevens (Belgian, 1823–1906), *L'Atelier (The Studio)*, 1869. Oil on wood,
37" H × 28" W (94 × 71 cm). Royal Museums of Fine Arts of Belgium,
Brussels. Photo: Ro Scan, J. Geleyns; © KMSKB-MRBAB

we see the artist working on a painting, his model before him. Nonetheless, as in *The Salon of the Painter*, the room is richly furnished and not a mere workspace. Like Chase's painting, *The Studio* shows known works by other artists in the background. Therefore, Chase's painting may have been a deliberate reference to Stevens, but there is no documentation to prove this point definitively. As an immensely successful international artist, Stevens was in many ways the ideal Chase aspired to. Furthermore, Chase enjoyed playing with the styles and iconography of other artists to create a visual dialogue or correspondence with them. For example, Chase and James Abbott McNeill Whistler once sat for portraits of each other. Chase's portrait of Whistler (1885, Metropolitan Museum of Art, New York) imitates Whistler's style of painting, using hazy veils of muted color, an overall tonality, and a simple compositional arrangement. The result is a doubly representative portrait. *A Friendly Call* could possibly be meant by Chase to pay a similar homage by mimicking Stevens's studio paintings.

Charlotte Gere thought enough of the decoration of Chase's studio in *A Friendly Call* to give the painting its own entry in *Nineteenth-Century Decoration: The Art of the Interior*, using it as the examplar of 'An American artist's country studio.'[20] In fact, few would recognize the rooms in *A Friendly Call* and *The Salon of the Painter* as studios on first glance or without knowledge of the artists, making it possible for the viewer to interpret these spaces as domestic rather than studio-oriented. Although it may have been the case that Stevens's salon was a showplace and his studio a different room, it is apparent from photographs and paintings of the Shinnecock studio that Chase combined the two.

Studios, Taste, and the Gendering of Enculturation

The concept of the society artist and his extravagantly decorated studio went hand in hand with the Aesthetic movement of the late nineteenth century. Roger B. Stein, in a catalogue of American artists and the Aesthetic movement, refers to Chase as the 'archetypal male artist in this period': an artist who had moved 'from a position of marginality to a more central status as designer, if not arbiter, of social space, whose task was to transform his or her Philistine clients into lovers of beauty.'[21] The change in the valuation of the American artist that Stein describes distinctly linked the artist not merely to the creation of art, but to the judging and teaching of all things aesthetic, including interior decoration. During this period the importance of the artfully decorated interior reached an apex unknown in previous American history, due in part to the greater number of people who could afford to pay for more extravagant homes. Certain characteristics were reproduced in interior after interior. Decorators attempted to fill every blank surface with ornament and

compartmentalized decorative objects into repeated rhomboid shapes and bands, to give the impression of controlled excess.[22] Novelist and designer Edith Wharton found careful selection of interior ornaments so important that she co-wrote a book, *The Decoration of Houses* (1897), to instruct the nineteenth-century homeowner in acquiring the proper accoutrements. Wharton reasserts the American desire to establish a cultural style as tasteful and justified as that of Europe:

> Good objects of art give to a room its crowning touch of distinction. Their intrinsic beauty is hardly more valuable than their suggestion of a mellower civilization – of days when rich men were patrons of 'the arts of elegance,' and when collecting beautiful objects was one of the obligations of a noble leisure. The qualities implied in the ownership of such bibelots are the mark of their unattainableness. The man who wishes to possess objects of art must have not only the means to acquire them, but the skill to choose them – a skill made up of cultivation and judgment, combined with that feeling for beauty that no amount of study can give, but that study alone can quicken and render profitable.[23]

Wharton's recommendations are double-edged: one must work hard to acquire the 'right' objects, but that work is for naught if an undefined, inherent discernment is lacking. A two-way relationship is established between the objects and the person who can afford and appreciate them, with each reinforcing the quality of the other.

The development of this 'unattainable' enculturation was viewed by nineteenth-century writers as valuable not only socially and intellectually, but also morally. W.J. Loftie, in his 1876 book *A Plea for Art in the House*, emphasizes equally 'The Prudence of Collecting' and 'Art and Morals.' Throughout the lengthy text, Loftie recommends an extensive review and alteration of home surroundings on the basis of both aesthetic and moral pleasure:

> But, further than this, it may fairly be argued, and, indeed, has several times been pointed out already, that it is the duty of every one who is so fortunate as to possess a home and to be the head of a family, to endeavour, so far as he can, to make his family happy by making his home beautiful.[24]

Loftie's use of male pronouns is interesting, because it seems to contradict the normative view that making the home beautiful and the family happy was a woman's job, particularly before the Progressive Era's call for greater male involvement in the domestic sphere. The pronoun's use here can be interpreted three ways. On the one hand, texts like these show both the total control that men actually had in all spheres and the way that authors would address the 'head of the household,' always the husband rather than the wife. Although the woman would discharge or complete the tasks of decoration, cleaning, and maintenance of the home, her husband should be the one to know the 'rules' and dictate them. On the other hand, it also strongly suggests

that men would be actively involved in the aesthetic considerations of home design and decor, thereby complicating the normative rhetoric of separation of spheres. The third possibility is that a housewife who hoped to interest her husband in such issues could provide him with this book, showing him that his willingness to provide for, if not personally enact, a more tasteful home would be in his best interests. In any case, directly connecting the happiness and moral uplift of the entire family with their physical surroundings was not a new concept in the US, but connecting it to the collection and understanding of art objects certainly was.

As Russell Lynes and Kathleen Pyne both establish, the quick rise to money and power of the growing middle classes often put them in a situation in which they needed to learn quickly the enculturing aspects of the upper classes they wished to emulate. Artists, whose lives were spent acquiring artistic knowledge, could share their honed tastes with their upper-middle-class and nouveau riche patrons, thereby saving the patrons from spending their time acquiring the same knowledge and discernment. As the Ververs demonstrate in Henry James's novel *The Golden Bowl* (1904) by their 'acquisition' of the Italian Prince, enculturation can be achieved not only by training oneself, but also and more easily by purchasing the time and talents of another. The role of the arbiter of taste in the development of American enculturation was vital, and Chase was one of the chief New York tastemakers of the period. Someone had to determine for the public which things ought to be collected and how to use them in decorating. Chase accomplished this both in his role as an art teacher and as decorator and host of his famous studio. In his book on nineteenth-century artists and their societal roles, Russell Lynes argues that Chase was perhaps more valuable as a teacher of art and a friend to developing artists and collectors than he was as a painter.[25] Chase saw himself as the physical embodiment of the new American artist concerned with aestheticism as a way of life, an advocate of sophistication and the importance of culture in the developing nation.[26]

We know from his work that Chase was concerned with representing the studio as a crucial location in the world of culture, and his studio was a site that showed his skill as an interior decorator as well as his skill as an artist. The question continues to arise, however, of just how clear it is that *A Friendly Call* is set in a studio. Students of Chase's work would almost certainly guess that such was the case. Also, the above discussion suggests that the nineteenth-century art buff would recognize it. Yet no easel is shown, no artist is hard at work, and no unfinished canvases lie about. The purported figural focus of the painting is not the artist, but his wife and the woman who is calling on her. Unlike *Hall at Shinnecock* (1892 or 1893, Terra Collection), the mirror does not reflect Chase working on the image before the viewer. Although the depicted interior is certainly more casual than the usually more formal parlor used for such calls, a studio is suggested chiefly by the many works on the walls. As we

have seen, such a large number of art works on the walls was not an unusual feature of a well-decorated home at the time. In fact, this room impresses the viewer most as a bourgeois parlor. Therefore, identification of this painting as a studio painting comes from knowledge of the artist rather than careful study of the work itself. Despite the painting's title and content, however, most critics have seen the work as having a primarily formal orientation, focusing on shapes and materials more than the subject matter.[27]

Even those few critics who are able to look beyond Chase's abilities as a technician (or decorator) tend to jump past the most obvious elements of the subject and into either more finely detailed or more sweeping discussions. Cikovsky, for example, cleverly suggests that Chase's subject matter is art itself.[28] Using Velázquez as a touchstone, Cikovsky argues for a reading of most of Chase's works as explorations of the nature of representation.[29] The prevalence of the mirror in Chase's art is said to be an attempt to invoke the many questions of illusion associated with the mirror, as well as the mirror's symbolic meaning as an instrument of self-knowledge.[30] This argument of the mirror as psychological tool is echoed in John Kasson's discussion of etiquette in *Rudeness and Civility*: 'The increased prominence of mirrors in particular is indicative of the habitual self-regard and preparation for public roles that etiquette advisers demanded.'[31] Cikovsky wants to read the mirror in *A Friendly Call* as reflecting Alice Chase's profile 'as a dark reflection of her inner self surrounding her like a psychological penumbra,' but is also willing to see it as 'the psychological dimension of the ritual of modern manners that is the painting's nominal subject; for her head is placed before, and its reflection is located within, the mirror in the "deepest" part of the painting.'[32] Despite this acknowledgment of Alice's visual significance, short shrift has consistently been given to the titled subject of this painting. Even Cikovsky, a rare supporter of Chase's interest in subject matter, thinks the essential subject of *A Friendly Call* is not its nominal one, but the larger concept of representation. No effort is made to link the two subjects and see them as mutually supportive; instead, representation usurps etiquette and the bourgeois woman's life in the critical discourse around this image.[33]

Could the subject matter's relationship to bourgeois women's pursuits explain its lack of interest for most (male) critics, both past and present? Encountering *A Friendly Call* at the 1895 exhibition of the Society of American Artists, contemporary critic Royal Cortissoz found it vivacious and elegant, if lacking in grand content:

[I]ts dainty light charm is made the most of with an evident enjoyment
of the technical facility needed for the exploitation of such a thin motive.
The theme is certainly not a lofty one, yet undoubted ability has gone
to this celebration of it, and while its painter may not seem a man of
high imagination, he is just as plainly a technician of good taste, one
with a feeling for the suave picturesqueness of some social life.[34]

Unable to find any justification other than Chase's ability to render appealing this unimaginative scenario, Cortissoz dismisses the subject more ardently than any twentieth-century critic has, further suggesting that Chase's contemporaries saw nothing remarkable or worthy in a painting of bourgeois domestic concerns. This 'unlofty' theme shares with the typical view of domestic decor an oft-marginalized worth, almost certainly because etiquette and domestic affairs have long been seen as the domain of women. As Kasson notes of nineteenth-century etiquette,

Females would be confined to a significantly more restricted range of emotional expression than males and given special responsibility to provide 'altruistic' charm and comfort as part of the price of their subordination ... In this way the realm of emotional management extended the 'hidden injuries' of both gender and class in a putatively democratic capitalist society.[35]

Surprisingly, critics seem to show no awareness of the singular importance of women's conversations in society. As Patricia Spacks points out, despite the common devaluation of women's discourse as unhealthy and potentially damaging gossip, such discourse 'provides a mode of power, of undermining public rigidities and asserting private integrity, of discovering means of agency for women, those private citizens deprived of public function.'[36] Although critics and viewers alike might be tempted to imagine the women in *A Friendly Call* engaged in frivolous chatter, they are equally likely to be participating in far more serious business. Nonetheless, the painting has been dismissed in terms of content because its every element – two women engaged in bourgeois duties of etiquette, sitting in a room whose decor reflects tasteful bourgeois domesticity – represents the feminized side of the gender division clearly established by nineteenth-century bourgeois social constructs.

Domestic Space, Class, and Femininity

Writing in 1899, Thorstein Veblen traced the connection between economic theory and social constructs of gender and class to argue that in the shift from a non-industrial to an industrial economy the social structure of the world changed as well. In fact, an entirely new class arose: the leisure class. This class was driven to acquire property not just for its own sake, but to keep 'any reputable standing in the community.'[37] Over time, possession of wealth was no longer enough to hold esteem; to establish one's superiority, one must make one's wealth conspicuous.[38] Two of the primary ways of doing that were to surround oneself with valuable or rare objects, and to make one's ability to lead a life of leisure apparent. Veblen defines leisure strictly: it 'does not connote indolence or quiescence. What it connotes is non-productive consumption of time.'[39] By emphasizing one's leisure, one can appear too successful to need to

be productive. Manners are thus a tool by which the leisure class can assign status, 'a useful evidence of gentility, because good breeding requires time, application, and expense, and can therefore not be compassed by those whose time and energy are taken up with work.'[40]

The acquisition and knowledge of proper etiquette was one way of asserting status in the leisure class. Another went hand in hand – the taste for and collecting of objects that enhance one's surroundings. Veblen concedes that the development of both the taste and the collection are a type of labor in themselves, making the attainment of the evidence of leisure ironically in fact quite time-consuming and difficult.[41] The 'objects' collected need not be inanimate; rather, the entire household of family, servants, animals, and property should work to emphasize leisure's possibilities. As another of the various goods purchased to show off the gentleman's skill in the economic world, the wife played a significant role in this equation. She must be both beautiful and non-productive (except in childbearing, of course):

Propriety requires respectable women to abstain more consistently from useful effort and to make more of a show of leisure than the men of the same social classes. It grates painfully on our nerves to contemplate the necessity of any well-bred woman's earning a livelihood by useful work. It is not 'woman's sphere.' Her sphere is within the household, which she should 'beautify,' and of which she should be the 'chief ornament.'[42]

Veblen argues that leisure time was created almost deliberately by the middle and upper classes and altered the kind of work women did, shifting them from productive labor (such as taking part in the family business or making the household goods) to an ornamental role whose designated labor is equally decorative (choosing and wearing elaborate clothing or hostessing events).[43] The Chase family, like the families of most successful artists in the late nineteenth century, definitely resided in the leisure class – and their participation in its restrictions of manners (Alice Chase taking calls), collection of un-useful objects (the paintings, drawings, mirrors, pillows, and fabrics strewn around the room), interest in aesthetics (the variety, quality, and arrangement of art objects in the room), and belief in the role of the woman as decorative (the caller whose face is obscured by her veil, limiting her specificity as an actual person) are all shown in *A Friendly Call*.

Additionally, it was in Chase's best interests, as an artist, to encourage the development of the leisure class. Its members were the primary purchasers and valuers of art, and for Chase to make a living, an appeal to their sensibilities and self-image certainly could not hurt. By depicting a bourgeois woman greeting a caller in such a way that it seemed a mundane event to contemporary viewers, Chase created an image that was familiar, unthreatening, and uncritical of leisure class mores. His oft-mentioned technical skills could then become the focus of interest, simultaneously reinforcing both Chase's inherent aesthetic sensibilities and the art patron's ability to identify and appreciate

them. As with flattering portraits of kings, popes, and emperors by court painters throughout art history, the art market of the late nineteenth century demanded a positive view of its patrons and their leisured lives. As was the case with seemingly leisured women helping their husbands' businesses by maintaining the family status and connections, the Chase family was both representing the appropriate bourgeois lifestyle and working to maintain that image because it helped them in business.

As simple as such time-honored congruities of motive might seem at first, *A Friendly Call*'s combination of bourgeois leisure and tastefully decorated studio raises interesting questions about gender and the division between labor and leisure in the late nineteenth century. The studio certainly could be and was used as a place of display, sales, gathering, and entertainment, but its primary ostensible purpose was for creating works of art. In Chase's case, the works created in his studio formed a significant part of his income and the backbone of his career. Therefore the studio was Chase's place of work. If, as Veblen and countless others have argued, the bourgeois family of the late nineteenth century divided work and home lives by gender, turning work/office spaces into masculine spaces of labor and home spaces into feminine spaces of leisure, where would the home-based male artist's studio fit? In *A Friendly Call*, the studio is a site both of male labor and apparent female leisure, complicating and challenging the standard division of those two spaces. The emphasis on the domestic interior with female domestic activity in the painting suggests that the space it represents should be read as primarily feminine, so how can we now read Chase's labor within that space?

By combining work and home lives in the most extreme manner, William Merritt Chase risked being gendered at least ambiguously, if not effeminately, in a manner that was very much a problem for the late nineteenth-century artist. As T.J. Jackson Lears argues, those who chose unusual careers not easily gendered male or female risked a problematic level of ambivalence in their gender identities.[44] Chase and other artists whose painting styles and subject matters did not immediately establish a clearly masculine persona (as compared to, say, Winslow Homer or Thomas Eakins) became suspect as much as women who chose 'masculine' public careers.

In a reading that differs from those of Veblen and Cikovsky, Celia Betsky argues, in 'In the Artist's Studio,' that the flourishing trend of painting artists' studios in America was linked to a desire to combine home and workplace to escape society:

For Americans of the Gilded Age, worried about materialism and vulgarity, culture was redemption, the artist high priest in a cult of art. With subjectivity winning over objectivity, self over society, and self-consciousness paving the way to a modernist consciousness of self, the artist was endowed with the ability to capture intangible and psychological realities lying 'below the surface,' to express abstract ideas and intellectual concepts through his work and work methods,

and to serve, more significantly, as the apotheosis of the imagination. The symbol and setting for these developments and beliefs was the artist's studio.[45]

Most importantly, paintings at the end of the century seem to me to be on the cusp of the change between constructs of division and newer possibilities for the changing roles of men and women. We see much greater comfort with the combination of home and workspaces in art and text *after* 1900 (as in later work by the Nabis and Henri Matisse, for example – whereas American artists shifted toward realist depictions of urban public life or more abstract images of city or landscape scenes, as extravagant interiors became associated with an older, conservative group of artists).

Kathleen McCarthy suggests that the growing interest in elaborate studios and aestheticized sensibilities that artists such as Chase exemplified in the late nineteenth century contributed to the backlash by those who wished to champion virile masculinity. Citing Frank Norris's 1903 novel, *The Pit*, McCarthy notes the tendency of fin-de-siècle authors to describe artists in terms that emphasized their gentility, leisure, and lack of toughness.[46] Men like Chase and Whistler, who projected a potentially effeminate self-image through their dress and interests, could be seen as unfit for the more masculine realm of business, as well as those careers that might be located more domestically but carried a certain prestige and association with manliness (doctors, for example). Both Chase and Whistler were known for their extravagant and carefully arranged appearances, involving at the very least formal black suits, spats, and top hats, if not also elaborately carved walking sticks, scarf-rings, finger rings, and more unusual headgear.[47] Chase was generally disinterested in anything other than art and his family; Katherine Roof describes him as avoiding sports or other such manly pursuits and instead focusing his energy on things that pleased his eye (people, objects, views) and storytelling.[48] The strict division between the work world, which was difficult and strenuous, and the home, which emphasized comfort, adornment, and refinement, aligned these 'genteel bohemians' more with the home world and its attendant feminization.[49] Therefore, extremely genteel men such as Chase were often marginalized as bohemian, rather than properly masculine or 'normal.'

The possibility of interpreting Chase as effeminate, or at least not remarkably masculine, presents itself not merely because of his chosen career, his interests, and his manner of dress, but also in his style of painting. The previously cited criticism of his works by Cortissoz, as well as others both past and present, uses terminology and description ('dainty light charm,' 'feeling … for picturesqueness') often more associated with female artists. Charles Caffin, in his 1907 book *The Story of American Painting*, notes that '[genuine insight and feeling] are qualities one does not generally associate with [Chase's] work, any more than one looks for evidence of imagination. It is with the external appearances that he is preoccupied …'[50]

Later in the text, Caffin creates a list of the 'best' American portrait painters and divides it into two categories: painters of esprit and painters of character. Of the seven painters of esprit, two are women and another is Chase, and their chief skills are rendering the sitter with charm and refinement. Rarer and more ideal, in Caffin's view, are the portraitists of character – all male artists painting (with psychological insight) male sitters of the 'strong breed that is shaping the life of affairs in modern America.'[51] Caffin's acceptance of the ability of female and feminized artists to render skillful but superficial portraits notwithstanding, he clearly ranks more evidently 'masculine' works as more significant both in form and meaning. Interest in surfaces, color, lighting, and compositional effects over issues of subject matter (for example, the more 'intellectual' content in history, religious, or mythological painting valued by the academies) or psychological depth were supposed to be characteristics of more feminine artistic endeavors such as needlework, pastels, and the like. Chase's work was always considered overly interested in decorative visual effect above meaning, leading critics to applaud his painting skills but give precedence to his role as a mentor in order to praise him more completely.

All studies of Chase in the last hundred years have focused on one or another of these aspects of his work and life (his dandified dress and behavior – such as requiring his African servant to wear a fez while walking Chase's elkhound in the streets of New York – his skill in surface techniques, his teaching), neglecting to bring together the often gender-troubled (and, clearly, racialized) image they raise with his fascination for the studio as subject and setting. Chase created and defined his studios, both real and represented, in ways that emphasized their domesticity. They did, after all, set and follow the standard for home decor that was to be adhered to by bourgeois housewives in maintaining the expected dichotomy of work and home spaces: the style of decoration preferred by women at this time was meant to provide a counterpoint to the masculine world, providing complex combinations of patterns, textures, shapes, and styles in one setting. Chairs and couches were soft and plush, and every corner held some visual (re)treat.[52] The ideal housewife was supposed to help her husband forget, at least temporarily, the more austere and efficient settings of his work world. Chase's studio, filled with art objects and bric-a-brac, overstuffed couches and souvenirs from foreign lands, and always an art atmosphere, accomplished that very same division.[53]

Yet the space of the studio, despite its apparent feminine characteristics, was seen as eminently masculine. Celia Betsky notes that while reactions to the studio took a variety of forms, there was one aspect upon which all agreed: '"It is the one place on earth," wrote art critic S.G.W. Benjamin in 1879, "where the dominion of the ever busy and tidy housewife cannot hold sway."'[54] Even when women were the primary subjects of studio scenes, they served as substitutes for men, rather than subjects in their own right.[55] Stevens's paintings of studios presided over by women artists, for example, clearly present those women not

2.4 William Merritt Chase (American, 1849–1916), *A Corner of My Studio*, c. 1895. Oil on canvas, 24⅛" H × 36" W (61.3 × 91.4 cm). Fine Arts Museums of San Francisco. Gift of Mr. and Mrs. John D. Rockefeller III. 1979.7.29

as actual artists, but as 'stand-ins' for a real artist, presumably male. In both *The Painter's Salon* (c. 1880) (Fig. 2.2) and *In the Studio* (1888) (Fig. 1.3), Stevens has included references to his own and other male artists' works and the room depicted is his own studio. In the former painting, he is probably the nominal painter, but rather than show himself within the room, he has chosen instead to show three well-dressed bourgeois women. The room is as likely a drawing room as it is a studio, and in fact its lavish decor outshines even Chase's studio images. In the latter painting, Stevens has created a scenario that involves a woman painter, but she is unnamed, representing no real artist but merely the idea of one.[56] To drive this point home, Stevens shows the viewer both the canvas and the model the artist supposedly paints, and this represented painting is actually a known one: either Stevens's own *Salomé* (1888, Royal Museum of Fine Arts, Brussels), or as Griselda Pollock argues, a 'compound' of his own version and Henri Regnault's *Salomé* (1870, Metropolitan Museum of Art, New York). Although their radically different garb classes and identifies each woman in *In the Studio* distinctly, the effect is finally generalized into types: 'model,' 'artist,' and 'bourgeois audience.'[57] Chase painted one studio scene that included a female painter at an easel in the background (*A Corner of My Studio*, c. 1895, Fine Arts Museums of San Francisco) (Fig. 2.4). But once

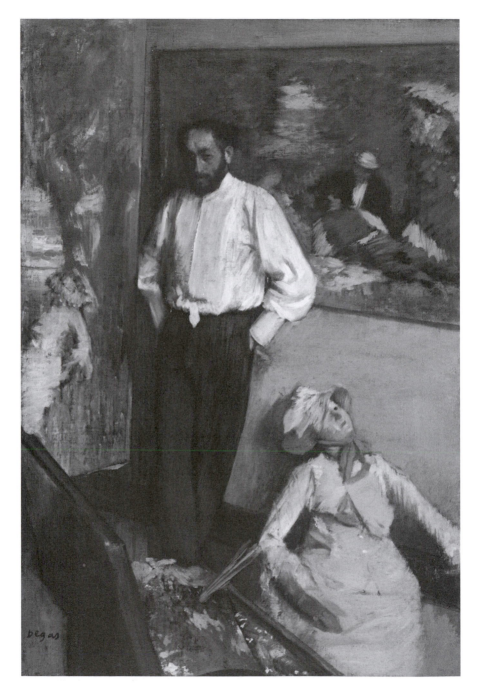

2.5 Edgar Degas (French, 1834–1913), *Un Artiste dans son atelier (Portrait of Henri Michel-Lévy)*, c. 1878. Oil on canvas, 16⅜″ H × 10¾″ W (41.5 × 27.3 cm). Museu Calouste Gulbenkian, Lisbon, Portugal. © 2009 Fundaçao Calouste Gulbenkian

again, both title and setting emphasize Chase as the painter and creator of the setting, to which the inability to identify the female painter as a specific person is added.[58] Whereas generalized males do occur in the studio images of Chase, they are extraordinarily rare and tend to appear only in paintings with such loose brushstrokes and incomplete rendering as to obscure the figures; in Stevens's studio paintings the only images of men shown are self-portraits. Edgar Degas made several portraits of fellow male artists in their studios, following the established convention of using the images in the background to refer to the subjects, other artists, or himself. Strikingly, the one that includes a three-dimensional female figure in it, *Un Artiste dans son atelier (Portrait of Henri Michel-Lévy)* (c. 1878, Museu Calouste Gulbenkian, Lisbon) (Fig. 2.5), shows neither an appreciative female viewer nor a surrogate female artist, but rather a fully dressed artist's mannequin.[59] Flopped on the floor and looking blankly up and to the right, this bourgeoise is perhaps the ideal studio visitor, representing female fashions but otherwise entirely under the artist's control, literally and figuratively. The emphasis in the studio paintings was believed to be on art, and the male artist's positive relationship to history and culture. The depiction by a male artist of an individualized female artist, known to the viewer as a real person, would disturb this discussion – or at least the male painters seemed to think so.

To answer questions about why the space of *A Friendly Call* seems more domestic than artistic, Betsky posits that by the 1880s the two had begun to come together: 'And although Chase's 1895 *A Friendly Call* reads as a social moment in female domestic life, it takes place in his Shinnecock studio, furnished with the requisite artworks and Orientalia and painted with the light Impressionist palette of his later years.'[60] Again, the art critic's knowledge of the setting overrides the painting's title and subject matter. If Chase had wanted the viewer to think 'studio' when looking at this painting, he probably would have made his references more obvious, as he did with all his other studio paintings.

Although this discussion sounds as if it might clear up the issue of the femininity of these studio spaces, it does not. For this melding of domestic and studio spaces in fact served to reinforce the linkage between women and artists – both were relegated the duty of maintaining society's creativity and beauty. In fact, Betsky indirectly reminds us that the upsurge of decorated artists' studios created an upsurge in similar interior decorating, for which women were responsible.[61] Women and artists were practicing many of the same techniques to the same effect in their interior creations. How did the male artists elude complete effeminization?

Essentialist ideas about skill and talent that run through the history of art come to the rescue of the male Impressionist. Sarah Burns has amply documented the way two late-nineteenth century American painters whose styles were nearly identical were critiqued in such a fashion that

the male painter, John Singer Sargent, always managed to supersede the female painter, Cecilia Beaux.[62] After pointing out the startlingly numerous similarities between Beaux's and Sargent's painting styles and subjects, Burns notes that 'critics before and after the turn of the century, however, almost invariably contrasted the two painters' works as expressions of an essentially feminine versus an essentially masculine nature and, with almost no exceptions, declared Sargent the superior.'[63] Describing Beaux and her painting in terms that emphasized sympathy, hard work, and soothing calm, critics then turned to describe Sargent's paintings with terms evoking the diagnostic, surgical skill of an analytic intelligence. Thus his work, potentially effeminate in its similarity to a woman artist's, could be remasculinized (as by extension could Sargent himself, and even the broader group of male artists).[64] Sargent, and probably Chase, escaped being seen as too feminine in part because the men who wrote about him established him, usually, as masculine – by using language which encoded difference so that even male and female artists whose work was extremely similar were written about differently.[65] Chase was clearly aware of such a reading and was known to fight it directly with words as well as images. Guy Pène du Bois said of him that 'he was filled with the importance of the artist and could defend him with clipped, witty, biting sentences, could even make him acceptable to men convinced that art was an effeminate pastime, the last resort of incompetents. Some may even have shivered a little, seeing him approach.'[66] Furthermore, in some cases, those who feared the over-effeminization of American culture at the turn of the century, with the advanced influence of women in a multitude of spheres, hoped men would seek out leisure and enculturation as one possible cure. As Josephine Conger-Kaneko wrote in 1906:

Leisure is the crying need of our men, and it is most emphatically denied them to-day. Indeed, man's 'business interests' are running away with them, devouring him body and soul. And with him goes the rugged strength, the red blood corpuscles that we need to make our culture a living, breathing reality.[67]

If men took full control of culture and leisure, rather than relegating them to women's work, culture would become more virile, rather than less. The fact that Chase was biologically male could override most ambiguities presented by his work or his melding of domestic and work spaces, allowing him to perform feminine gender attributes or characteristics with less likelihood of censure.

It is also conceivable that Chase upheld his masculinity in the face of such charges by using the very aspects of his life that could be cited to feminize him: his tutelage and support of women artists and his depiction of women in interiors. Chase was known to support artists like Mary Cassatt, Berthe Morisot, and Eva Gonzalés by encouraging them and by purchasing their

works.[68] Although these female artists were reasonably successful during their lifetimes and have become even more popular in recent decades with the growth of feminist art histories, their work has always been seen as fundamentally different from even nearly identical works by their male contemporaries. For example, Robert Herbert, writing in the late twentieth century about Impressionist interior scenes, describes the work of these women in terms that could be equally applied to Chase:

Instead of prowling cafés or canvassing public thoroughfares, they lift a bell-jar off the society of upper-class women and examine its ways with an acuteness and a sympathy that few men could attain to. The two pictures under discussion single out the rounds of daytime visits among women, a central feature of nineteenth-century social life. Relationships among women are their subjects, and the prominence of social conventions is signaled by a telling use of household furnishings ... [69]

According to Herbert, these works by women are still easily differentiated from those of male artists, who tended to charge their scenes with more emotional or contextual content, highlighting the figures over their surroundings. Chase has stopped to pay attention to the 'daytime visits among women' with a sympathy born of actually experiencing these calls firsthand – yet his paintings, whether better or worse at depicting such scenes, have been viewed as inherently different due to his sex. In trying to increase the value and respect given to the works of women artists, Chase may have been at the same time trying to add value to his similarly styled – but always different because male-produced – works. Also, despite such support and the radical growth of the number of women in art classes, men still completely dominated the art world at every position and garnered the bulk of professional rewards.[70] In this manner, artists like Chase could simultaneously support women artists and control their success by keeping them from important positions and awards. The effect would be to re-establish a difference between perceivedly masculine and feminine art by maintaining the difference between male and female artists.

The second possible way in which Chase may have challenged notions of his femininity is in his depictions of women in interiors. Had his female sitters been shown in states other than contemplation or general cheerfulness, perhaps with an awareness of some psychological dimension, viewers might not have so easily dismissed them. Rather, the women become blank, non-signifying objects upon which he might lavish his skillful brushstrokes as readily as on a vase or carpet. By constantly asserting his interest in visual effect over subject matter, Chase could contribute to the sense of such women as purely decorative.[71] The depiction of women in such a way as to delimit any reading of them as individuals was hardly new, but it could be a particularly useful tactic for a man whose own persona could be read as feminized and insignificant.[72]

2.6 Thomas Wilmer Dewing (American, 1851–1938), *A Reading*, 1897. Oil on canvas, 20¼″ H × 30¼″ W (51.3 × 76.8 cm). Smithsonian American Art Museum, Washington DC. Bequest of Henry Ward Ranger through the National Academy of Design. Photo: Smithsonian American Art Museum, Washington DC/Art Resource, New York

The concurrent rage for purely decorative images with almost no discernible content, peopled solely by women, seems more than coincidental. While Pre-Raphaelite paintings are more usually connected with the decorative style, in the 1890s the term 'decorative' came to be used quite specifically with paintings that depicted contemporary young women in bourgeois domestic settings containing at least one other aesthetic object, such as a bowl, vase, musical instrument, or piece of furniture.[73] Examples of such images are particularly evident in the work of Frank W. Benson, as in his *Twilight* (1891, private collection) and Thomas Wilmer Dewing's *A Reading* (1897, Smithsonian American Art Museum, Washington DC) (Fig. 2.6). Both paintings show two women seated in a domestic interior, surrounded by a few carefully chosen *objets d'art*. The women appear listless and still, fingering the objects they touch lightly. Such depictions are commonplace in the late nineteenth century, and these two artists built their careers upon the many similar images they produced. For the full decorative effect to be mastered, a vague, impersonal title was needed, and the features of the figures were to be as indistinct and inert as possible. To avoid narrative, only women could be grouped together, because they 'were perceived as being neutral toward

each other in a way that did not destroy a painting's decorative intent. In other words, female figures could be seen without the identity or character that would establish a narrative context within the painting.'[74]

Relegating the woman more and more to the domestic realm made it easier to associate her with the inanimate furnishings of the lavishly decorated aesthetic home, thereby sublimating men's fear of the growth of women's activity in the public sphere at the end of the century. In most of these respects, *A Friendly Call* fits perfectly. For example, neither woman's face can be clearly seen, and the only activities besides conversation that are suggested in the painting are needlework and reading, both laid aside. Bailey Van Hook maintains that despite their active role in perpetuating this view of women, male artists like Chase *et alia* 'identified with the feminine realm of culture that they portrayed.'[75] One could take the opposite tack, and insist that by picturing women as embodiments of the decorative aesthetic, artists like Chase hoped to prevent any association of men with such a feminized role. In that way these men could maintain their difference despite leading lives that appeared superficially similar to the lives of women in their emphasis on beauty, surface, and leisure.[76] Although both the bourgeois woman and the professional artist worked harder than many might think, the professional artist could defend himself by showing work (the finished painting) which depicted the bourgeois woman (rather than himself or other men) as indolent and indeterminate.

A similar tack can be seen in some of Chase's literary contemporaries. Looking at Henry James's oeuvre, for example, it is hard to escape his tendency to feature female protagonists, and these women are quite varied: some are more active and subjective, others more passive and abstract. But in either case, as Tamar Katz points out, James puts his own writing in the forefront, if necessary by pointing this effacement out in the preface. In doing so, he, like Chase, uses the figure of the nineteenth-century woman both as a figure of changing cultural norms and as a way to display his own skills – the woman is extraordinary, but only because James's superior understanding and writing make her so.[77] James risked the same connections between his work and those of female authors – and even popular novels written for and by women – so his emphasis on narrative complexity was a necessary tool to distance himself from femininity.

It is important to remember another significant difference between these male artists and their female counterparts: Chase could make a living teaching and creating art – most women artists could not. By making his domestic space also a 'working space' (since of course all domestic spaces were in reality already working spaces for the women and servants whose job it was to maintain them), Chase gave it and himself a value that upper-middle-class housewives' spaces would not have had. For although the room in *A Friendly Call* is in part Alice Gerson Chase's space, it is much

more her husband's. While most housewives had to decorate their homes with their husbands' money, they were allowed considerable creative input in that decor. Alice Gerson Chase was in the unusual position of being the housewife in a most highly decorated home not of her design or arrangement.

A Friendly Call is a painting that raises many questions. It depicts multiple subjects simultaneously: nineteenth-century social mores, an artist's studio, a domestic interior, and two women in conversation. Chase's intentions in this particular painting are unknown. Despite much evidence that Chase himself emphasized technique over subject matter, his equally renowned active interest in society gives reason to believe he was aware of the issues broached in his painting. At the least, as Michael Baxandall argues in *Patterns of Intention*, it is worth the effort to link 'the visual interest of pictures and (taking the extreme case) the systematic thought, science or philosophy, of the culture they come from.'[78] Chase fully accepted and in fact encouraged the atmosphere of 'genteel bohemianism' in which artists maintained lavish studios filled with exotic collected rarities, encouraged others to make their lives more aesthetic, and assumed the behavior of the previously elite gentry without being born into it. *A Friendly Call* can thus be read as operating in the realms of *both* the feminine and the masculine, revealing Chase's strategic performance and manipulation of a more fluid gender identity. While the human subjects in the painting are female and their constructor male, the conventional view of the studio as masculine and the parlor as feminine are not so tidily described within this painting.

Notes

1. Chase submitted the painting to the Society of American Artists in 1895 and won the Society's Shaw Fund Prize that year. Nicolai Cikovsky argues that since the work was reproduced in the spring of 1895, it is more likely that the work had been painted the summer before. However, Chase himself inscribed the date 1895 on the painting, so it is maintained here. See Nicolai Cikovsky, *William Merritt Chase: Summers at Shinnecock* (Washington DC: National Gallery of Art, 1987), pp. 49–50.

2. See Ronald G. Pisano, *William Merritt Chase* (New York NY: Watson-Guptill, 1979), p. 70; Celia Betsky, 'In the Artist's Studio,' *Portfolio*, January–February 1982, 32–9; Charlotte Gere, *Nineteenth-Century Decoration: The Art of the Interior* (New York NY: Harry N. Abrams, 1989); and Cikovsky, *William Merritt Chase*, pp. 39–65.

3. Although the word 'studio' implies that artistic work (study) would be the primary goal of such a room, by the late nineteenth century the word 'studio' was used interchangeably with 'atelier' and 'salon,' and all three could be used to name an artist's room of any description.

4. Alice Bellony-Rewald and Michael Peppiatt, *Imagination's Chamber: Artists and Their Studios* (Boston MA: Little, Brown, 1982), p. 173.

5. Bellony-Rewald and Peppiatt, *Imagination's Chamber*, p. 178.

6. Neil Harris, *The Artist in American Society: The Formative Years 1790–1860* (New York NY: George Braziller, 1966), pp. 268–9.

7. Bellony-Rewald and Peppiatt, *Imagination's Chamber*, p. 73.

8. 'Introduction,' in *The Artist's Studio in American Painting 1840–1983* (exhibition catalogue, Allentown PA: Allentown Art Museum, 1983), n.p.

9. Katherine Metcalf Roof, *The Life and Art of William Merritt Chase* [1917] (New York NY: Hacker Art Books, 1975), p. 64.

10. Roof, *Life and Art*, pp. 153, 230.

11. Keith L. Bryant, Jr., *William Merritt Chase: A Genteel Bohemian* (Columbia MO: University of Missouri Press, 1991), p. 67.

12. Cikovsky, *William Merritt Chase*, p. 46. Mrs. William Hoyt was the main contributor. See Kathleen D. McCarthy, *Women's Culture: American Philanthropy and Art, 1830–1930* (Chicago IL: University of Chicago Press, 1991), p. 88.

13. Leland M. Roth, *The Architecture of McKim, Mead and White 1870–1920: A Building List* (New York NY: Garland, 1978), p. 41, p. 209. Roth also spells the name 'Atterberry,' and states that according to the books the house was remodeled in 1895 although it is known that Chase resided there prior to that date. Details about the floor plan and specific changes made are not available.

14. David Garrard Lowe, *Stanford White's New York* (New York NY: Doubleday, 1992), pp. 202–3. Lowe's comparison of the decor of one public room in Manhattan to an entire private house in the Hamptons is questionable, particularly as Chase's decoration of the Shinnecock studio contained many of the same elements present at the Tenth Street studio. More interesting is Lowe's stress on the somewhat less over-decorated Shinnecock home as therefore more American – to most viewers, the studios would appear equally filled with decorative materials, and the Shinnecock studio's artifacts were largely of non-American origin. A fishing net seems about the only object one would not have found at the Tenth Street studio.

15. Cikovsky, *William Merritt Chase*, pp. 46–7. Cikovsky is arguing against the likes of Bryant, who insists that White made the house under Chase's direction, and that the studio was specially designed as such – see Bryant, *William Merritt Chase*, pp. 160–3. I have visited the house personally and the room appeared to me neither to be designed specifically as a studio nor separated from the other domestic spaces of the house in any significant way.

16. Chase was an ardent admirer of many fellow artists past and present and not afraid to imitate their styles or subjects. Most well-known of these is his portrait of Whistler in Whistler's own style, currently hanging in the Metropolitan Museum of Art in New York.

17. Cikovsky, *William Merritt Chase*, pp. 52–6.

18. William A. Coles, *Alfred Stevens* (exhibition catalogue, Ann Arbor MI: University of Michigan Museum of Art, 1977), p. xxix; and Roof, *Life and Art*, p. 95. Chase and Stevens knew each other fairly well and are known to have responded to each other's work. Stevens is significant to this study in having depicted so many studio images during the same time as Chase and Fairchild, although he does not get equal treatment in this text not only as a European, but because his paintings are so evidently fantastical and academic. They are thus radically different from *A Friendly Call* and *Dans la nursery* in style and import. However, it would be remiss to fail to note the influential connections between Stevens and Chase, and the strong possibility that Chase could have been making reference to Stevens's depictions in his own.

19. Cikovsky, *William Merritt Chase*, p. 56.

20. Gere, *Nineteenth-Century Decoration*, p. 351.

21. *In Pursuit of Beauty: Americans and the Aesthetic Movement* (exhibition catalogue, New York NY: Rizzoli, 1986), p. 37.

22. *In Pursuit of Beauty*, p. 128. It is this controlled excess, as well as the greater number of homes that indulged in it, that set the Victorian era apart – equally expensive homes in the eighteenth century were decorated with relative restraint. For more on the significance of the parlor and the tension of creating an appropriately moral yet cultured room for public display, see Katherine C. Grier, *Culture and Comfort: Parlor Making and Middle-Class Identity, 1850–1930* (Washington DC: Smithsonian Institution Press, 1997).

23. Edith Wharton and Ogden Codman, Jr., *The Decoration of Houses* [1897] (New York NY: W.W. Norton, 1978), p. 187.

24. William John Loftie, *A Plea for Art in the House* (London: Macmillan, 1876), pp. 19–20. Although this text was published in England, it came from a series, Art at Home, that was published in both

the UK and the US, through Porter & Coates, Philadelphia. Thus Loftie's recommendations seem to have applied equally to British and American readers.

25. Russell Lynes, *The Art-Makers of Nineteenth-Century America* (New York NY: Atheneum, 1970), pp. 425–7. Downplaying Chase's role as a painter in this manner is one way of devaluing the meaning and importance of the works he produced, much in the same way that, as Sarah Burns has pointed out, occurred with women artists.

26. Bryant, *William Merritt Chase*, p. 57.

27. For example, Gere, *Nineteenth-Century Decoration*, p. 351: 'When it was exhibited it was quite well received by the critics, although one commented on the subsidiary role allotted to the two figures, remarking that the furnishings, the silks and cushions seemed to assume a greater importance in the composition. This can hardly have displeased the artist, since it was what he intended.' There is no footnote to tell us where Gere got her knowledge of Chase's intent. Gere and Pisano (*William Merritt Chase*) quote contemporary accounts that include a mention in the *Art Amateur* of May 1895 (157). Cikovsky's comments in his *William Merritt Chase* are rare in their ascription of importance to the subject matter as well as the layout.

28. Cikovsky, *William Merritt Chase*, p. 59.

29. Cikovsky, *William Merritt Chase*, pp. 56–63.

30. Cikovsky, *William Merritt Chase*, p. 61.

31. John F. Kasson, *Rudeness and Civility: Manners in Nineteenth-Century Urban America* (New York NY: Hill & Wang, 1990), p. 166.

32. Cikovsky, *William Merritt Chase*, p. 62.

33. Since my initial work on *A Friendly Call* in my 1993 master's thesis, Linda J. Docherty has published an article that discusses Chase's studio images in regard to his use of family members as models within them, signaling the beginnings of a change in the standard readings of Chase. Although she consults many of the same documents I did in 1993, Docherty's work does not focus on a single image and compares Chase's works to similar paintings by Edmund C. Tarbell. See her 'Model-Families: The Domesticated Studio Pictures of William Merritt Chase and Edmund C. Tarbell,' in *Not at Home: The Suppression of Domesticity in Modern Art and Architecture*, ed. Christopher Reed (London: Thames & Hudson, 1996), pp. 48–64.

34. Royal Cortissoz, 'Spring Art Exhibitions. The Society of American Artists,' *Harper's Weekly* 39 (April 1895), 318.

35. Kasson, *Rudeness and Civility*, pp. 180–1.

36. Patricia Meyer Spacks, *Gossip* (New York NY: Alfred A. Knopf, 1985), p. 170. Spacks looks at several centuries of drama and literature, especially that of the eighteenth century, and discusses the reputation, use, and power of gossip both in those forms and in society at large. Spacks notes that much of the devaluation of gossip comes from an understanding of its power to control and alter social standing, business affairs, and family lines. Of particular interest to this author is Spacks's study of the novels of Edith Wharton, which show late nineteenth-and early twentieth-century women's conversations 'participating, more or less effectively, in complex financial speculation' (p. 187).

37. Thorstein Veblen, *The Theory of the Leisure Class: An Economic Study of Institutions* [1899] (New York NY: Modern Library, 1934), p. 29. Although some of the elements that came to define the leisure class of the late nineteenth century can be found in the aristocracies of previous eras, the proportionate number of people who adopted these strategies (conspicuous displays of wealth, elaborate rules of etiquette, visible 'free time') grew dramatically in the late nineteenth century. These strategies became a widespread social phenomenon and were employed on some level by all but the very lowest classes, in contrast to, for example, the relatively small and circumscribed community of a European court in a largely agricultural or warfare-based economy.

38. Veblen, *Theory of the Leisure Class*, p. 36.

39. Veblen, *Theory of the Leisure Class*, p. 43.

40. Veblen, *Theory of the Leisure Class*, p. 49.

41. Veblen, *Theory of the Leisure Class*, pp. 74–5.

42. Veblen, *Theory of the Leisure Class*, pp. 179–80. Veblen's emphasis on the woman's role in this scenario contrasts nicely with the quotation from Loftie, in which the man is instructed to make

sure these things happen. Veblen thus makes clear the difference between the overseer and the worker in the domestic economy.

43. Eighty years after Veblen, Carl Degler theorized that the newfound leisure time was a result of industrialization easing the workload for women: 'That leisure, of course, was a function of the urbanization of society and the consequent reduction in the household chores of women. ... Alongside this general development must be placed the long history of assigning women to a special moral role in the family.' See Degler, *At Odds: Women and the Family in America from the Revolution to the Present* (New York NY: Oxford University Press), pp. 324–5. I do not find the bored housewife with the new washing machine argument totally convincing. As Boydston, Strasser, and Filene all point out, these developments gave a false impression of an increase in leisure time for the housewife. In actuality, management of the household remained a more-than-fulltime job, and even those women who were freed up from housework found that time filled with new tasks, such as shopping for the household or calling on other women and receiving calls. The conversations women had during these calls would be considered work today, as they involved networking, arranging marriages, trading information about household tasks and servants, and spreading information about and for the husbands' businesses. In *The Awakening* (Kate Chopin's 1899 novel), Edna Pontellier's sudden failure to maintain her calling duties causes her husband to fear the effect it will have upon his career.

44. T.J. Jackson Lears, *No Place of Grace: Antimodernism and the Transformation of American Culture 1880–1920* (New York NY: Pantheon, 1981), p. 221.

45. Betsky, 'In the Artist's Studio,' 32.

46. McCarthy, *Women's Culture*, pp. 97–8.

47. Both artists were often caricatured during their time, and both Katherine Metcalf Roof and Keith L. Bryant, Jr. filled their biographies of Chase with anecdotes about his extravagantly arty appearance. One such anecdote involved a young street urchin, impressed with Chase's clothing and deportment, addressing him with 'Say, mister, ain't you somebody?' (Roof, *Life and Art*, p. 261).

48. Roof, *Life and Art*, pp. 253–8.

49. Lears, *No Place of Grace*, p. 15. Bryant uses the term 'genteel bohemian' to describe Chase in his biography, in which he describes Chase as 'the most colorful artist in America,' a 'witty bon vivant,' and the 'Prince of the Atelier.' See Bryant, *William Merritt Chase*, pp. x–xi.

50. Charles H. Caffin, *The Story of American Painting: The Evolution of Painting in America from Colonial Times to the Present* [1907] (New York NY: Johnson Reprint Corporation, 1970), p. 117.

51. Caffin, *The Story of American Painting*, p. 257. Caffin continues, 'Indeed, it is worth notice that where psychological insight appears in an American portrait, the subject will usually be a man. ... That the decline of the English Portrait School was due in a large measure to the excessive popularity of the portraits of women of fashion, with all its temptation to the artist of preoccupying himself with furbelows and finery in lieu of stronger and deeper qualities, can scarcely be doubted; and equally in modern America the same cause is at work, retarding the lustier growth of our art' (p. 257).

52. Harvey Green, *The Light of the Home: An Intimate View of the Lives of Women in Victorian America* (New York NY: Pantheon, 1983), p. 94.

53. There is a distinction between the bibelots that Chase could display in his studios and those which might appear in the average bourgeois home – an added level of size and grandeur of the objects was possible, for example in his enormous Japanese umbrellas, that a bourgeois woman might display in a much smaller size.

54. Betsky does not cite the origin of Benjamin's quote and I have been unable to locate it. Betsky, 'In the Artist's Studio,' 34.

55. Betsky, 'In the Artist's Studio,' 37.

56. Griselda Pollock argues persuasively that the artist – and perhaps all three women, metaphorically – are in fact the actress Sarah Bernhardt, a friend of Stevens's, following Peter Mitchell's initial suggestion. Pollock maintains, however, that Stevens did not intend the reference as portraiture, which would explain his not naming her in the title. Griselda Pollock, 'Louise Abbéma's *Lunch* and Alfred Stevens's *Studio*: Theatricality, Feminine Subjectivity and Space around Sarah Bernhardt, Paris, 1877–1888,' in *Local/Global: Women Artists in the Nineteenth Century*, ed. Deborah Cherry and Janice Helland (Burlington VT: Ashgate, 2006), pp. 99–119.

57. Pollock sees these women quite differently, as 'three conditions [that] are the signifiers of a more complex representation of femininity, creativity, and interiority precisely because Sarah Bernhardt herself worked, professionally and creatively, across the spaces and modes of representation between theatrical imag(in)ing and visual representation in painting and as an artist.' See Pollock, 'Louise Abbéma,' p. 117. This reading is in tune with my discussion in Chapter 4 of alternative ways of viewing the women in these paintings; however I feel the representation of either Stevens's own *Salomé* or, as Pollock argues, a 'compound' of Stevens's and Henri Regnault's *Salomé*, must be considered a clear disempowerment of the female subject in the painting. The 'artist' in the image cannot be the artist of the image, and Stevens makes that clear.

58. Kirsten Swinth has described interpretations like mine as 'eras[ing] social reality' because 'art, interior space, and aesthetic experience were expressions of feminine values – and, importantly, productions of female hands' (p. 101). Citing Chase student Rosalie Gill's *The New Model* (c. 1884, Baltimore Museum of Art) as asserting female production of aesthetic space and female subjectivity in the gaze of the painter's model toward the viewer, however, Swinth seems to undercut her own point. If the female painter's vision of a female model in her male teacher's studio better asserts female creativity and individuality, does this not suggest that Chase's painting lacks these elements? That he does not share a progressive view of gender equality that he sometimes reluctantly assented to, but rather continues to see it from the norms of his own time? And do not both Chase's and Gill's paintings, which are clearly set in Chase's studio, which we know he, and not she, designed and decorated, extend his dominance in that dyad? I believe they do, much as I would like to share Swinth's optimistic view of Chase – an optimism that sometimes shows signs of fraying, as on page 144 where, quoting an 1891 concession by Chase that 'Genius has no sex,' Swinth includes an aside that he does so 'despite much patronizing.' Later, on page 148, in a discussion of the spreading fear that art was becoming a feminized domain, Swinth points out that 'Chase, after abandoning his elaborately decorated aesthetic studio in 1896, clearly felt it necessary to reassert the masculinity of the artist's image.' Despite these seeming contradictions, Swinth's superb *Painting Professionals: Women Artists and the Development of Modern American Art, 1870–1930* (Chapel Hill NC: University of North Carolina Press, 2001) is not to be overlooked, and we clearly hope for some of the same changes in art-historical study of the period and its artists.

59. For more on this painting, see Theodore Reff, 'The Pictures within Degas's Pictures,' in *Metropolitan Museum Journal*, vol. 1 (1968), 125–66; and Sidsel Maria Søndergaard, 'Women in Impressionism: An Introduction,' in *Women in Impressionism: From Mythical Feminine to Modern Woman* (Milan: Skira, 2007), pp. 11–97.

60. Betsky, 'In the Artist's Studio,' 38.

61. Betsky, 'In the Artist's Studio,' 38–9. See also David P. Handlin, *The American Home: Architecture and Society, 1815–1915* (Boston MA: Little, Brown, 1979). Handlin remarks that artists in the 1890s began commissioning studio apartments, often duplexes with double-height rooms and skylights, in which to work. Apparently, they began a 'fad' for such apartments among those who had no intention of using them as studios per se, and by the turn of the century the majority of such buildings were being built for and used by non-artists, many of whom wished to entertain in a space that mimicked that of an artist's. Handlin notes that many of them 'did not even face north, and the apartment plan was uneconomical and inefficient' (p. 381).

62. Sarah Burns, 'The "Earnest, Untiring Worker" and the Magician of the Brush: Gender Politics in the Criticism of Cecilia Beaux and John Singer Sargent,' *The Oxford Art Journal*, vol. 15, no. 1 (1992), 36–53.

63. Burns, 'The "Earnest, Untiring Worker,"' 36–7.

64. Burns, 'The "Earnest, Untiring Worker,"' 43–5.

65. Betsky, 'In the Artist's Studio,' 36. Ann Douglas indirectly concurs with Burns in *The Feminization of American Culture*, where she argues that although the United States became more feminized during the second half of the nineteenth century, it was not a permanent or revolutionary change, and it never helped the women who forced that change. The very people, male and female, who espoused feminization aided in its marginalization as a separate category of behavior. See Douglas, *The Feminization of American Culture* (New York NY: Alfred A. Knopf, 1977), p. 13. See also Douglas's *Terrible Honesty: Mongrel Manhattan in the 1920s* (New York NY: Farrar, Straus & Giroux, 1995), where she argues that 'the very weapons they [the moderns – ensuing generations in the 1910s and 20s] used against the [Victorian] matriarch were borrowed without acknowledgment from her arsenal' (p. 7).

66. From *Artists Say the Silliest Things* (unknown publisher, 1940; republished by Kessinger in 2007), p. 85, quoted in H. Wayne Morgan, *New Muses: Art in American Culture 1865–1920* (Norman OK: University of Oklahoma Press, 1978).

67. Josephine Conger-Kaneko, 'The "Effeminization" of the United States,' *The World's Work* (May 1906), p. 7524.

68. William H. Gerdts, *Lasting Impressions: American Painters in France 1865–1915* (New York NY: Terra Foundation for the Arts, 1992), p. 75.

69. Robert L. Herbert, *Impressionism: Art, Leisure, and Parisian Society* (New Haven CT: Yale University Press, 1988), p. 48.

70. McCarthy, *Women's Culture*, p. 84.

71. Patricia Hills, in *Turn-of-the-Century America: Paintings, Graphics, Photographs 1890–1910* (exhibition catalogue, New York NY: Whitney Museum of American Art, 1977), makes this point about turn-of-the-century artists in general, 'who had absorbed the dominant values of their time' (p. 74).

72. We could even extend this reading to the many photographs of Chase with rooms full of female students. Chase (appropriately, as the teacher) is usually standing in front or beside the group, who become generalized by their similar clothing and physical separation from Chase. Chase can be seen as the magnanimous patriarch, herding scores of young, unidentifiable, women through his classes. Of course if you are related to any of the women in these photographs, you would read them quite differently. The presentation of these photographs in art-historical texts nearly always emphasizes the anonymity of the students, adding to the sense that although there were many, none of them was quite good enough to be famous and therefore identified.

73. Bailey Van Hook, *Angels of Art: Women and Art in American Society, 1876–1914* (University Park PA: Penn State University Press), pp. 51–2.

74. Van Hook, *Angels of Art*, p. 58.

75. Van Hook, *Angels of Art*, pp. 61–2.

76. Kathleen Pyne, in her book *Art and the Higher Life: Painting and Evolutionary Thought in Late Nineteenth-Century America* (Austin TX: University of Texas Press, 1996), is one of several scholars who point out the simultaneously feminized yet male-controlled art of the 1890s, 'an era that was reviled by the self-consciously masculinized modernists of the next generation as overwhelmingly "genteel" and thusly feminized. For the most part the painters of the 1890s offered to their viewers "her/story" – the image of therapeutic leisure and domesticity – but from the masculine point of view' (p. 292).

77. Tamar Katz, *Impressionist Subjects: Gender, Interiority, and Modernist Fiction in England* (Urbana IL: University of Illinois Press, 2000), pp. 76–9. For further study of James in this and other lights, I particularly recommend Hugh Stevens's *Henry James and Sexuality* (Cambridge: Cambridge University Press, 1998).

78. Michael Baxandall, *Patterns of Intention: On the Historical Explanation of Pictures* (New Haven CT: Yale University Press, 1985), p. 74.

'The Painter will not Sink into the Mother': Mary Fairchild's Nursery/Studio[1]

In Mary Fairchild MacMonnies Low's *Dans la nursery*, painted in 1896–97 (Terra Foundation of American Art, Daniel J. Terra Collection) (Plate 2), we also find a conjunction of studio and domestic spaces. The title suggests that this painting primarily shows us the nursery for Fairchild's first daughter, Berthe MacMonnies. Certainly Berthe is there, playing in her high chair, with governess and maid engaging in domestic duties nearby. However, the foreground of the painting contains an easel with a nearly completed work upon it (*C'est la fête à bébé*, 1896–97, Terra Foundation for the Arts, Daniel J. Terra Collection) (Plate 3); on the far wall we see what may be a copy Fairchild has made of another artist's works as well as a study for one of her most famous paintings; and the window on the left stretches overhead in a manner typical of a studio space. As I shall argue, this painting's deliberate conflation of both studio and domestic iconography keeps the image from contributing to Fairchild's effacement as a professional artist in favor of her socially predicated domestic role. The melding of domestic and studio spaces often served to reinforce the linkage between women and artists – both were relegated the duty of maintaining society's creativity and beauty. However, Fairchild emphasizes both her labor and the labor of the other women of her household in equal proportion to the domestic and artistic elements. Given Fairchild was a successful, well-known artist whose works were widely considered typical of the prevailing styles and subject matter of their time, one cannot locate this painting in the margins of dominant cultural modes.

As Fairchild steers her images away, even briefly, from the normative gender identifications and associations of the late nineteenth century, she forms the ideal focus of a study that seeks to allow for greater play in the representation of the artist's identity. By conflating her domestic and working spaces, Fairchild gave that location and herself a complexity that the

contemporary view of gendered bourgeois space would not otherwise have allowed. Mary Fairchild MacMonnies Low, by combining work and home lives in the most extreme manner, raises a specter of gender performativity that is not limited to our own time and social constructs. Fairchild's simultaneous roles as painter, mother, society wife, and occasional family bread-winner are all presented here in visual form. Fairchild's image is unique, but it points to issues that other women artists shared; I will explore two complementary cases here. Berthe Morisot, a contemporary artist with a nearly identical set of circumstances (both Morisot and Fairchild were married to husbands active in the art world, had children, and were well-established financially and in terms of professional success), tried a variety of approaches to having a studio, even if she never directly represented it – itself a curious and previously unmentioned fact. Fiction also served as a place in which to wrestle with the idea of a woman artist's studio and its implications, as I will discuss in terms of Kate Chopin's *The Awakening*. But I begin, as would any art historian, with the represented site.

In the Nursery?

Dans la nursery, a vertically oriented painting (approximately 32 × 18 inches / 81.3 × 43.2 cm), depicts the corner of a room in which two women and a child sit among sewing materials and other furnishings.[2] On the far wall, horizontal to the picture plane, four framed paintings obscure a tapestry hung behind them. Below these objects sits a woman (identified by family members as Lili, the MacMonnieses' nurse) in a white cap and apron, possibly darning a garment whose identification is unclear. Close by her on the right, a toddler is seated in a high chair, her face turned to the viewer. On the left side of the painting, a woman in a dark blue dress (Marthe Lucas, the MacMonnieses' governess) sits sewing a white cloth, the tools of her labor arrayed around her.[3] Above her, a skylight window half-covered with maroonish-brown curtains lets in bright white light. In the foreground on the right side, an easel stands at an angle from the picture plane, its projecting wooden appendages shooting diagonal lines across an otherwise largely vertical and horizontal composition.

The three rectangular works on the far wall are usually described either as copies of a Pierre-Cécile Puvis de Chavannes[4] or as 'panels, which resemble mural studies in the mode of Pierre Puvis de Chavannes.'[5] I have searched all available sources on Puvis de Chavannes and no similar work appears in his oeuvre.[6] Fairchild's admiration of Puvis was well known and linked to her success in her Chicago mural, whose reviewers saw as a positive but not overly determinant influence, but she was equally well known for her remarkable abilities as a copyist, particularly at the

Louvre, so these panels may represent another artist's paintings. More likely, however, is that they represent initial efforts at determining the style and arrangement of figures for Fairchild's commission to paint one of the two large lunettes in the Women's Pavilion of the World's Columbian Exposition of 1893, as it is known that Fairchild went through dozens of different sketches for that project before arriving at her final painting, the widely acclaimed *Primitive Woman* (1892–93, whereabouts unknown).[7] Many of the figures in both these possible drafts and the final version are posed and arranged similarly, and despite the very different settings (one in a wooded landscape, the others showing a classicizing interior), both are heavily inflected with a strong classical feel and a melding of the influences of early Renaissance painter Sandro Botticelli and Puvis, both artists whose works she had copied and admired previously. The lunette-shaped panel above these images is a small study Fairchild made for the final version of *Primitive Woman*, a verified attribution that supports somewhat the hypothesized one for the rectangular images.[8] In any case, the paintings she chose to represent in this scene emphasize her fame, her painting skills, and her pedigree as an artist well versed in and equal to more established male artists.

With the exception of the title, Fairchild seems to have given equal emphasis to the domestic and studio aspects of the setting. In 1896–97, the MacMonnieses rented both an estate in Giverny (a former priory, called *Le Prieure* at the time) as well as a large apartment and several studios in Paris. The setting of this painting is either that of Fairchild's painting studio in the MacMonnieses' Paris home at 44, rue de Sèvres, the studio in the rented Villa Bêsche in Giverny, or her painting studio on the grounds of the Giverny monastery (Fig. 3.1).[9] That any of these rooms actually functioned as the MacMonnieses' nursery is questionable. As their apartment in the chic neighborhood of the Bon Marché was suitably large enough to have separate rooms for the nursery and the painting studio, and as their significant real estate holdings and staff assistance at both locations in Giverny suggest in terms of finances (as well as the impractical distance from the main house to this studio at *Le Prieure*), the presence of the child and servants in this image can be seen as a deliberate choice – *not* merely the documentation of a daily scene.[10]

As a bourgeois woman who earned an income through painting, Mary Fairchild MacMonnies Low was certainly somewhat of an anomaly in the late nineteenth century. It is possible that this painting, exhibited in 1899 at the Salon Nationale des Beaux Arts in Paris, functioned as 'proof' that its author was not ignoring her 'respectable' feminine duties and desires by painting – a strategy art historians have suggested of other images by women artists of their children and servants.[11] Moreover, unlike those in the studio paintings of most male artists of the time, including Chase's,

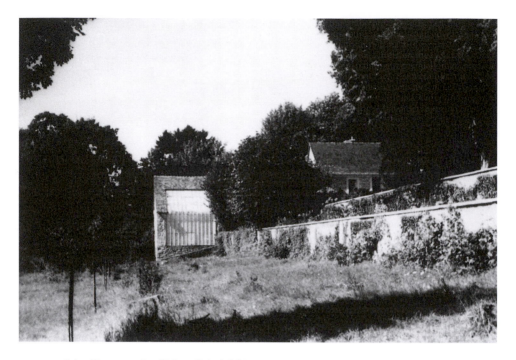

3.1 Photograph of Mary Fairchild MacMonnies's painting studio in the grounds of her Giverny home, *Le Prieure*. Photo courtesy of the Raymond Inbona family

the women in *Dans la nursery* are actively working, taking over the labor that was no longer the leisured bourgeois woman's province and, in this case, allowing the woman artist the time and energy to devote to her art. Looking at a painting by Berthe Morisot of her daughter Julie on the lap of her nurse, Ruth E. Iskin makes a point that could be equally applied to Fairchild's painting:

[The painting] indicates the class differences between the nurse and Julie, privileging the baby who is seen in frontal view while the young nurse appears in profile with a downward tilt of her head that suggests deference … express[ing] a new woman's perspective by featuring the baby with a hired nurse in place of the common mother/daughter portrait.[12]

That this painting can be read as a negotiation of the two normally separate worlds which Fairchild simultaneously inhabited is obvious. A contemporary critic, discussing Fairchild's works, including this one, at the 1899 Salon, saw exactly this connection:

Mrs. MacMonnies, who threatened at one time to become absorbed in domestic life to the detriment of her painting, has found a way of combining the two:

she paints baby now, or rather babies in all sorts of pretty and interesting surroundings. *The Christmas Tree*, *In the Nursery*, and *Baby's Birthday* are three of her pictures this year, and the names explain them. Besides, there are a couple of portraits. All these are of a size and elaborateness of composition that prove that the painter will not sink into the mother. The MacMonnies still keep their studio in the Rue de Sèvres, and it is one of the gathering places of the art clan.[13]

But Fairchild does not emphasize the domestic scene over and above her own skilled labor as a painter by disguising the nature of the room. She instead highlights the studio-oriented elements of the space, such as the room's window, its size, and its other paintings – including an easel holding a work in progress as the only sharp diagonal in the room. One would only need a passing knowledge of art to guess at Fairchild's role as an artist (and the head, rather than the laborer, of the household) in *Dans la nursery*.

The copies, if they are such, of other works hanging on the walls of her studio draw attention to Fairchild's acting within a tradition of copying and commenting on the works of predecessors. In this instance, that gesture is conspicuous for the way that it points to a conspicuous absence in late nineteenth-century art: women artists painting their studios.[14] Women artists did paint self-portraits, most often without signs of their position as artists, but even when these images show the artist holding a palette and paintbrush, they never show more than a slight glimpse of the studio in which they were painted.[15]

More common than paintings are photographs of women's studios (Berthe Morisot, Mary Cassatt, Fairchild, Lilla Cabot Perry, Elizabeth Jane Gardner, and Cecilia Beaux were all photographed in their studios), suggesting that these women were not necessarily hiding the space from the public and that they may have considered their own representations of the space differently. In these photographs, we see women working in a variety of types of studios, from the most barren and work-like to the most decorative and domestic. We see, in the case of Beaux and Fairchild, female artists smilingly posing in their studios, and in none of these images does there seem to be a reluctance to have the room or its contents, human or artistic, photographed. Yet despite this relative willingness to have these spaces photographed, women artists did not seem eager to paint them as such. The difference between photographing and painting the studio may be rooted in the difference between self-representation and documentation. Female artists may have been reluctant, consciously or unconsciously, to define this space themselves, or they may have been desirous of hiding the space *as they saw it* from view. Perhaps the photograph, capturing only what was there from the photographer's point of view, rather than the artist's herself, was somehow less threatening. However, we must remember that even photographs of the studios of celebrated women painters, albeit more common than paintings, were rare, suggesting a reluctance to have them photographed on some level. After all, there are hundreds of

photographs of William Merritt Chase's various studios, compared to only one of Morisot's, one of Cassatt's, and only a small handful of Perry's, Beaux's, and Fairchild's.[16]

Dans la nursery is thus, in our understanding of painted subjects by women in the late nineteenth century, a radical image. Perhaps unsurprisingly, it and *C'est la fête à bébé* were briefly attributed to Fairchild's husband Frederick MacMonnies until William Gerdts suggested their likelier authorship in his survey of American artists working at Giverny.[17] Gerdts points out that, although a precise inventory of the paintings MacMonnies left in Giverny after his death does not include either of these, a misattribution probably occurred when both Fairchild's and MacMonnies's works ended up together in the collection of their granddaughter Marjorie MacMonnies-Young.[18] Young then attributed them to MacMonnies when she sold them, perhaps encouraged by art dealers who would have been far more familiar with Frederick's name. However, Fairchild submitted two paintings to the Salon in 1899 with titles that match the subjects of these two paintings precisely.[19] Yet until 1991, when the Terra Foundation changed the attribution to Fairchild based on Mary Smart's and Gerdts' scholarship, it was assumed that *Dans la nursery* and *Painting Atelier at Giverny* – the title given to the painting when it was located, purchased, and attributed to MacMonnies – were two different paintings. Although it is true that MacMonnies dabbled in painting throughout his career (turning to it more seriously in 1901; the vast majority of his two-dimensional work dates after 1900), and both *Dans la nursery* and *C'est la fête à bébé* are somewhat different in style from the plein air lighting and cotton candy palette of *some* of Fairchild's other well-known paintings of the period, such as *Roses and Lilies (Roses et Lys)* (1897, Musée des Beaux-Arts, Rouen) (Fig. I.1), a glance at the body of her work clarifies any misconceptions critics might have about her as a single-style artist (Figs 3.2 and 3.3).[20] Furthermore, other similarly styled paintings of the time have been attributed to Fairchild, including *La Repriseuse (Woman Darning)* (1896–97, private collection), a painting clearly painted by the same artist at the same time as both *Dans la nursery* and *C'est la fête à bébé*. Although *La Repriseuse* is also unsigned, it is dedicated to Madame Baudy, owner of the Hotel Baudy in Giverny, to whom Fairchild dedicated several of her paintings in the same manner (while MacMonnies never did).[21] One such painting, *Lady with an Umbrella and Child (Femme à l'ombrelle et enfant)* (1897, private collection), is signed by Fairchild, dated, and dedicated to Mme. Baudy, and although it shows Berthe and her nursemaid out of doors and is painted in a brighter, more Impressionist style, Berthe turns toward the viewer from a seated position exactly as she does in *Dans la nursery*.[22] *French Nursemaid and Baby Berthe* (1896–97, private collection) (Plate 4), *Marthe Lucas, Betty et Marjorie* (before 1904, Musée Alphonse-Georges Poulain, Vernon) (Fig. 3.4), and *Portrait of Berthe Hélène MacMonnies* (1898, private collection) are similar

3.2 Mary L. Fairchild MacMonnies (later Low) (American, 1858–1946), *Normande en costume avec son chat*, n.d. Miniature on ivory, 4" H × 3⅜" W (10 × 8.6 cm). Musée Alphonse-Georges Poulain, Vernon, France. 79.17. Donated to the Musée by the artist

works that are also either signed (in the latter case) or have been and continue to be attributed to Fairchild (in the case of the first and second paintings).[23] MacMonnies did include his family members in some of his relatively few painted scenes, but in all of them Berthe is clearly older than she appears in Fairchild's paintings and not a single one of MacMonnies's paintings shows the same studio space. The studio space depicted is without doubt Fairchild's

3.3 Mary L. Fairchild MacMonnies (later Low) (American, 1858–1946), *The Breeze*, 1895. Oil on canvas, 69" H × 52" W (175.3 × 132.1 cm). Daniel J. Terra Collection, Terra Foundation for American Art, Chicago. 1987.23. © Terra Foundation for American Art, Chicago/Art Resource, New York

3.4 Mary L. Fairchild MacMonnies (later Low) (American, 1858–1946), *Marthe Lucas, Betty et Marjorie*, before 1904. Oil on canvas, 9¼″ H × 7½″ W (23.5 × 19 cm). Musée Alphonse-Georges Poulain, Vernon, France. 89.13.1. Former collection of Marthe Lucas

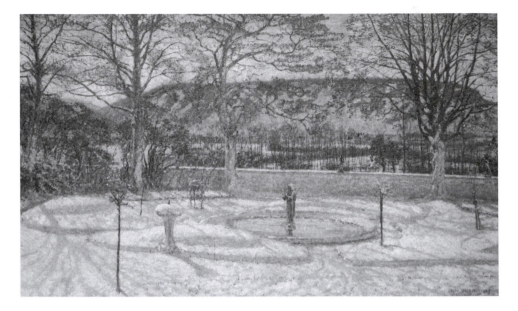

3.5 Mary L. Fairchild MacMonnies (later Low) (American, 1858–1946), *Un coin de parc par temps de neige, le jardin de l'artiste à Giverny*, before 1904. Oil on canvas, 38⅜" H × 64⅜" W (97.5 × 163.5 cm). Musée Alphonse-Georges Poulain, Vernon, France. 79.18. Donated to the Musée by the artist

painting studio (and in fact no one disputes this), whose layout, scale, and décor (including the tapestries on the walls of both spaces) do not match any of MacMonnies's paintings. Fairchild's studios were consistently smaller (and in the case of *Le Prieure*, on the opposite end of the Giverny grounds from the much larger one belonging to MacMonnies and quite different from the room he apparently used in the main house as an additional studio).[24] Its separation from the main house and MacMonnies's studio, much closer to Fairchild's famous terraced gardens, shown in her painting *Un coin de parc par temps de neige, le jardin de l'artiste à Giverny* (before 1904, Musée Alphonse-Georges Poulain, Vernon) (Fig. 3.5), argue for this studio as a 'room of one's own' for Fairchild, one her husband might have visited but clearly never worked in. In Paris, he had a studio separate from the domestic spaces of their home, while she worked in a studio within their apartments. When an overt studio image is found, the assumption is made that it must be the product of a male artist, and disproportionate work must be done to prove it otherwise, particularly where attribution is connected to art market prices and the approval of potential buyers/donors.

Given the rarity of this image's subject matter, along with its initial and renewed misattribution, *Dans la nursery*, a seemingly ordinary painting largely ignored, has much to teach us about the way in which paintings and artists

are seen, and often dismissed, on gendered grounds. Far from ordinary, the painting publicly and straightforwardly raises the question of the status of women artists as professionals, and unlike other images of the period, it does so without identifying the woman artist as a general or metaphoric figure, as a figure of pity or ridicule, as a model for a male artist, or as the exception that proves the rule that women must choose a profession or a family, but not both.[25] Although other images from the period can be *interpreted* as considering these issues, the interpreter must come prepared with magnifying lens and reference texts. By depicting her space as containing coexisting features of professionalism, maternity, and bourgeois status, Fairchild claims an affirming role for herself, and by extension other female artists, as someone capable of more than one identity.

Representing Women Artists

Dans la nursery is a tour de force painting of carefully delimited feminine strengths and responsibilities. The equality of emphasis given to domestic, artistic, and biological creations/labors here is what makes the painting so unique. When placed with a painting that clearly shows more than a nursery, even the title suggests a challenge to the strictures that held women artists; although women were seen as the representatives (rather than creators) of culture and the generators of children, Fairchild's nursery grows both happy children and successful artworks. Other female painters of the time emphasized one of these things over the others. Mary Cassatt, for example, often painted domestic scenes and women with children, but always as an outside observer of the particular image; she never appears in any of her numerous woman-and-child compositions. Furthermore, in none of her paintings do either a studio or a woman artist appear. The most celebrated woman painter in Europe in the last half of the nineteenth century, Rosa Bonheur, never painted a single domestic or maternal scene, with the result that critics (even approving ones) described her as essentially a man.[26] Fairchild shows the viewer more: her ability to successfully refer to the work of famous male painters, her ability to create her own paintings of more 'appropriate' maternal imagery, and her ability to condense all of these styles and more within one painting.

One of the more common criticisms launched at women who sought careers in painting in the nineteenth century was that they lacked the versatility and depth of their male counterparts. Those with talent were generally dismissed as having talent for only one type of art making, such as painting flowers or children, painting in miniature, or imitating their (always male) mentors.[27] Fairchild's painting overtly presents her skills in more than one area. She is able to represent a domestic scene with sensitivity, but she can also paint classicizing allegories similar to those of Puvis de Chavannes (at the height of

his career during this time). Puvis was not the only male artist whose works Fairchild copied successfully for money. For example, the Louvre attempted to purchase a Botticelli copy Fairchild refused to part with.[28] The poses of the two servants in the image recall Jan Vermeer's work. Placing paintings and windows in the background and a child looking toward the viewer in the foreground may have been a reference, as in Chase's work, to Diego Velázquez's *Las Meninas* (1656).[29] Fairchild could have been looking to other painters' representations of studios as models, rather than focusing only on her immediate surroundings as was often charged of women painters of this era. More interestingly, her relation of her own image to those of more famous male painters may be understood as an assertion of her own skill and an effort to elevate her status. In tackling both such complex iconology and the great compositions of 'master' painters, she equates her work with theirs and suggests that hers should be as highly valued.

Fairchild does not stop at displaying her artistic versatility, however. She also shows the viewer her creative powers as a mother running a successful home and representing her surroundings in paint. *Dans la nursery* depicts a scene that clarifies Fairchild's domestic standing: she has done well enough financially and socially to have servants and time for painting. She also knows domestic work well enough to reproduce it accurately on canvas, and to feel comfortable with the servants' presence in her own workspace. In fact, by showing the servants working on needlework in her studio, Fairchild's strategy can be read two ways: coming surprisingly close to conflating their efforts with hers both artistically and in terms of labor, or setting up a contrast between their domestic labor and hers.[30] Additionally, like a good bourgeois housewife, she decorated her interior; however, she literally made the works of art that decorate it. In sum, Fairchild represents herself in all these aspects: as professional painter, as mother, as head of the domestic household, as bourgeois woman with servants, as bourgeois woman with leisure time and skills.[31] It is almost as if she looked at self-representations by women artists like Elisabeth Vigée-LeBrun, Angelica Kauffmann, Berthe Morisot, and Mary Cassatt, and tried to best them by conflating *all* the possibilities.

Fairchild's painting gives the lie to criticism that strictly divides painted subjects by gender. The standard readings of paintings by Morisot and Cassatt, Fairchild's contemporaries, focus on their superior ability to represent the interiors of bourgeois homes and the lives of bourgeois women, children, and servants.[32] Although this is certainly the case in the Fairchild painting, Fairchild does not stick so readily to the professional self-effacement often linked to this type of image. Fairchild's copy of her own well-known painting is significantly visible and recognizable on some level to even a casual observer of the painting. Furthermore, the easel and work-in-progress in Fairchild's canvas are true rarities in images by women artists of the time. Curiously, when works of art and easels do appear, they

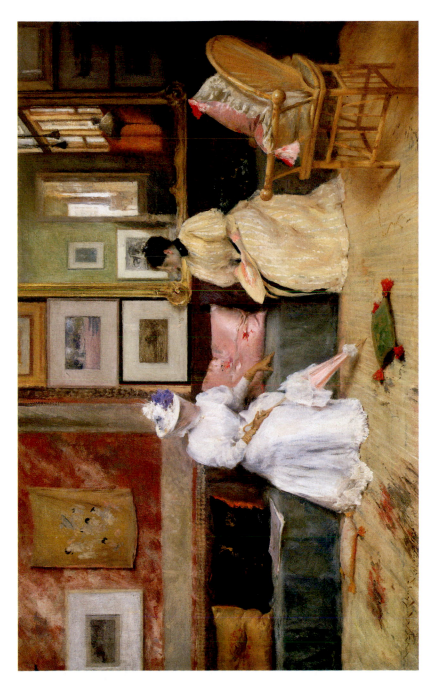

1 William Merritt Chase (American, 1849–1916), *A Friendly Call*, 1895. Oil on canvas, 30⅛″ H × 48¼″ W (76.5 × 122.5 cm). National Gallery of Art, Washington DC. Chester Dale Collection, 1943.1.2.(703)/PA. Image courtesy of the Board of Trustees

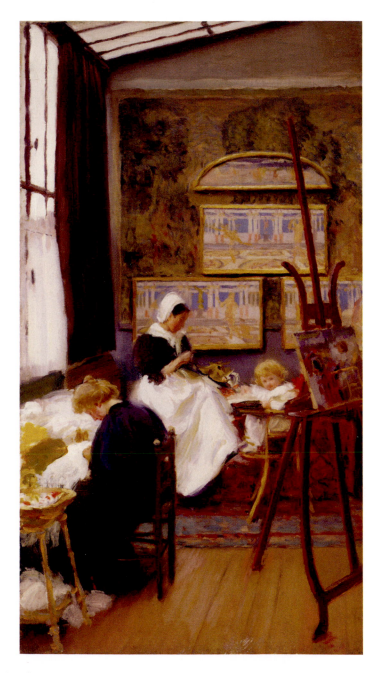

2 Attributed to Frederick William MacMonnies (American, 1863–1937), *Atelier at Giverny*, 1896 or 1897. Oil on canvas, 32" H × 17" W (81.3 × 43.2 cm). Daniel J. Terra Collection, Terra Foundation for American Art. 1999.91. © Terra Foundation for American Art, Chicago/Art Resource, New York

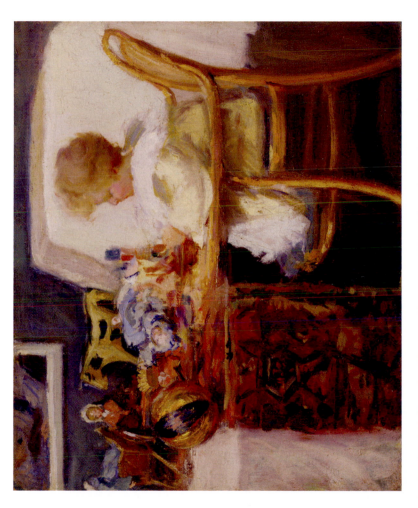

3 Attributed to Frederick William MacMonnies (American, 1863–1937), *Baby Berthe in a High Chair with Toys*, 1896 or 1897. Oil on canvas, 15⅛″ H × 18¼″ W (38.4 × 46.4 cm). Daniel J. Terra Collection, Terra Foundation for American Art, Chicago. 1999.90. © Terra Foundation for American Art, Chicago/Art Resource, New York

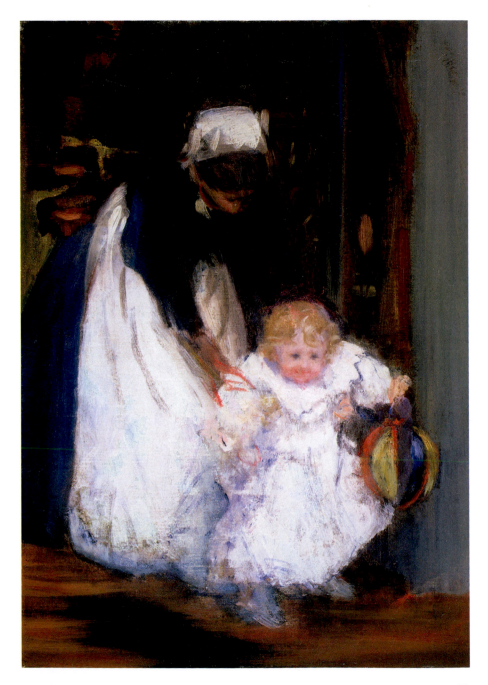

4 Mary L. Fairchild MacMonnies (later Low) (American, 1858–1946), *French Nursemaid and Baby Berthe*, 1896–97. Oil on canvas, 18" H × 13" W (45.7 × 33 cm). Private collection. Photo courtesy of Post Road Gallery, Larchmont, New York

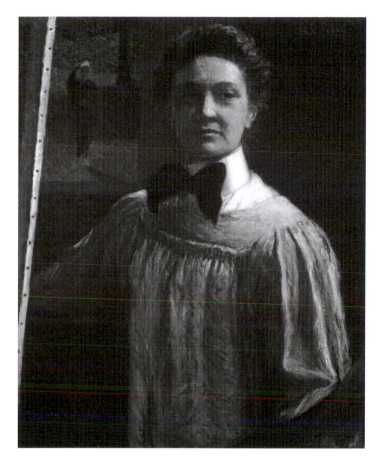

3.6 Lilla Cabot Perry (American, 1848–1933), *Self-Portrait*, between 1889 and 1898. Oil on canvas, 31⅞" H × 25⅝" W (81 × 65.1 cm). Daniel J. Terra Collection, Terra Foundation for American Art. 1999.107. Photo: Terra Foundation for American Art/ Art Resource, New York

tend to be in portraits – not self-portraits. Two portraits of Rosa Bonheur, one by Anna Klumpke (1898, Metropolitan Museum of Art, New York) and the other by Achille Fould (exhibited in the Salon of 1893, whereabouts unknown) do show that artist's famous depictions of animals on canvas. The fact that these two images are both portraits rather than self-portraits, and that they both depict the exceptional Bonheur whose career and success are usually likened more to male than female artists of the time, suggests that they are to be treated as revealing little about the identity of the more typical female artist of the late nineteenth century. One exception is Lilla Cabot Perry's self-portrait (between 1889 and 1898, Terra Foundation for American Art, Daniel J. Terra Collection) (Fig. 3.6) which shows her easel

– but because she adopts the convention of depicting her reflection in a mirror, the viewer can only see the back of the canvas, a canvas which in any event likely contains the portrait itself and not a self-conscious display of the artist's versatility and scope. The same is true of Edma Morisot's portrait of her sister Berthe at an easel (1863, private collection). Elizabeth Nourse's *Self-Portrait* (1892, private collection), like Perry's, shows the artist looking at the viewer/mirror while painting on an unseen easel, but the tight space of the composition ends just behind her body at a folding screen where a small print or painting is affixed. The suggestion of a studio is there, but again the room could be any room.[33]

In *Dans la nursery*, Fairchild's paintings do not appear as nearly hidden references; their role as skillfully made paintings is immediately evident by their placement on an easel or a wall.[34] The studio window arching overhead adds to this sense, keeping the viewer from confusing the room with an 'ordinary' domestic interior and emphasizing instead its function as a specific type of workplace. It is impossible to view this room as anything but a studio – its purpose is clear.

Perhaps this is why *Dans la nursery* was so quickly accepted as the work of a male painter despite so much evidence to the contrary. Neither Morisot, nor Cassatt, nor any other significant female artist of the late nineteenth century depicted their studios in such an evident way. Male artists, on the other hand, painted their studios *as studios* often (see works by Jean-Frédérick Bazille, Alfred Stevens, and William Merritt Chase, for example). Additionally, Fairchild did not paint her studio as a private piece or a study for her own private pride; she submitted it to the Salon. She expected it to be viewed by one of the largest art audiences available. Why is her act so unique in the late nineteenth century? What is so extraordinary about a bourgeois woman artist depicting her studio? What is even more extraordinary about displaying this work publicly?

Women and the Unrepresented Studio

When Fairchild undertook the representation of her studio, she likely did so with an eye to the way women more generally tend to show up in late nineteenth-century artistic renderings of these spaces: as models, visitors, and within representations in the room. These women are rarely if ever seen as individuals of mentionable status. Yet, as Sarah Burns points out, their presence did have an effect on the images and by association, the art world: 'the almost exclusive identification of women with studio interiors reinforced the construction of the art world as feminine, passive, and dependent for its very existence on industrial and commercial sources of wealth, unseen and unmentioned, yet all-powerful.'[35] Even when we find female artists

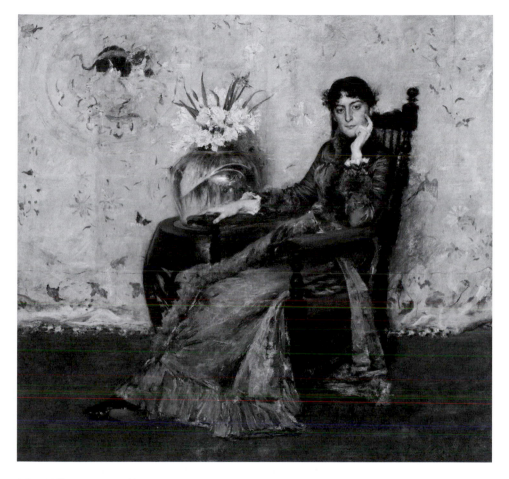

3.7 William Merritt Chase (American, 1849–1916), *Dora Wheeler*, 1882–83. Oil on canvas, 62⅝" H × 65⅛" W × 4½" D (159 × 165.5 × 11.5 cm). The Cleveland Museum of Art, Cleveland, Ohio. Gift of Mrs. Boudinot Keith in memory of Mr. and Mrs. J.H. Wade. 1921.1239

linked with studios during this time, it is usually as models rather than artists. Without the studio element, when others depicted women artists, they were most often shown without the evident trappings of their work, as Frederick MacMonnies did with Fairchild. Some of Edouard Manet's most famous artworks are his paintings of Berthe Morisot in a variety of poses and costumes, each with a different focus, but none of these depict her as an artist. Chase's portrait of Dora Wheeler (1883, Cleveland Museum of Art) (Fig. 3.7) famously follows the same pattern; as Barbara Weinberg notes, Chase emphasizes Wheeler's sophisticated and fashionable attire and setting in a manner that makes them indistinguishable from those of potential

patrons and thus equates Wheeler with them. However, this representational strategy renders invisible both the actual nature of the setting, in Wheeler's New York design studio, and Wheeler's role as a creator of the type of objects that surround her.[36] Although clues to her work are there in the wall hanging and other decorative objects, Wheeler is lumped among them, rather than shown in the act of design that would have made her profession clear. This aspect was commented on directly by critics of the time, as for example W.C. Brownell's review of the work at the Salon of 1883: 'Miss Wheeler counts for next to nothing in it, not only in lack of character ... but in point of pure pictorial relation to her surrounding.'[37]

That women could be associated with the artist's studio without being considered artists themselves is made clear by every discussion of this issue both at the time and now. In fact, representations of women in studios in comparable French paintings, although more rare in comparison to those of the US, have been seen as helping to define avant-gardism and modernity; most extreme – and persuasive – is T.J. Clark's argument that the lifeless artist's mannequin in Edgar Degas' *Portrait of Henri Michel-Lévy* (c. 1878) (Fig. 2.5, described more fully in Chapter 2) 'is modern woman herself, the lady he chooses (or is able) to represent. She sits on the floor of the studio, a mannequin made up for the countryside, out of joint and overdressed, compliant and featureless, her minimum physiognomy seeking the studio sun.'[38] In Degas's painting, the woman in the studio is not only not an artist, she is not even alive. When women *were* artists, it was hoped (and reality often collaborated) that their artistry would be domestic in flavor – a kind of 'compliant and featureless' display of mere manual or ornamental skill. Celia Betsky points out that Dora Wheeler and other decorative artists were put forth as models for women, with the hope that women would focus their efforts on beautifying the domestic sphere and hence standing themselves as models of appropriate feminine artistic behavior.[39] Thus the conflation of woman with home effaced the professional labor aspects of studio spaces and emphasized rather their domesticity – whether the artist was male or female.

This contrast raises the possibility that in choosing not to represent their studio space, professional women artists also avoided being equated in value and effect to the more typically depicted women of the studio. Perhaps Morisot and Cassatt did not want their hard work to be outweighed by the relationship viewers might make between their studios and the studios of male artists, with their merely decorative women. To create such an image would be to collaborate with the creation of the gendered boundaries that already vexed women artists. Furthermore, male depictions of studios were threatening to women artists not merely as competition artistically or for social value but also domestically. If women were supposed to be the arbiters of all things domestic, the multitude of male artists' paintings of

the studio as domestic interior were one method of usurping this power. If the spaces were equated, Burns' assertion of the devaluation of the studio may have a flip side: the devaluation of the domestic space as something easily managed by men. In Chapter 2, I have argued that William Merritt Chase had a closer relationship to his domestic space than a virile bourgeois man was theoretically supposed to. Was such an encroachment threatening to bourgeois women? It seems likely – they did not have dominion over very much, after all. Fairchild's bold move may thus be read as a reassertion of control over both domestic space and work space as the provinces of women.

However, despite Fairchild's rare willingness to depict her studio and then to display that depiction publicly, the female artist was still doubly bound, linked with leisure and domesticity not just through the increasing popularity of depictions of bourgeois life, the artist's desire to sell to this market, or the emergence of the bourgeois artist, but by the very fact of her gendered role as wife, mother, household manager, hostess, and decorative object. The Baronne Staffe, in a contemporary manual on appropriate female pursuits, put it this way: 'as young wives, young mothers, women will have to renounce, for periods of time at least, the sanctioned joys art gives. Sanctioned, that is, when such art is not too absorbing, when it does not take precedence over the sacred obligations of woman.'[40]

The Case of Berthe Morisot

The radical nature of Fairchild's assertive painting and the associations that she needed to negotiate in the process of designing it are manifest in the accounts we have of women artists. The female artist's studio was a common feature in contemporary literature: 'For women and artists were linked in the mind of the age as patron saints in the religion of art and creativeness. During the decades following the Civil War, women artists were so numerous they became stock figures in life and letters'[41] Anne Higonnet, Berthe Morisot's biographer, provides some information about that artist's studios, giving us an interesting insight into how the female artist viewed her studio and how her relationship to it was viewed by others. As a developing student painter, Morisot seemed to consider a separate studio space important. Higonnet informs us that Morisot and her sister Edma had a 'substantial' studio built for them in the garden, at great expense to the family.[42] This room was 'furnished in the standard studio way, with a red sofa and a central pouf, and ... cluttered, both on the walls and on the floor, with canvases in various states of completion.'[43] Later, as Morisot settled more firmly into her career as an artist, her studio was destroyed during the Commune. Puvis de Chavannes visited the studio afterwards, remarking romantically:

'I sought your ghost in a white peignoir, but conjured you up in vain. I didn't, moreover, cross the threshold, waiting to do so for the return of she who animates this solitude.'[44] Note the domestic language in which Puvis described his experience; a gloomy curtained room, whose threshold was uncrossed for lack of the peignoired woman whose absence kept the space from its most appealing presentation. A truly romantic notion of feminine domesticity abounds here, especially as we try to imagine Berthe working in her nightgown. This studio was never replaced; Morisot apparently painted in her bedroom in the family's next house, never turning it into a full-blown studio.[45] Not long after her marriage to Eugène Manet, Morisot moved to a house in suburban Bougival, where her studio and dining room occupied the same space, having one wall almost entirely of glass.[46] Once their Paris home on the rue Villejust was completed, Morisot and Manet took up residence on the main floor, whose largest room was a living room with high ceilings and windows. They decorated this room in typical late nineteenth-century fashion, with Japanese screens and umbrellas and Empire furniture. Here Morisot painted as well as entertained, hiding her work materials in a closet she had 'built behind a wall.'[47] Higonnet implies that Morisot would carefully return her non-studios to their domestic appearance at the end of each day, putting away unfinished canvases and eliminating signs of her work. Presumably, the use of a domestic space not specifically dedicated to a studio would have other uses that Morisot would be respecting by hiding her work.

We wonder what could prevent such a prolific artist from choosing to devote significant, separately demarcated household space to her career for the majority of her life. In fact, much later in her life Morisot brought the studio back, but not into her own home. As her husband Eugene became fatally ill, Morisot turned the attic of a house they rented in a village near Paris into a private studio fully separate from her living quarters.[48] Morisot only revived her desire for a separate studio space when her husband was nearly dead, and one cannot help but wonder if the timing was mere coincidence – with the bulk of Morisot's household duties as wife and mother behind her, perhaps she no longer felt that her studio needed to be disguised or indistinguishable from her home. In 1892, after her husband's death, Morisot and her daughter sold their other homes and rented an apartment in Paris on the rue Weber, and there she again had the top floor turned into a studio.[49] Nonetheless, she never overtly depicted it.

Turning to Morisot's self-portraits, we find similar problems of gendering both the images and their interpretations. In 1987, Kathleen Adler and Tamar Garb pointed out the dearth of material on Morisot that did not present her as marginal to an otherwise male-dominated art scene or a logical if lesser outcome of a feminized style (Impressionism).[50] Since then, feminist attempts to read Morisot less marginally have grown dramatically; most

significant in terms of self-portraiture specifically has been the work of Anne Higonnet, who happens also to be the foremost scholar of Morisot's life and work, in part due to unique access to family members and documents. Higonnet begins her analysis of Morisot's self-portraits by discussing not her works but eleven portraits of her made by Edouard Manet. None of these images show her as an artist. Higonnet reads Manet's paintings as depicting Morisot in the role of a decorative and perhaps sexualized woman with all the trappings of nineteenth-century femininity, including fans and veils. Higonnet interprets these images positively – rather than limiting Morisot's identity, they 'affirmed the duality of her character. They promised her she could be both an artist and a desirable woman…'[51] Higonnet argues that Morisot could not make a proper, that is, fully self-aware, self-portrait until maternity and public success had helped her constitute her identity. She elsewhere asserts that Morisot's self-portraits can be read in contrast to Manet's portraits as explorations of the 'triangular relationship among self, daughter, and image making.'[52] Higonnet does not explain how these dualities and triangularities work but merely assumes that these were basic, integral parts of Morisot's psyche. In fact, Higonnet seems afraid to allow Morisot's self-portraits to stand each on its own but prefers the story of a unified (yet dual, or treble?) self she can create by seeing the works as a combined whole. There is one self-portrait representing neither paint nor brushes nor daughter (*Self-Portrait*, 1885, Art Institute of Chicago) (to be discussed later in this chapter as Fig. 3.9) that Higonnet finds self-effacing (both literally and figuratively, as the image provides the least number of iconographic clues and is significantly factured in form).[53] Higonnet finds Morisot to be so much more relaxed with herself with the other relatively early self-portraits (and from then on), confident in her choice to be both artist and mother, that she is able to refer to them and Manet's paintings in her later works.

In trying to construct a new and feminist story for Morisot's self-portraits, Higonnet has raised some important points. Yet I feel that Higonnet falls into a familiar trap by attempting to move from Morisot's images by Manet, taken as signs of Morisot's inability to represent a fully formed self, to her self-portraits, understood as an effort to reconcile her boundary-breaking role as artist with her boundary-reaffirming role as mother. Her story of Morisot requires that the latter solve her gender and/or identity problems, essentially, through motherhood. In this manner, Higonnet argues, Morisot can avoid being imaged as a woman through male eyes (posed by, for example, Manet) or as a 'woman as male artist' (simply reiterating the poses and iconographies associated with traditional self-portraits). With motherhood an acceptable part of her life, Morisot becomes the ultimate female creator, à la Fairchild. Only through a predictable transformative female experience – one that necessitated a male intervention, at least in

that century – can Morisot identify herself. Is the suggestion being made that women who do not have children cannot develop as fully self-aware individuals?

I believe that reading the Morisot images through Judith Butler's notion of gender as 'a kind of impersonation and approximation,' a performance, gives us a way to look at them in more depth.[54] The paintings of Morisot by Manet are striking in their performativity. Looking at three in particular, *Jeune femme voilée* (1872, Musée du Petit Palais, Paris), *Femme à l'éventail* (1872, Musée d'Orsay, Paris), and *Une étude* (1874, private collection), we can assume provisionally that Manet probably did not consider them portraits per se or he would have put her name in the titles.[55] It follows that Manet was more interested in these paintings as studies, literally of the formal possibilities of depicting a woman with these various props and in these various positions, than in them as specific attempts to capture Berthe Morisot's likeness or personality. In these images Morisot plays with traditional feminine attributes and uses them as props, and both Manet and Morisot seem to have agreed upon the performativity of an artist's model in concert with femininity as a gender construction (it is, after all, the attributes, costuming, and posing that identify Morisot as a 'woman'). Morisot does not seem reluctant to take part in these depictions, but rather lends a sense of playfulness and interest to her gestures. The use of fans and veils works doubly: these props obscure her face and at the same time bear the symbolism of immediately recognizable womanhood, given their status as proper bourgeois feminine accessories.[56] Manet's bold, obscuring black strokes and dramatic flashes of white paint provide an emphatic drama to the paintings, causing the viewer to attempt against hope to get a clearer view of Morisot's face. In *Femme à l'éventail*, the brightest touches of light occur on Morisot's feet (a typical site of male fetishism), which thus vie for interest with her hand and face. If Manet did not consider these paintings portraits but rather studies of any-woman-with-props, these works function more suggestively as performances in the opposite sense of such dominant types as Madonna Ciccone – who changes her image constantly but is always irreducibly Madonna. Morisot could be accused of agreeing to the sort of typology of the enigmatic, narcissistic woman as portrayed by many nineteenth- and twentieth-century theorists, because she is willing and perhaps even eager to put the focus on her shifting appearance. I take Sarah Kofman's outline of Freud's theory:

… if woman is enigmatic, it is because she has reasons – good ones – for hiding herself, for hiding the fact that she has nothing to hide. … Her beauty, her charms would be a late and all the more precious compensation for her 'natural sexual inferiority'. The reasons women would have for wanting to be enigmatic would all link up with man's need for a certain fetishism, in which woman, her interests being at stake, would become an accomplice.[57]

Morisot could enact the double play of appealing to men's fetishistic desire for an unknowable and attractive Other and showing that she needed the trappings of artificiality and disguise to make something of herself. Her position in this period and society operated in an interesting manner when she agreed to pose for Manet – as a single, upper-class woman and talented artist she was in a position to model for Manet (under chaperone, no doubt) without taking too big a risk with her reputation, provided, of course, she kept her clothes on. She could be playful and enigmatic by altering her image with props, but the props are all intrinsic symbolic parts of the life of the upper-class French woman of the nineteenth century. She did not go so far as to suggest that she 'really' was other than conventional or that she took the performance too seriously by completely altering her image or behaving differently outside Manet's studio. In discussing one of the more controversial images Manet painted of Morisot, *Repose* (1870, Rhode Island School of Design Museum of Art, Providence, Rhode Island), Beatrice Farwell suggests the most appealing conclusion thus far: 'Morisot was embroiled, in Manet's portrait, with that freer, less circumscribed world to which he belonged and she did not. The picture balances on the edge between the two, leaving its original audience unsure about an appropriate response, and not quite knowing why.'[58]

The sense in Morisot's self-portraits is vastly different. Here the performativity of gender is less overt, and she seems not to be as interested in veiling herself, as if she knows there *is* something to hide by doing so. Although one of these paintings shows Morisot as mother (a briefly sketched oil painting of Morisot with her daughter Julie looking towards her – 1885, private collection), and another as artist (her oil *Self-Portrait* of 1885, Musée Marmottan-Claude Monet) (Fig. 3.8), the focus in most is on her face. These works stand out even in Morisot's oeuvre as less fully rendered than others. The canvas shows through, resisting any attempt to create an illusionistic surface. One of the most obvious differences between Morisot's and Manet's images is their coloration. Manet was already famous at the time of his paintings of Morisot for his interest in the effects of black tones, and they are strikingly evident in his studies of Morisot. By contrast, Morisot's works are more varied in color with an emphasis on white. 'Color … with its associations with contingency, flux, change, and surface appearance, was firmly grounded [at that time] in the sphere of the feminine.'[59] Whether or not we agree with Garb's assertion here, an interesting twist occurs when we remind ourselves of the common argument for the femininity of Impressionism as a style. Norma Broude, in her excellent book on the subject, outlines the gendering of Impressionism since its inception, when it was 'gendered as female by its conservative critics and its Symbolist rivals in the 1890s' because of its association with the sensory response to nature as shown through its use of color and line.[60]

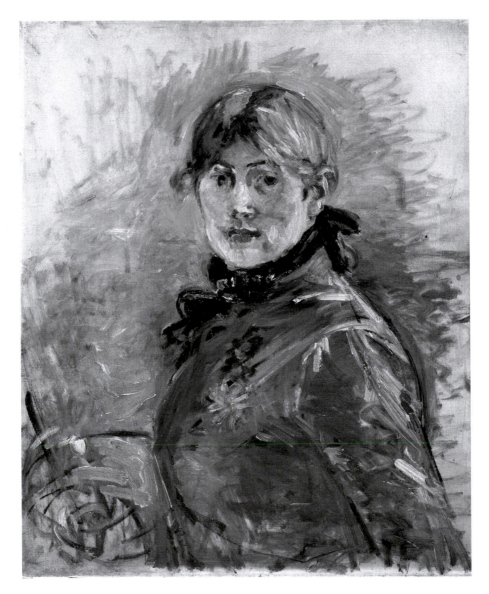

3.8 Berthe Morisot (French, 1841–1895), *Self-Portrait*, 1885. Oil on canvas, 19⅝″ H × 24″ W (50 × 61 cm). Musée Marmottan-Claude Monet, Paris, France. Photo: Bridgeman-Giraudon/Art Resource, New York

Despite the occasional effort by modernist critics to regender Impressionism as masculine in order to substantiate Abstract Expressionism's claim for dominance in twentieth-century art, the associations of femininity with Impressionism have never fully disappeared. As Manet was not a true Impressionist, and Morisot's categorization as an Impressionist has never been questioned, a good phallocentric theorist could still argue for the essential gender difference in these images of Morisot. Broude informs us that this is in fact what happened, even when compared with other Impressionists:

Berthe Morisot's paintings, for example, were consistently praised by critics of her period for qualities that these same critics objected to in the work of her male colleagues. These qualities included the quickness and fluidity of her brushwork, what appeared to be her exclusive concern for superficial sensation rather than for draughtsmanship and compositional structure, and her responsive and imitative facility. These characteristics, as the art historian Tamar Garb has shown, were part of the nineteenth century's cultural construction of femininity in general and its notion of 'feminine art' in particular.[61]

Despite Manet's veiling of Morisot and her own unveiling of herself, their distinct styles could be used to re-inject these images back into the old dichotomy: '"Impressionism" is offered as the answer to the problematic of Morisot's "femininity," the problem posed by a skilled and prolific professional woman painter in a world which deemed such activities to be "unfeminine."'[62] The emphasis here is on the word 'professional' – an amateur woman painter was not only acceptable but also highly pleasing in the bourgeois world.

Yet I think it is perhaps with the contemporary comment that the attention to surface detail and everyday life of Impressionism was ideal fodder for the superficial female that Morisot was hoping to wrestle in her self-portraits. For although the exposing of canvas or paper in those images keeps us aware of the surface plane, it also subverts it. The lack of traditional finish in these images could be used to argue that Morisot was attempting to go beneath the surface qualities of the art of painting to forge an identity. I cannot help but begin to read the revealing of the canvas or paper underneath her self-portraits as a metaphorical suggestion that there was more to Morisot than mere surface effect, that the artificiality of a traditional painting would not do justice to her image of herself. And of course it is unlikely that she would find a single image, regardless of how packed it might be with attributes (child, brushes, etc.), that she felt satisfied with as a representation of her self. If her works were 'unfinished' in either sense of the word, it could be that she felt she was, also. As we know from her failure to exhibit – or even share with friends, in some cases – these paintings, Morisot did not seem to wish to share these images with the public – perhaps she felt that, like their surfaces, they were far too revealing.

The self-portrait that Higonnet considers incomplete in terms of identity (*Self-Portrait*, 1885, Art Institute of Chicago) (Fig. 3.9) is nonetheless given a formal analysis that seems better suited to my thesis than her own:

Morisot's strokes sweep back and forth, emphasizing the evanescent nature of fragile pastel crayon marks. The sure touch of her execution and the sophistication of her color harmonies, characteristic of her best work, are here quickened to pathos. On the right of her divided face, the deep shadows at the corners of eye and mouth, the reddened rims of eye and ear, could express anxiety or exhaustion. The left side of her face, though, denies its own physical substance. Her left eye, a black smudge, bores into a dense black, cream, and brick red field, in which the face, amidst hair, background, and bow, appears as mere incident. Floating in the middle of a gray paper expanse, the image seems less constructed than in the process of being effaced.[63]

One aspect of the image that Higonnet ignores is the curious white hemispheric line that tops Morisot's head. This element increases the difficulty of reading the image, because no clear meaning can be attributed to it. It may be a halo, or the merest suggestion of a veil, but it really appears to be neither. In fact, there is a line that runs across Morisot's forehead that appears to be a fold or tear of the paper, suggesting that Morisot discarded the pastel in a careless manner and thus the white line could even be read as an extraneous mark or a first attempt. Nonetheless, this is a description of a self-portrait more interested in challenge and discernment than in masquerade. Instead of hiding behind the props of femininity she used in Manet's images of her, or depicting herself with the symbols of her success as an artist and mother, Morisot focuses on her face alone. She does not flatter herself but attempts, albeit in conventional effects of division and effacement, to get closer to some sense of her face in deeper terms than mere external appearance. Arguing that Morisot's other self-portraits are more meaningful because they depict her struggle with her professional and private selves, Higonnet finds this image lacking any but the most conventional associations: 'A codification of the self, the self-portrait obeys the parameters within which privacy may, in a given time and place, manifest itself publicly. It functions as both an act of self-revelation and an act of professional advertisement (hence the greater number of self-portraits with emblems of the trade).'[64] Stating this as the ideal (and citing Manet's images as lacking only that) Higonnet forgets, astonishingly, that Morisot never exhibited these works publicly, and therefore to argue that she was concerned with her public self-presentations in these images needs to be more solidly proven. Higonnet gives precedence to her perception of Morisot as struggling between her role as a professional woman and her role as a mother. In doing so, Higonnet ignores the possibility that Morisot may have been more interested in herself as an individual than in her public roles. What is different about this pastel self-portrait is not its

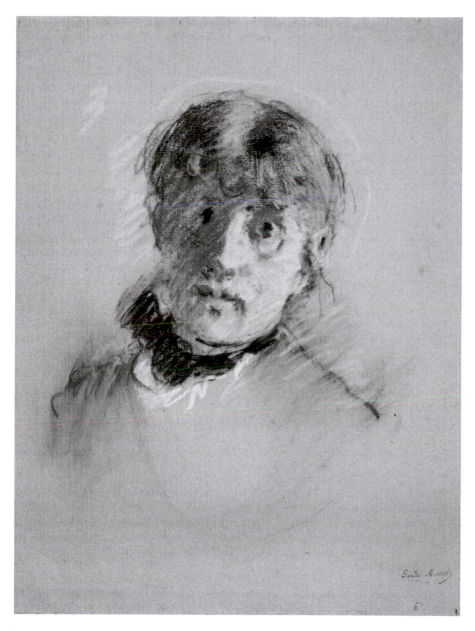

3.9 Berthe Morisot (French, 1841–1895), *Self-Portrait*, c. 1885. Pastel, with slumping, on
gray laid paper with blue fibers, 18⅞″ H × 15″ W (48 × 38 cm).
Helen Regenstein Collection, The Art Institute of Chicago, 1965. 685R.
Photo: © The Art Institute of Chicago

treatment of the face, but its status as the only image of Morisot that does not attempt to contextualize or place her within the standard identities of the day – except perhaps the identity of artist, typically gendered as male but here presented as, if anything, ungendered. Higonnet is so interested in placing Morisot in the struggle of both the nineteenth and the late twentieth centuries, the difficulty of being professional and mother at once, that she does not care to think about Morisot in an introspective or potentially struggling moment. Perhaps Higonnet needs props in the images to understand Morisot, and she thus disposes of the pastel self-portrait with either indifference or confusion, ironically tying the artist to the same association with role-playing from which she hoped to free her. Furthermore, Higonnet's assumption that Morisot's images of herself with attributes can only mean that Morisot has become comfortable with these two sides of herself is itself troubling. It is conceivable that she could view those attributes similarly to the fans and veils of Manet's paintings, or that she felt a need to incorporate them because she felt uncomfortable with them and wanted through imaging and repetition to accustom herself to them.

In my story of Morisot's self-portraits, I would like to suggest that it was not maternity that separated Manet's images from her own, as Higonnet suggests, but performativity. In assembling an identity for Manet, Morisot could call into play her gender as a performance. She was well versed by a lifetime of social tradition in the appropriate games of coyness and sexuality for a woman of the nineteenth century. These images were meant to be shown to some kind of public, as she well knew. Two of the eleven were sent to the Salon (*Repose* and *The Balcony*), and Manet sold most of the others. On the other hand, her self-portraits were never shown publicly until after her death. The solitary self-portrait in oil (Fig. 3.8) was the first to be shown, at the one-year anniversary of Morisot's death, and according to her daughter Julie Manet 'no one ever saw it; she rolled it up and left it in a wardrobe or store-room.'[65] Morisot was not constructing images of herself for public consumption, and thus did not need to perform her, or a, public self. In private, faced with the desire to represent herself for herself alone, she either gave up performance as best she could in order to locate a 'true' self, or she tried to represent her face as she saw it in a direct and unmediated way – without the veil. That the blurring of the image and its clear representation of the artist's hand have the potential to become another form of veil suggests the difficulty, or perhaps undesirability, of this enterprise.

In one self-portrait in particular, the pastel, Morisot reduces the image completely to her face and presents herself not as the 'beauty' Manet and other contemporaries, oft-quoted, found her to be, but in a less immediately categorized way. Higonnet describes it thusly: 'This woman who sees

herself in the mirror might vanish at any moment. No place, no body, no signs of class or time, almost none of gender – just a questioning gaze, soliciting nothing, remorselessly self-appraising. No flattery, no excuses, no conviction other than the necessity of looking.'[66] If Judith Butler is correct that the 'unconscious is this excess that enables and contests every performance, and which never fully appears within the performance itself,' perhaps Morisot sought, hopelessly, to uncover that self that her performances disrupted.[67] Despite her well-known conventionality in the bourgeois sense, perhaps Morisot's unconscious called her to be aware of the performance she enacted for others. Perhaps she thought that simplicity – of pose, style, and technique – would help her reveal her self to herself. The almost-vanishing sense of the pastel is not just illusory, for it calls in to mind both the real vanishing of her face in the mirror which she uses to create the self-portrait and the constant changing of face and identity over time, ending in complete loss with death. It seems as if the pastel self-portrait is the work that attempts to elude conventional image making of the time (despite Higonnet's assertion that it is the most conventional) and deconstruct her otherwise heavily mediated and 'propped-up' image. Morisot cannot elude convention entirely, as her images show, but the pastel self-portrait does its utmost to appear unmediated by the strictures of performance normally associated with her and with late nineteenth-century women more generally, even as – and perhaps because – it is mediated by the performance of art making.[68] John House supports this interpretation with his perspective on Morisot as rejecting 'the notion of *flânerie* as a defining characteristic of modern experience … to posit [instead] an alternative world in which modern woman could willfully manipulate – and abstain from – the whole business of viewing and being viewed.'[69] In this way, as a successful female Impressionist artist with a family, Morisot presents us with the complexities of self-representation that such an artist might face and the ways in which she might grapple with them.

Morisot's case makes a few things clear: prominent women painters did have studios; those studios were sometimes also domestic spaces, but not always; and even prominent women Impressionists known for painting the spaces around them did not paint their studios as such. These first two characteristics are shared by male artists of the time, making the third, representation, the only dividing issue between male and female artists. Griselda Pollock's discussion of gendered Impressionist subject matter in *Vision and Difference* does not assist us in this case; although bourgeois women painters did not have access to the cafés and brothels that many considered the spaces of modernity in the late nineteenth century, they obviously had access to their own studios. In fact, as the studio, like the academy, was becoming more accessible to women, it is surprising that

studios did not become a popular space for women to represent. A woman painter's studio was as much a harbinger of the modern era as a painting or photograph of a room full of female art students studying a nude model. Marie Bashkirtseff's *Atelier Julian* (1881, Dnipropetrovsk State Art Museum, Dnipropetrovsk), requested by Julian and submitted to the Salon of 1881, is a remarkable depiction of women studying from the nude in an all-female class. Although not the first image of an atelier of women students (Adrienne Grandpierre had submitted a painting of her husband Abel de Pujol's class of women to the Salon in 1822, and Alice Barber Stephens painted her life class at the Pennsylvania Academy of Fine Arts in 1879), it is certainly the most famous, and the event's depiction novel.[70] Photographs of ateliers like Julian's (such as *Julian Academy at rue de Berri, Atelier with Students*, 1889, André Del Debbio Collection, Paris) were much more common, and their frequent reproduction shows how remarkable such a sight was. In both cases, one of the signified elements was the growing number of women who were choosing art as a career, rather than a hobby.[71] Written accounts of the studios of women painters were as frequent as photographs (that is, not unheard of but not common), and the assumptions of a culture not yet ready to accept professionalization are heard even in this relatively approving 1891 *New York Herald* description of Lucy Lee-Robbins' studio: 'It must be owned that I had expected to possibly find a "five-o'clock tea" or "reception" kind of studio. Not a bit of it. Miss Lee-Robbins' studio is comfortable and cheerful-looking, but above all things it is the studio of a working artist.'[72] The 'dabblers' generally more acceptable to bourgeois society would not have needed a working studio space – just a corner of the drawing room, perhaps near the piano they also learned to play for parties. A studio signifies a greater degree of serious goal-oriented intent; women were not just attending academies and then dropping out to look wistfully back at their romantic holiday with art, they were taking that work home and continuing it there, in a space devoted to that work. Such societal changes are clearly representative of modernity, so the space created to accommodate them must be as well. Why, then, is that space absent from the history of nineteenth-century art as we know it?

One possibility is that discussed above – women wanted to keep this space private on some level, to allow themselves to think and produce work without the exigencies of their domestic lives. As Virginia Woolf argues so eloquently in *A Room of One's Own*, those exigencies had kept women from the world of valued creative and intellectual work for too long.[73] To make real headway as professional artists, women may have had to isolate themselves – or appear to – to really concentrate on their art. If they represented their studios more regularly, they would make those spaces more visible, and therefore more easily encroached upon by men, babies, and society's dicta. To a public equally enthusiastic to know more about artists and art and

anxious about what seemed a rapidly growing destabilization of familiar gender roles and codes, such an image may have provided too much opportunity for a sort of consuming engagement in the woman artist's space, both physical and psychic. The strategies that men engaged to bolster their societal roles (for example, claiming symbolic entitlement to their workspace by representing themselves in it) were not chosen by these women, who seemed instead to prefer avoidance of the question of a proper space for their profession. Fairchild's work thus strikes a compromising note, by showing her studio but not her body in it – her body being alluded to by the presence of her baby daughter's body, looking directly at the viewer. This direct look implies the painter/mother as its object, but also conflates the viewer with Fairchild, hence forcing the viewer into an engaged, rather than merely passively consumptive, role in the image. Without the societal changes that allowed Woolf to express her needs as a creative professional more overtly in the 1920s, Fairchild, Morisot, and other female artists were forced to speak their desires in metaphorical ways.

The Awakening: Playing Out the Possibilities in Fiction

Kate Chopin's *The Awakening*, published in 1899, provides a fictionalized parallel to Fairchild's *Dans la nursery* in its depiction of a woman struggling with the normative gender roles assigned by societal values while at the same time trying to develop her own identity and creative abilities. Chopin herself seemed to be able to reconcile the two in her own life. A well-educated woman, Kate O'Flaherty was raised in St. Louis by a group of independent female relatives. At twenty, she married Oscar Chopin, with whom she had six children and moved to New Orleans. She seems to have had positive relationships with both her husband and children, despite her occasionally independent views. On her husband's death in 1882, she took over his business and ran it herself for two years. After turning down a marriage proposal, Kate Chopin sold the business and moved back to St. Louis. There she focused her energies upon writing and raising her children. She died in 1904. Unlike her protagonist in *The Awakening*, Chopin seems to have managed quite well in juggling her husband, family, career, and other pursuits.[74]

The Awakening follows a contemporary woman's journey to self-realization. At the beginning of the novel, Edna Pontellier is the largely satisfied wife of a Creole businessman living in New Orleans. The Pontelliers are vacationing on an island in the Gulf, when a solitary swim prompts an 'awakening' in Edna's consciousness. At first, Edna links the growing feeling of dissatisfaction with her life to falling in love with a man other than her husband. When this man leaves on an extended business

trip and the Pontelliers return to New Orleans, Edna spends her days in gradually more selfish pursuits – including an increasingly serious attempt at painting – depressed by a strange longing for something other than what is available to her emotionally or physically. Eventually, Edna leaves her husband and his house for a small cottage of her own, paid for by the sale of her artworks, and changes her social circle to include some of the more marginally accepted figures of New Orleans' bourgeois society (a spinster musician, a promiscuous man who prefers married women). When the man she thinks she loves returns, she realizes that it is not him she loves, but her own independence and freedom from the restrictions of bourgeois society and its vision of the most appropriate life for women. Realizing that continuing such a life would bring scandal upon and thus hurt her children, Edna returns to the spot of her first swim to drown herself.

The Awakening and Dans la nursery are exactly contemporary, the respective creators are both women from St. Louis who led lives that both followed and diverged from bourgeois society's norms, and both works have as subject matter the interconnection of servants, children, artistic creation, and work and home spaces. Although rarely discussed in this context, Kate Chopin's The Awakening provides a useful parallel to Fairchild's painting – in both works, the artist's studio is a contested site, holding the potential for a redefinition of female roles. Unlike Fairchild, Chopin's fictional subject could play more overtly with bourgeois standards for female creativity and responsibility without suffering a 'real' societal retribution. Reading The Awakening, a novel that scandalized its fin-de-siècle audience, as a textual conversation partner to Fairchild's painting emphasizes the daring and unusual nature of the painting. Chopin's work is more evidently critical of the difficulty women faced in fulfilling their bourgeois duties and expressing themselves artistically and socially, but Fairchild clearly does not share Edna Pontellier's vision that artistic autonomy was incompatible with motherhood as the nineteenth century understood it.[75] The Awakening's protagonist, Edna Pontellier, shocked readers at the turn of the century with her individuality and her decision to choose suicide over the restrictive and devastating roles offered women at that time.[76]

One of the major symptoms of Edna Pontellier's 'awakening' to these limitations and to her own desire to live differently appears through her interest in becoming an artist. Perhaps because it is seen as merely symptomatic, literary criticism about Edna's interest in art has rarely included an examination of the works of contemporary female painters and their studios.[77] The links between art, freedom, and a separate place in which women might be able to combine the two should be studied more closely – as a writer, Chopin would clearly have linked these issues deliberately and significantly.

Near the beginning of the novel, upon Edna's return home to New Orleans from a summer resort where she first recognized a change in her thinking,

one of her first decisions is to take up painting (she had taken some lessons previously). She stops receiving callers and 'conduct[ing] her household en bonne ménagère,' instead turning her attic into a studio and pressing her servants to model for her.[78] Her husband responds to Edna's neglect of her wifely duties with shock and anger: 'Then in God's name paint! but don't let the family go to the devil.'[79] As Mr. Pontellier begins to wonder if his wife has not lost her mind, Edna turns to art as a way to express her growing individualism and consciousness. The spaces she chooses for this are significant, for they too portend of her growing separation from bourgeois norms. Her work begins in an atelier at home, 'a bright room in the top of the house. She was working with great energy and interest, without accomplishing anything, however, which satisfied her even in the smallest degree. For a time she had the whole household enrolled in the service of art.'[80] Edna's early dedication to her art combines the domestic and the artistic completely – she paints at home, and her subjects are her children and servants. And although the first description of the Pontellier house is through the eyes of a proud man surveying his beautiful possessions (with the strong sense that his family is among them), when Mr. Pontellier leaves for an extended business trip, Edna senses 'a feeling that was unfamiliar but very delicious [coming] over her. She walked all through the house, from one room to another, as if inspecting it for the first time.'[81] Once she is able to feel a level of ownership and control over all of her domestic surroundings, rather than just her studio, Edna begins to awaken even more thoroughly.

The happiness Edna feels when her husband is away does not last, however, and her increasingly physical relationship with another man almost immediately results in Edna's decision to move, alone, to a small house around the corner. At first, Edna justifies this move by expressing to Mademoiselle Reisz (the pianist who first inspires her artistic awakening through a performance of Frédéric Chopin at the outset of the novel) her exhaustion with maintaining a large household, and her feeling that nothing in the house is truly hers.[82] However, she soon realizes that her true reason is a desire to escape the feeling that her husband in some way owns her as long as she remains in his house. This move is possible because Edna has put away some money and is beginning to sell her artworks: '"Laidpore is more and more pleased with my work; he says it grows in force and individuality. I cannot judge that myself, but I feel that I have gained in ease and confidence. However, as I said, I have sold a good many through Laidpore."'[83] Edna's art is both a symptom of and an excuse for her budding freedom from conventional bourgeois women's roles, and her art improves with her consciousness.

Throughout the text, Edna describes her painting not only as art but also as work – an exercise of labor with a goal of self-awareness. Although she does not think herself an exceptionally talented artist, this effort becomes one of her most valued engagements. As she discusses this with the one female

friend – Mademoiselle Reisz, a professional musician – who seems to share her 'radical' interest in independence, Reisz warns Edna that her artistic drive requires both talent and a 'courageous soul' that 'dares and defies.'[84] In other words, a soul that Edna's lifestyle would not normally permit. To have this soul, Edna must change her surroundings, jettisoning the trappings of bourgeois domesticity for a small 'pigeon house' in which she can do her own work by herself.[85]

Mademoiselle Reisz, the chief artistic model for Edna, lives in isolation in an apartment 'under the roof' that is small and dingy but whose windows look out upon the river and its commerce – signaling a greater awareness of the outside world than that from the bourgeois housewife's verandah or perhaps presenting a view open to artists as opposed to housewives. The focal point of the apartment is Reisz' piano; she has sacrificed comfort and appearances for her art.[86] Edna feels most emotionally alive there, until she moves into her own house. The lesson is clear: an artist needs to be isolated to create worthwhile art, and a woman must not be forced into the many obligations of maintaining home and children if she is to be an artist. Reisz is an imperfect model for Edna, however, because she is an 'old maid'; she has chosen her art even above the physical and emotional nourishments of love, or for that matter any kind of community. Other than Edna, no one visits Reisz; she is alone, and if art cannot be shared with others (displayed at the Salon or given in a concert hall), it becomes too self-indulgent – no real changes occur. In many ways, it is Edna's youthful selfishness that makes her quest so problematic. Her children are as marginalized in the text as her servants. Edna is unwilling to live a life that excludes her own choices – of sexual partners, of communities, of freedom from household decisions and chores, of freedom from responsibilities to children.

Chopin's heroine chooses death over compromise – she cannot satisfy both her longing to focus on her own needs and her desire to connect with others without giving something up – as Barker puts it, 'she does not simply trade the role of wife and mother for that of the artist; instead, she rejects the limitations and assumptions of both roles.'[87] Unlike Edna, both Chopin and Fairchild did find a way to combine these things. As Margo Culley argues, 'the [Solitary] soul is a female soul, characteristically defined as someone's daughter, someone's wife, someone's mother, someone's mistress. To discover solitude in the midst of this connectedness is surely among the most painful of awakenings, because the entire social fabric sustains the dream and the illusion.'[88] Edna cannot see a way to combine her motherly and other societal duties with her artistic/self-expressive self. Although she has a great many advantages, such as a studio space, money, servants, and interested suitors, Edna knows that her full self-expression would include some failure of responsibility toward her children, and she is unwilling to sacrifice her needs for theirs.

Fairchild and Chopin, as real rather than fictional women, chose to stay and fight. But Chopin's novel makes it clear that such a fight was not subconscious, or easy, or the same for every woman. As Suzanne Wolkenfeld states,

The richness of Chopin's vision of life comes from her awareness of the many paths to self-realization from which to choose, each one involving compromise and renunciation. ... Chopin, as wife, as mother of six children, and as writer, is herself an affirmation of the many modes of living a woman can attain – each limited, each problematic, each real.[89]

Unlike other women artists of the late nineteenth century, both Fairchild and Chopin chose to represent this struggle overtly but without the clichés to be found in more typical representations of the woman artist as a passive, possibly unbalanced, probable victim of so-called bohemian artistic life.[90] Chopin chose to create a fictional character whose choices differed from her own – to experiment with some of the issues contained in the struggle. Fairchild, whose work is so much more overtly self-referential, chose to represent the possibility of achieving more than one type of self. In effect, Fairchild's painting can be read as a positive response to Edna's negative one: yes, one can be a mother, wife, household manager, and successful artist. Fairchild's step was bolder than Chopin's, as she chose to show herself, rather than a fictionalized woman; any criticisms that might have been launched at her work would have been all the more obviously launched at her, as well. Yet there were no criticisms of this work beyond Helen Cole's supportive nod in the July 1899 *Brush and Pencil* article, despite its having been shown at the Salon and the Pennsylvania Academy of Fine Art. Where Chopin's book was an immediate scandal, Fairchild's painting received no negative response. Rather, it was accepted at the Salon.[91] Fairchild's affirmation of her ability to juggle both spheres of social experience did not cause society to reel at her hubris nor condemn her for her cynicism, as it had Chopin for Edna's suicide or Cassatt for her image of 'Modern Woman' at the 1893 Exposition; perhaps society was easing toward acceptance of the possibility; perhaps the foils of child and servants effectively squelched a negative reading, as it seems to have done in Cole's assessment. Nonetheless, the representational gambit, like the female artist, went largely ignored.

The Unexceptional Woman

Late nineteenth-century bourgeois women were indeed largely restricted to the domestic sphere, both physically and intellectually. Yet we have many examples of women who broke through these restrictions. And these examples do not include only independently wealthy women, women whose families were unconventional, lesbians and bisexuals, or women who chose

careers instead of marriage and children. Having nearly all of these qualities and acquiring some others along the way, Rosa Bonheur became the most famous and popular woman artist of the nineteenth century. Because she broke entirely with typical conventions for women, society could on some level accept her as a fascinating anomaly. Mary Cassatt, Berthe Morisot, and Cecilia Beaux also fit into this pattern in one way or another, despite their maintenance of bourgeois conventions otherwise. As a result, we have focused our attention upon them and hence ignored the women artists who more closely fit societal conventions. Griselda Pollock calls us to a better practice: 'What this means is that ... new significations will not emerge either from a repressed culture of those always-already women, nor from a position of radical alterity, outside the system.'[92] Among this crowd of ignored women artists there are revolutionaries, women who saw themselves differently than either binary social constructs or strictly monitored exceptionalism would seem to allow. Mary Fairchild was neither an anarchist nor an angel of the house, neither a dabbler nor a solitary tortured genius. In the late nineteenth century, the majority of women artists were representing themselves either without any references to their professional status, with veiled references, or with standardized references typical of male artists (Perry's self-portrait with brush and canvas). Male artists who painted them almost exclusively avoided even the standardized references, focusing instead on the women themselves (and, usually, their attractiveness) rather than on their status as artists. Fairchild eclipses these representations by painting her studio both as a site of domesticity, fitting her role as a bourgeois wife and mother, and as a site of artistic creation, fitting her role as a professional artist.

Recognizing and re-evaluating Fairchild's act as a radical declaration for women artists – one that demanded professional autonomy and respect for a variety of skills – helps us reconsider women artists specifically and all artists generally. Fairchild fitted the profile of the forgotten nineteenth-century woman artist perfectly, even to the extent that in the collections that include her there is a sense that she perhaps *deserved* to be forgotten. Having none of the singular status accorded Mary Cassatt, Berthe Morisot, or Rosa Bonheur, Fairchild became obscured not only by her position as a woman in a patriarchal society, but also by her very ability to juggle a professional career with her marriages and children. Her husbands' fame caused their names to eclipse her own, so that when researchers attempt to find her, they can only and repeatedly find Frederick MacMonnies and Will Hicok Low instead. After her death, Fairchild's paintings became as entangled in her husbands' histories as her name had been. Part of the reason for the lack of discussion is that there were so many images by male artists of their studios that it was easy to see the whole field as flooded, rather than take note of just by whom it was flooded. This caused the false attribution of Fairchild's painting to her husband, because it seemed 'natural' to assume that he would represent

his workspace, while she would not.[93] Historians took for granted that the photographs of women's studios, combined with the few self-portraits, covered the issue of self-representation significantly, thereby ignoring the fact that studio paintings were a major and popular subject matter in the late nineteenth century. So, because of the gendered and masculinist perspectives that have historically devalued and misunderstood both her art and women artists generally, Fairchild was forgotten, and her erasure still generally accepted by art historians.

Once found, Fairchild's work reflects and contributes to significant nineteenth-century concerns about art, the female artist, and women in general. Applying the standards of gender essentialism to her fails to advance our understanding of her work beyond a simple resuscitation. Fairchild's unique interest in displaying her workspace as such, undisguised by a veneer of leisurely indifference and giving equal credence to domestic and artistic labors, signals the coming of a new type of self-image rather than the reification of old standards. The 'New Woman' of the Progressive Era was already coming on the scene, and such changes undoubtedly provoked the censorious response to Chopin's *The Awakening*. Like Edna Pontellier, increasing numbers of women artists were unwilling to disappear behind domestic façades in order to maintain the illusion of separate spheres. Such a challenge could only be seen as a threat to the established order of the time, so it is no surprise that it was either repressed (in the case of *The Awakening*) or neglected (in the case of Fairchild's work). Now that we understand the separate spheres to be constructed, we have no reason to reify them in our analyses of the art and literature of the time.

Notes

1. A significantly shorter version of this chapter appeared as 'No Room of One's Own: Mary Fairchild MacMonnies Low, Berthe Morisot, and *The Awakening*,' in *Prospects: An Annual of American Cultural Studies*, ed. Jack Saltzman, Cambridge University Press, vol. 28 (2004), pp. 127–54.

2. I am using the title that was initially adopted when the work was reattributed to Fairchild in the 1980s, because its content clearly aligns with that implied by the title of a work Fairchild exhibited the painting at the Salon National des Beaux-Arts in 1899. A 'society brief' section on artists in the 29 August 1896 edition of the *Chicago Evening Post* describes an untitled painting Fairchild was working on in Paris of 'a corner of her own nursery, with life-size portraits of her baby and his [sic] nurse.' This is clearly not the same painting; however, Fairchild exhibited two different paintings with similar titles at the Pennsylvania Academy of Fine Arts: *The Nursery* (#214) in 1896–97 and *In the Nursery* (#117) in 1899–1900. No second painting matching the description of the work mentioned in the *Post* has to my knowledge been publicly exhibited, so perhaps this is lost. Nonetheless, the date and coincidence of themes here are persuasive that this painting was one of a group of such images Fairchild worked on while Berthe was a baby.

3. See Ringelberg, 'No Room of One's Own'; and Ringelberg, 'Risking the Incoherence of Identity: Locating Gender in Late Nineteenth-Century Paintings of the Artist's Home Studio' (PhD dissertation, University of North Carolina at Chapel Hill, 2000); see also Derrick R. Cartwright, 'Beyond the Nursery: The Public Careers and Private Spheres of Mary Fairchild MacMonnies Low,' in *An Interlude in Giverny* (exhibition catalogue, University Park PA: Palmer Museum of Art and Pennsylvania State University, and Giverny (France): Musée d'Art Américain Giverny and

Terra Foundation for the Arts, 2000), pp. 31–56. See also William H. Gerdts, *Lasting Impressions: American Painters in France 1865–1915* (New York NY: Terra Foundation for the Arts, 1992), p. 182 (entry by Jochen Wierich); E. Adina Gordon in *Frederick William MacMonnies (1863–1937), Mary Fairchild MacMonnies (1858–1946): deux artistes américains à Giverny* (exhibition catalogue, Vernon (France): Musée Municipal Alphonse-Georges Poulain, 1988), p. 97 (note that Gordon attributes the painting to Frederick MacMonnies). For information on Mary Fairchild MacMonnies Low, see Mary Smart's 'Sunshine and Shade: Mary Fairchild MacMonnies Low,' *Woman's Art Journal*, vol. 4 (Fall 1983–Winter 1984), 20–25; and Smart, *A Flight With Fame: The Life and Art of Frederick MacMonnies (1863–1937)* (Madison CT: Sound View Press, 1996).

4. In Gordon's catalogue entry for *Frederick William MacMonnies, Mary Fairchild MacMonnies*, p. 97, and in William Gerdts' *Monet's Giverny: An Impressionist Colony* (New York NY: Abbeville, 1993), p. 136.

5. In Jochen Wierich's commentary in Gerdts, *Lasting Impressions*, p. 182.

6. Email correspondence with several Puvis specialists confirmed my [lack of] findings – none was aware of a work like this.

7. One of these rectangular works, probably the lower right panel, was available at auction in September 2007 at Christie's in New York. It was listed as *Study for 'Dans la nursery'* by Fairchild (28 × 52½ inches / 71 × 133.3 cm), but did not sell. It should probably be renamed *Study for 'Primitive Woman.'* As this book went to press, I had placed a request with Christie's to have the anonymous owner contact me, with no reply. However, the image is visible on a variety of art auction websites like <askart.com>. An article in the *Chicago Inter-Ocean* of 12 March 1893 mentions that 'more than forty different designs and studies were prepared before the artist settled upon the composition' and 'her first thought was to make the picture allegorical – semi-angelic pre-Edenic womanhood.' The same article, interestingly, mentions that 'when someone questioned if she had not assisted the sculptor [MacMonnies] in his designs she gave a prompt and somewhat indignant denial.' It is surprising to see the gender tables turned on the normative nineteenth-century argument that women artists must have gotten all their ideas and a lot of help besides from the male artists in their lives.

8. This study was recently unearthed and attributed by Derrick R. Cartwright when he was director of the Musée Américain at Giverny. See Cartwright, 'Beyond the Nursery.'

9. Mary Smart and William Gerdts have previously argued that the painting was probably made in the MacMonnieses' rented and then purchased home *Le Prieure* in Giverny. However, according to Smart, correspondence between MacMonnies and Fairchild suggests the cottage building had not been transformed into a studio at the time of the painting (most likely 1896–97 due to the age of Berthe Hélène in the picture), even though the proportions of the space and the placement of the studio window in the painting are identical to those of that studio as seen both in a photograph given to me by the current owners (Fig. 3.1) and my own experience of that building's interior space. As the painting was submitted to the SNBA in 1899, however, Smart's date for the building, based on correspondence between MacMonnies and Fairchild, would not match up with the painting. The dating of the image by Berthe's age certainly suggests that if this is Giverny, it is likely that the Villa Bêsche is the site, although I could not locate enough information about its layout to be empirically certain. Smart then suggested their winter home in Paris, 44 rue de Sèvres. That building's façade does not currently include a skylight, but it has been renovated. A larger sculpture studio on the property for MacMonnies's use appears, in a photograph printed in a *New York Times* article on MacMonnies on 1 August 1897, to have a quite different layout and larger skylights; furthermore, no artwork beyond his sculptures appears in the space (and no tapestries on the walls). In Edith Petit's 29 October 1906 article 'Frederick MacMonnies, Portrait Painter,' she states that 'two or three years ago anyone visiting Mr. MacMonnies' studio would have found himself in a huge, dusty, barn-like workshop, filled with all the unsightly paraphernalia of a sculpture' (p. 319) and 'A series of decorative panels, a few portrait studies, and some charming random sketches were all the visible signs of his interest until two or three years ago' (p. 324); the article continues with a line that is supported by his body of paintings – that his emphasis in painting, as in sculpture, is on the portrait (*The International Studio*, pp. 319–24). This seems to make the location of this work in MacMonnies's studios unlikely. Derrick Cartwright suggested to me in conversation that perhaps the information Smart has for the studio building is in fact for the *later* renovation of MacMonnies's large sculpture studio on the other side of the Giverny grounds, and what little information exists on that renovation seems to support his suggestion. My own independent assessment of Fairchild's small painting studio on the Giverny property had convinced me that this must have been the location of the painting, given the exact correlation of proportions and scale between the painting and this space. To further reinforce the attribution of the work to Fairchild, documentation on MacMonnies's painting and teaching activities at *Le Moutier* never mention using Fairchild's studio, but emphasize rather plein air painting or work in his home or larger studio, and none of his paintings show the room depicted in *Dans la nursery*.

However, it continues to be possible that Fairchild's painting shows studio space in Paris, as she was still splitting her time between both places at this point. Additionally, MacMonnies was largely absent, traveling and conducting an affair with Helen Glenn that resulted in an illegitimate child born in Fall 1897.

10. In Fairchild's unpublished memoirs, found in the Mary Smart Papers in the Archives of American Art, on page 149 Fairchild mentions that she had a studio in the Paris apartment that adjoined the principal bedroom and also that the family was assisted by a butler, cook, and chambermaid while there.

11. Elisabeth Vigée-Lebrun and Berthe Morisot are the two women artists most commonly thought to use this strategy, although even Mary Cassatt (a single woman with no children) has been said to have chosen her subject matter with an eye to establishing and legitimating her role as a 'proper' woman with appropriately maternal and domestic interests. See Griselda Pollock and Roszika Parker, *Old Mistresses: Women, Art and Ideology* (New York NY: Pantheon, 1981); and Tamar Garb, *Sisters of the Brush: Women's Artistic Culture in Late Nineteenth-Century Paris* (New Haven CT: Yale University Press, 1994). A more complex reading of Vigée-Lebrun's self-imaging is undertaken by Mary D. Sheriff in *The Exceptional Woman: Elisabeth Vigée-Lebrun and the Cultural Politics of Art* (Chicago IL: University of Chicago Press, 1996).

12. Ruth E. Iskin, 'Was There a New Woman in Impressionist Painting?' in *Women in Impressionism: From Mythical Feminine to Modern Woman*, ed. Sidsel Maria Søndergaard (Milan: Skira, 2007), pp. 189–223; at p. 210. The conversation on Impressionist women artists and their depicted servants was begun in Linda Nochlin's essay 'Morisot's Wet Nurse: The Construction of Work and Leisure in Impressionist Painting,' in T.J. Edelstein, ed., *Perspectives on Morisot* (New York NY: Hudson Hills Press, 1990), pp. 91–102; it is continued in Harriet Chessman's 'Mary Cassatt and the Maternal Body,' in *American Iconology: New Approaches to Nineteenth-Century Art and Literature*, ed. David C. Miller (New Haven CT: Yale University Press, 1993), pp. 239–58.

13. Helen Cole, 'American Artists in Paris,' in *Brush and Pencil*, vol. 4, no. 4 (July 1899), 199–202; at 201.

14. I wish to make it clear that when I am speaking of overt representations of the studio, I mean those images in which viewers can tell they are looking at a studio, rather than a mere room. Although we may very well be looking at a female artist's studio when she depicts her mother and sister sitting on overstuffed chairs, serving from a silver tea service, if we cannot distinguish that space from any other domestic space, then we do not *know* that we are in fact seeing her studio. The majority of male painters' studio representations during the late nineteenth century clearly referred to art making, displaying, and/or purchasing. The images contain lounging models or patrons, various works of art both original and copied, and an easel or other apparatus. Even when they do not, as in William Merritt Chase's *A Friendly Call* (1895, National Gallery of Art, Washington DC), a critic leaps to the rescue, ensuring that the viewer will see that space as a studio first and as a domestic space second, or the sheer number of other studio images by male artists provide that reading as an omnipresent possibility. There are almost no such overt images by female artists of this time, and none by artists considered significant in current nineteenth-century art history. I am hoping this latter distinction will change, and although she does not fit my parameters of study here, Asta Nørregaard is an artist who deserves fuller consideration in this regard. Her painting *In the Atelier* (1883) is briefly mentioned by Siulolovao Challons-Lipton in *The Scandinavian Pupils of the Atelier Bonnat* ('an image that summarises Bonnat's influence on his Scandinavian students. Asta stands in her studio in Paris looking at her finished altarpiece of Gjøvik Church, the only official commission granted to a Norwegian painter before 1900' and 'The painting is an extraordinary demonstration of professionalism and capability' (Lewiston NY: Edwin Mellen Press, 2001), pp. 166–7). A more full and fair treatment of her (and this painting) is to be found in Anne Wichstrom's 'Asta Nørregaard: Aspects of Professionalism' in *Woman's Art Journal*, vol. 23, no. 1 (Spring–Summer, 2002), 3–10.

15. Marie Bashkirtseff's *Self-Portrait with a Palette* (c. 1883, Musée des Beaux-Arts, Nice, France) depicts the artist in a frontal, half-length pose, holding the nominal palette down by her waist. The area behind her is almost entirely opaque, except for a rectangle of gray that offsets a harp placed before it. See Louly Peacock Konz, *Marie Bashkirtseff's Life in Self-Portraits (1858–1884): Woman as Artist in Nineteenth-Century France* (Lewiston NY: Edwin Mellen Press, 2005), pp. 103–9. Lilla Cabot Perry's *Self-Portrait* (1891, Terra Museum of Art, Chicago) offers slightly more detail, as behind Perry we can see what appears to be either a painting or a window through which one can see a figure in a landscape of grass and a tree, shading his eyes as he looks at the artist. Martindale suggests that the figure 'possibly represents Perry's husband making ineffectual attempts to divert her from her art,' although she does not say why she arrives at this interpretation (Meredith Martindale, *Lilla Cabot Perry: An American Impressionist* (Washington DC: National Museum of Women in the Arts, 1990)).

16. Lest the reader think this trend of publishing emphasis on male over female studios ended in the nineteenth century, Liza Kirwin's 2007 book *Artists in Their Studios* (New York NY: Collins Design), which mined the Archives of American Art's collection for letters and photographs of prominent artists' studios, features 74 late nineteenth- and early twentieth-century artists with photographs of their studios. Of these 74 (not counting the nine men shown in a group on page 63), only 11 are women, and most of these are twentieth-century artists. Chase appears, naturally, but none of the women painters mentioned in this book do – there are a few sculptors, including Enid Yandell who studied with MacMonnies. Most depressingly, the entry on Lee Krasner is really an additional entry on Pollock and the studio shown as hers was originally his. Wives of male artists are discussed and even shown (and in many cases were artists themselves, some quite well known like Agnes Martin), but the gendered imbalance of the photographic entries is generally amplified by their textual accompaniments.

17. Gerdts, *Lasting Impressions*, p. 64; and Gerdts, *Monet's Giverny*, pp. 134–6 and p. 237 fn 49. Gerdts and Mary Smart agree on this reattribution, contrary to E. Adina Gordon, an independent scholar who, while working on her dissertation on MacMonnies's sculptural works, authored the checklist in Smart's *A Flight with Fame*. Although she has not published her arguments, it is probable that Gordon is behind the re-reattribution of Fairchild's paintings to her husband; in 2002 we were both invited to present on the attribution question at the Terra Museum in Chicago, and after borrowing a copy of my dissertation, Gordon presented arguments that are similar to those now listed on the (anonymous) Terra website as outlined in my Introduction. Focus in the past had been on whether or not MacMonnies had begun painting seriously at the time these works were made; to me, this argument is irrelevant because it does not prove the authorship of these particular works, nor does it challenge Fairchild's authorship.

18. Berthe MacMonnies had inventoried the works that her father had left in Giverny in 1927, and according to Mary Smart, no paintings with matching or similar titles appear in that inventory. Fairchild took her work with her when she left France, but upon her daughter Berthe's death, her works were inherited by granddaughter Marjorie, who stored both her grandmother's and grandfather's works together. Confusion could have occurred at any point, as it so often does.

19. Christine E. Finkelstein, who wrote Fairchild's biography and catalogue raisonné (entitled 'Mary Fairchild MacMonnies Low') for her master's thesis in museum studies at City College of New York in 1989, simultaneously credits MacMonnies with the two paintings, concurs with Sophie Fourny-Dargére (curator of the Musée Municipal Alphonse-Georges Poulain in Vernon, which held the first exhibition of these works together in 1988) on another painting, *La Repriseuse*, clearly painted at the same time and by the same hand as the other two works, as attributable to Fairchild, and lists the works shown by Fairchild at the SNBA (Finkelstein, 'Mary Fairchild MacMonnies Low,' pp. 45–9). William Gerdts and Mary Smart argue that MacMonnies did not start painting in earnest until approximately 1900 (an argument backed up by all the contemporary press), which point made the connection to Fairchild's SNBA entries more persuasive. Smart also pointed out that no relevantly titled paintings show up in the list of paintings MacMonnies did exhibit after 1900, and that this list is extensive and seems comprehensive, particularly when added to the list of works found in Giverny later (Fairchild took her work with her, and the only works she left behind were left to the proprietors of Giverny's Hotel Baudy or to the museum in Vernon, or with Marthe Lucas). Although I believe from my research that MacMonnies painted before 1900, the extant, clearly attributed and dated paintings he made throughout his career are all quite distinct from this work and none appear to be of the family during the time that Berthe was the age she is in *Dans la nursery*. On the other hand, we have ample regularly exhibited works by Fairchild at this time and with this subject, as noted above and in Finkelstein: 'As Betty [Berthe] approached her first birthday there began to appear in the scrapbooks of exhibition reviews kept by her mother references to paintings that featured the baby, oftimes with her nurse' ('Mary Fairchild MacMonnies Low,' p. 42).

20. *Normande en costume avec son chat* (c. 1909, Musée Municipal Alphonse-Georges Poulain, Vernon) (Fig. 3.2), an ivory miniature, shows Fairchild's skill with detail, more than one medium, and a more academic style of painting. *The Breeze (La Brise)* (1895, Daniel J. Terra Collection, Terra Foundation for the Arts) (Fig. 3.3), a decorative image in an Art Nouveau style, depicts a swirling female figure swathed in draperies painted *en grisaille* against a blue background covered in silver lines. Fairchild exhibited this painting at the 1895 Salon Nationale des Beaux-Arts, and won a bronze medal for it in the 1901 Pan-American Exposition in Buffalo, New York.

21. An untitled landscape and *Woman in White under an Arbor* are also cited as examples of this practice in Finkelstein, 'Mary Fairchild MacMonnies Low,' p. 19.

22. This painting was published in color on the cover of the exhibition catalogue *Frederick William MacMonnies, Mary Fairchild MacMonnies*.

23. I should say that Gordon, in her checklist for Smart's *A Flight with Fame*, attributed *French Nursemaid and Baby Berthe* to MacMonnies, but the Post Road Gallery, which owned this work after that publication and gave me a transparency of it, attributed it to Fairchild. The painting was purchased and is now in a private collection whose location is unknown to me. David Bahssin at the Post Road Gallery thought it had been purchased, eventually, by Daniel Terra; however, Katie Bourguignon at the Musée Americain could not locate it in the Terra collection. Finkelstein dismissed the issue of the similarities between works we know to be by Fairchild and some assumed but not proven to be by MacMonnies by pointing out that Will Low, in his essay recounting a year spent at the 'MacMonastery,' talks of how he, Fairchild, and MacMonnies all painted the same view side by side on several occasions, albeit in different styles. Thus the similarity of other paintings to *Dans la nursery* must mean that Fairchild and MacMonnies were painting the same scene simultaneously. However, it is clear from reading Low's essay that the group only rarely painted together and primarily outdoors, and his essay was written in 1902, quite a few years after these paintings were made (Will H. Low, 'In an Old French Garden,' in *Scribner's Magazine*, vol. 32 (July 1902), 3–16). Furthermore, the date of the painting coincides with a period during which MacMonnies was often traveling abroad or otherwise away from home, as Smart mentions in *A Flight with Fame*. Although paintings by MacMonnies have been linked to the same period, the dating of these must be called into doubt; for example, *The French Chevalier* is dated to 1901, but a nearly identical painting, *Berthe with Doll Amelia*, is dated to 1898–99. In both images, Berthe has a bow on either side of her head holding her hair in the exact same style and length. She is also wearing the same or a nearly identical dress and carrying the same doll in both, and could be no more than one year older or younger in each image respectively. In the latter individual portrait as currently dated, Berthe would have to be three to four years old, and in the former, six, but she looks exactly the same age in both – older than she appears in the signed Fairchild painting *Portrait of Berthe Hélène MacMonnies* that has been dated to 1898. It seems clear to me that *Berthe with Doll Amelia* should be re-dated to 1900 at the earliest and probably 1901, which coincides with all the similarly styled and themed paintings by MacMonnies, as well as two c. 1901 photographs of Berthe – one in precisely this outfit and hairstyle – published in *An Interlude in Giverny*. Berthe's apparent age in *Dans la nursery*, which was probably painted in 1896 or 1897 when Berthe would be one to two years old, is quite distant from the age of *Berthe with Doll Amelia*, not merely one to two years older. I apologize to the reader for not providing all of these images, but most are in private collections and my many efforts to locate permissions for them met with no response. All are available for viewing in either *Frederick William MacMonnies, Mary Fairchild MacMonnies* or *An Interlude in Giverny*.

24. MacMonnies's paintings rarely show the interior of his larger sculpture studio, but often show the interior of the main house at *Le Prieure* – which the MacMonnies did not rent or own when *Dans la nursery* was made. This is also where Fairchild herself shows him having a studio in her *Frederick MacMonnies in his Studio* (undated, oil on canvas, 15 × 18 inches / 38 × 45.7 cm, private collection); a simple glance at this signed painting shows MacMonnies, some of his paintings and sculptures scattered around the room, and a completely different, much larger room than that shown in *Dans la nursery*. The easel that she shows in his studio, with one of his works recognizable upon it, is a much simpler one than that shown in Fairchild's studio painting. Its existence also reinforces the fact that Fairchild *did* make paintings of studios, something that the Terra website denies.

25. In fact, this point also strengthens the attribution of this work to Fairchild rather than MacMonnies: in the three paintings attributed to MacMonnies which show Fairchild, *none* of them show her as an artist. Rather, all three emphasize her as either a marginal figure (*Monsieur Cardin*, 1900–01, Berry-Hill Galleries, New York, and *The French Chevalier*, 1901, Palmer Museum of Art, University Park, Pennsylvania) or as a bourgeois mother of leisure (*Mrs. Frederick MacMonnies and Children in the Garden of Giverny*, 1901, Musée des Beaux-Arts, Rouen). In the first two, Fairchild is placed in the far background, in both cases sticking her head through a door as she enters the room, with only a small portion of her body visible. In the third work, a study, Fairchild's position is more prominent in the front left of the picture plane, but she reclines in the middle of a garden path, resting one arm on Marjorie – the passive, maternal, and stereotypically limited role Fairchild plays here shows MacMonnies representing his wife in precisely a Veblen-ized way, representing leisure and status that would be assumed, without other signifiers to the contrary, to be created by *his*, rather than *her*, success and labor (the nearby servant and chic clothes reinforcing the tale). Nowhere in MacMonnies's limited collection of paintings is Fairchild shown in any other way than as 'his wife,' and he never depicts her studio.

26. See Albert Boime, 'The Case of Rosa Bonheur: Why Should a Woman Want to Be More Like a Man?' in *Art History*, vol. 4, no. 4 (December 1981), 384–409; Tamar Garb, 'L'Art Féminin': The Formation of a Critical Category in Late Nineteenth-Century France,' *Art History*, vol. 12, no. 1 (March 1989), 39–65; and Garb, *Sisters of the Brush*. See also Dore Ashton, *Rosa Bonheur: A Life and a Legend* (New York NY: Viking, 1981).

27. See Bailey Van Hook, *Angels of Art: Women and Art in American Society, 1876–1914* (University Park PA: Penn State University Press, 1996), or for that matter nearly any nineteenth-century art criticism which touches the subject.

28. Eleanor Greatorex, 'Mary Fairchild MacMonnies,' *Godey's Magazine*, vol. 126, no. 755 (May 1893), 630.

29. Derrick R. Cartwright and I both came to this conclusion independently in separate publications in 2000, giving credence to the painting's call for such an interpretation. Of course, depictions of rooms filled with both mirrors and paintings intended to refer to other artists and to art making itself were tremendously common throughout the nineteenth century, and Impressionist artists were avid practitioners of the habit, as for example Edgar Degas's *The Belleli Family* (c. 1860), whose references to both Velázquez and Degas himself were noted by Theodore Reff in 1968 ('The Pictures within Degas's Pictures' in *Metropolitan Museum Journal*, vol. 1, 125–66).

30. For more on domestic servants in the nineteenth century, see Elizabeth O'Leary, *At Beck and Call: The Representation of Domestic Servants in Nineteenth-Century American Painting* (Washington DC: Smithsonian Institution Press, 1996); Susan Strasser, *Never Done: A History of American Housework* (New York NY: Pantheon, 1982); and Faye E. Dudden, *Serving Women: Household Service in Nineteenth-Century America* (Middletown CT: Wesleyan University Press, 1983).

31. Fairchild also played several musical instruments, including the harp and the piano. Will Hicok Low painted his first wife Berthe and future second wife Fairchild playing these two instruments together at the Giverny house.

32. See Griselda Pollock, 'Modernity and the Spaces of Femininity,' in *Vision and Difference: Femininity, Feminism and Histories of Art* (London: Thames & Hudson); and Robert L. Herbert, *Impressionism: Art, Leisure, and Parisian Society* (New Haven CT: Yale University Press, 1988).

33. Perhaps, as seemed to be the occasional case with Berthe Morisot described later in this chapter, Nourse used the screen as a partition between the part of a room in which she painted and the part in which she entertained. I am aware of Elizabeth Rebecca Coffin's *Artist and Model in the Studio* (c. 1890, Nantucket Historical Association), but until the painting is definitively attributed as a self-portrait I am reluctant to add it to the list here, although I am somewhat persuaded by Margaret Moore Booker's argument in that direction: see *Nantucket Spirit: The Art and Life of Elizabeth Rebecca Coffin* (Nantucket MA: Mill Hill Press, 2001).

34. Berthe Morisot used the painting-within-a-painting tack to refer to herself in several publicly displayed paintings, as Higonnet points out in 'The Other Side of the Mirror' in Edelstein, *Perspectives on Morisot*. These references are not immediately obvious to the eye, however, and the public would have known only one at the time.

35. Sarah Burns, 'The Price of Beauty: Art, Commerce, and the Late Nineteenth-Century Studio,' in *American Iconology: New Approaches to Nineteenth-Century Art and Literature*, ed. David C. Miller (New Haven CT: Yale University Press), p. 230.

36. Barbara Weinberg et al., *American Impressionism and Realism: The Painting of Modern Life, 1885–1915* (exhibition catalogue, New York NY: Metropolitan Museum of Art, 1994), p. 41.

37. Quoted in Ronald G. Pisano, *William Merritt Chase: Portraits in Oil*, vol. 2 (New Haven CT: Yale University Press, 2006), p. 51. It should be noted that some critics disagreed with this assessment, although the other critic quoted in Pisano as suggesting Chase had captured Wheeler's personality described that personality as sphinx-like, with a piercing gaze and no betrayal of feeling or self-disclosure.

38. T.J. Clark, *The Painting of Modern Life: Paris in the Art of Manet and His Followers* (Princeton NJ: Princeton University Press, 1984), pp. 257–8.

39. Celia Betsky, 'In the Artist's Studio,' *Portfolio*, January–February 1982, 39.

40. Baronne Staffe, *La Femme dans la famille* (Paris, n.d.), p. 56, quoted in Anne Higonnet, *Berthe Morisot* (Berkeley CA: University of California Press, 1995), p. 78.

41. Betsky, 'In the Artist's Studio,' p. 38.

42. Higonnet, *Berthe Morisot*, pp. 34–5.

43. Higonnet, *Berthe Morisot*, p. 89.

44. Higonnet, *Berthe Morisot*, p. 77.

45. Higonnet, *Berthe Morisot*, pp. 88–9. Instead, the room was merely 'a light, cool place devoid of self-consciously laborious or artsy trappings.' In this statement, Higonnet seems to consider Morisot's lack of a studio a sign of her genuineness; that is, by avoiding the kind of showplace studio full of 'artsy trappings' that Chase and others were known for or the garret whose focus is kept strictly on the artist's struggles, Morisot can be seen as serious but not superficially so. Higonnet's remark here seems to contradict her earlier waxings on the necessity of a non-domestic space 'consecrated to work' for 'intellectual independence' but the very language that Higonnet uses in both cases shows the importance of the studio space in Morisot's development as a dedicated, professional artist.

46. William P. Scott, 'Morisot's Style and Technique,' in *Berthe Morisot: Impressionist* (New York NY: Hudson Hills Press, 1987), pp. 197–8.

47. Higonnet, *Berthe Morisot*, p. 171. Jean Dominique Rey considers this home studio evidence that Morisot made 'no distinction between work and everyday life' (*Berthe Morisot*, exhibition catalogue, trans. Shirley Jennings, Naefels (Switzerland): Bonfini Press, 1982; p. 10).

48. Higonnet, *Berthe Morisot*, p. 202.

49. Denis Rouart, ed., *The Correspondence of Berthe Morisot*, trans. Betty W. Hubbard (London: Camden Press, 1986), p. 197. As Adler and Garb have pointed out, this source is one that must be read with suspicion, as Rouart (Morisot's grandson) presents only excerpts of Morisot's letters, and many seem to be presented out of chronological order. 'It is Rouart's Morisot which this document presents and it is, significantly, Rouart's Morisot which has determined much of the writing on this artist in the last thirty years.' See Adler and Garb, 'Introduction,' in Rouart, *The Correspondence*, p. 6. Naturally, this is both a problem and the nature of historical study.

50. Kathleen Adler and Tamar Garb, *Berthe Morisot* (Ithaca NY: Cornell University Press, 1987).

51. Anne Higonnet, *Berthe Morisot's Images of Women* (Cambridge MA: Harvard University Press, 1992), p. 130.

52. Higonnet, 'The Other Side of the Mirror,' pp. 67–78; at p. 73.

53. Higonnet, 'The Other Side of the Mirror,' p. 72.

54. Judith Butler, 'Imitation and Gender Insubordination,' in *Inside/Out: Lesbian Theories, Gay Theories*, ed. Diana Fuss (New York NY: Routledge, 1991), pp. 13–31; at p. 21.

55. These are the titles given to these paintings in a catalogue of Manet's works by his friend Théodore Duret. The paintings were not submitted to the Salon (which reinforces the interpretation of them as studies rather than portraits), so Manet's own titles are unknown. As Duret was also a friend of Morisot's, and names her presence in other works, I believe his titles are the most trustworthy. Sandra Orienti's thorough catalogue raisonné lists the works as *Young Woman with a Veil, Berthe Morisot with a Fan*, and *Berthe Morisot in Mourning Hat and Long Veil* respectively. Most common references to the works also name Morisot in the first painting's title. However, these titles are all retrospective and operating in the knowledge of the identity of the sitter. In Duret's catalogue, he groups a batch of Manet paintings of Morisot as such, and these are separated from those – I read this move as Duret recognizing a difference between those portraits of Morisot and these more generalized studies. See Théodore Duret, *Histoire de Edouard Manet et de son oeuvre avec un catalogue des peintures et des pastels* (Paris: Bernheim-Jeune, Editeurs d'Art, 1926), and Sandra Orienti, *The Complete Paintings of Manet* (New York NY: Harry N. Abrams, 1967).

56. A fuller discussion of these works can be found in Marni Reva Kessler, *Sheer Presence: The Veil in Manet's Paris* (Minneapolis MN: University of Minnesota Press, 2006).

57. Sarah Kofman, 'The Narcissistic Woman: Freud and Girard,' in *French Feminist Thought: A Reader*, ed. Toril Moi (Oxford: Blackwell, 1987), pp. 210–26; at p. 210. Kofman is of course arguing against this reading, seeing the narcissistic woman not as lacking but as totally self-sufficient.

58. Beatrice Farwell, 'Manet, Morisot, and Propriety,' in *Perspectives on Morisot*, ed. T.J. Edelstein (New York NY: Hudson Hills Press, 1990), pp. 45–56; at p. 56.

59. Tamar Garb, 'Berthe Morisot and the Feminizing of Impressionism,' in Edelstein, ed., *Perspectives on Morisot*, p. 61.

60. Norma Broude, *Impressionism: A Feminist Reading: The Gendering of Art, Science and Nature in the Nineteenth Century* (New York NY: Rizzoli, 1991), pp. 164 and 172.

61. Broude, *Impressionism*, p. 151.

62. Rouart, *The Correspondence*, p. 7.

63. Higonnet, 'The Other Side of the Mirror,' p. 67.

64. Higonnet, *Berthe Morisot's Images*, p. 200.

65. Julie Manet, *Growing Up With the Impressionists: The Diary of Julie Manet* (trans. Rosalind de Boland Roberts and Jane Roberts; London: Sotheby's, 1987), p. 93. As with Rouart above, this source must be considered carefully in light of its mediation through translation and editing.

66. Higonnet, 'The Other Side of the Mirror,' p. 189. Although of course one could say she was performing the code of the natural, as suggested to me by Mary Sheriff.

67. Butler, 'Imitation and Gender Insubordination,' p. 28.

68. Although I would like to add that I do not find that the other two self-portraits' maternal and iconographic features are as dominant as Higonnet does (Higonnet admits that the palette and Julie are both schematically rendered, but finds them central to understanding the images). See Higonnet, 'The Other Side of the Mirror,' pp. 71–3.

69. John House, *Impressionism: Paint and Politics* (New Haven CT: Yale University Press, 2004), p. 136.

70. For more on this painting, see Louly Peacock Konz, 'Marie Bashkirtseff (1858–1884): The Self-Portraits, Journal, and Photographs of a Young Artist' (PhD dissertation, University of North Carolina at Chapel Hill, 1997), pp. 233–41; and Christine Havice, 'In a Class By Herself: Nineteenth-Century Images of the Woman Artist as Student,' in *Woman's Art Journal* (Spring/ Summer 1981), 35–40.

71. There remain a fair number of photos of women sculptors, as well as a photo of Fairchild when she was working on the lunette for the Women's Pavilion; in other words, when large-scale projects were involved and there might be some doubt as to the actual physical ability of women to complete such projects. In Greatorex's 1893 article on Fairchild, much is made of the relative size of her palette and canvas in comparison to her slight figure, suggesting that the incongruity of the female artist's body with the greatness of her ambition (both actually and metaphorically) was a subject of remark at the least, if not also humor.

72. 'Our Artists at Home,' in the *New York Herald* (Paris), 18 January 1891, col. 1, p. 2. Cited in Brandon Brame Fortune, '"Not above Reproach": The Career of Lucy Lee-Robbins,' in *American Art*, vol. 12, no. 1 (Spring 1998), 41–65. Fortune's excellent essay traces the career of the daring Lee-Robbins, who unlike Morisot, Cassatt, and Fairchild, was willing to draw criticism in painting bold female nudes.

73. Virginia Woolf, *A Room of One's Own* (New York NY: Harcourt, Brace, 1929).

74. Emily Toth, *Kate Chopin* (Austin TX: University of Texas Press, 1993).

75. See Toth, *Kate Chopin*; see also Toth's *Unveiling Kate Chopin* (Jackson MS: University Press of Mississippi, 1999).

76. Although the book was not banned, as previously believed, it fell out of publication at the turn of the century and was not revived until 1953, when a French translation appeared. It was first reprinted in the US in 1964 and has gradually gained popularity through the support of feminist scholars in particular. See Margo Culley, 'Preface' to the Norton Critical Edition of Kate Chopin's book (which she also edited) entitled *Kate Chopin's 'The Awakening': An Authoritative Text, Biographical and Historical Contexts, and Criticism* (New York NY: W.W. Norton, 1994).

77. The best exception to this trend is Deborah Barker's chapter on *The Awakening* in her book *Aesthetics and Gender in American Literature: Portraits of the Woman Artist* (Lewisburg PA: Bucknell University Press, and London: Associated University Presses, 2000). Barker's attention is turned toward a Kristevan reading of Edna Pontellier's desire and vision within a broader thesis about the way women writers used representations of women artists to express their own desires and ambivalences toward their status as author/creators. I think Barker's interpretation of Edna's relationship to the other characters in the book is precisely right, and although a psychoanalytic reading is not my goal here, if it were I would extend Barker's ideas about bodily *jouissance* in Chopin's work to Fairchild's.

78. Culley, *Kate Chopin's 'The Awakening'*, pp. 54–5.

79. Culley, *Kate Chopin's 'The Awakening'*, p. 55.

80. Culley, *Kate Chopin's 'The Awakening'*, p. 55.

81. Culley, *Kate Chopin's 'The Awakening'*, p. 69.

82. Barker argues that it is not Reisz but close friend Adèle Ratignolle who inspires Edna's awakening when Edna attempts, but perhaps fails, to paint her beauty (Barker, *Aesthetics and Gender*, p. 122). I like that reading but still feel that the seeds are sown in this earlier scene with Reisz.

83. Culley, *Kate Chopin's 'The Awakening'*, p. 76.

84. Culley, *Kate Chopin's 'The Awakening'*, p. 61.

85. Mr. Pontellier's only reaction is a concern that her move might prompt Creole society to think his finances are not in good shape – he immediately sends off a note for print in the local paper stating he and his wife are making substantial renovations to their home and may go abroad soon. Chopin, *The Awakening*, p. 89.

86. Culley, *Kate Chopin's 'The Awakening'*, p. 59.

87. Barker, *Aesthetics and Gender*, p. 132.

88. Margo Culley, from 'Edna Pontellier: "A Solitary Soul,"' in Culley, *Kate Chopin's 'The Awakening'*, p. 251.

89. Suzanne Wolkenfeld, from 'Edna's Suicide: The Problem of the One and the Many,' in Culley, *Kate Chopin's 'The Awakening'*, p. 246.

90. For example as depicted by William Dean Howells in *The Coast of Bohemia* (a serialized novel published in *The Ladies Home Journal* between December 1892 and September 1893), wherein the female artist and the studio environment meet and help establish these clichés. As Mary Durkee points out, the studio space of the artist Charmain Maybough is 'a place of female self-sufficiency and autonomy' that helps render Charmain 'a girl who has no chance of making a respectable marriage (which means she is a failure as a woman). Charmain's insistence on dedicating herself to her art is implied to be due to mental instability' (Mary Durkee, 'In the (Female) Artist's Studio: Urban Bohemia's Dangerous Spaces,' in *Auto-Poetica: Representations of the Creative Process in Nineteenth-Century British and American Fiction* (Oxford: Lexington, 2006), pp. 129–38, at p. 133).

91. It is possible that the difference between public reactions to these works lies in their different media – Chopin's work would certainly be easier to access and thus more influential than Fairchild's painting. Fairchild did exhibit the majority of her paintings at various key institutions in the US, however, and *Dans la nursery* was shown at the Pennsylvania Academy of Fine Arts at the very least (it was her tendency to send her most significant works to the PAFA, Chicago, sometimes New York, and occasionally St. Louis – in this case we know only that she sent it to the PAFA). So the lack of commentary it received in the journals and catalogues of the time is still suggestive. In fact, this might relate to Barker's argument that 'the [figure of the] female visual artist allowed women writers to signal the aesthetic seriousness of their own writing and explore issues of creativity and sexuality that conflicted squarely with the limitations of feminine decorum that readers and critics often expected of the woman writer and her heroines' (Barker, *Aesthetics and Gender*, p. 11). A further difference, the cultural difference between the US and France, may be relevant as well – the benchmark for a work's 'immoral' or otherwise scandalous content was significantly lower in the American public taste than in the French. As many American art historians have pointed out, this accounts for the greater number of nudes by French artists than American artists in the last decades of the century. However, as *Dans la nursery* was exhibited in both countries and its creator was equally or perhaps even better known in the US, this difference seems debatable.

92. Griselda Pollock, *Looking Back to the Future: Essays on Art, Life and Death* (Amsterdam: G & B Arts International, 2001), p. 104.

93. Or, as seems to be the case currently, that lacking substantive proof on either side somehow signals preference in attribution to the man.

Rendering Invisible by Display: Representations of Late Nineteenth-Century American Women

In their representational strategies of gendered self-definition, William Merritt Chase and Mary Fairchild MacMonnies Low both clearly knew the role that images of women in domestic interiors were playing in their own contexts. Indeed, these abound in the history of art, yet the remarkable proliferation of such images in the work of late nineteenth-century American painters has attracted little scholarly notice in comparison to such images in French Realism and Impressionism. Charles Baudelaire's association of Parisian women of all types from bourgeois to prostitute with modernity itself – in part because of their superficiality – has been thoroughly mined, as has his valuation of the public over the private for the same reasons.[1] And Griselda Pollock's landmark critique of the resulting scholarship's tendency to view images of or by women in the domestic sphere as relatively irrelevant in defining modernism is now canonical and paved the way for the radical increase in attention French Impressionist paintings of this type now receive. Aided by both the same feminist theories that have benefited French art history and US historians' increasing attention to cultural studies, this change is slowly making its way to studies of American paintings of women in domestic interiors. Many, myself included, have accepted Bailey Van Hook's and Celia Betsky's persuasive suggestions, outlined in the preceding chapters, that these images were considered largely decorative in their time, with the women represented therein as lacking in any possible narrative content or meaning, believing that the (for the most part) men who painted them saw those women as essentially indistinguishable from the highly ornamented interiors in which they whiled away their many hours of leisure. I was convinced that these women were symbolic of the new leisure class of the nineteenth century, either forced (in Thorstein Veblen's view) or enabled (in Carl Degler's view) to perform as tangible displays of the conspicuous

consumption that their husbands and fathers worked for in their separate public spheres. As I researched such images more intently, however, I began to see them (and the women represented within) as more complex than they at first seem. Feminist studies have shifted from looking for proof of patriarchal inequity to perceiving both patriarchies themselves and the women oppressed by them as multivalent, and I have shifted my perception of the images that once seemed exclusively negative in their implications with this change in understanding. Now it seems clear – even obvious – to me that representations both visual and literary of bourgeois American women in the late nineteenth century show the inherent contradictions and destabilizations of a society that had not come to a single view about either gender or societal advancement.

Class and gender were key arguments throughout society in the Gilded Age, and these representations show possibilities for visualizing women both within and beyond the boundaries of social norms.[2] This chapter will explore the several ways in which American women, so commonly represented and displayed, were in a sense hiding in plain sight. Art-history and literature scholars alike are complicit in finding little of value in representations of them, which has led to diminishing the value of the works of both Chase and Fairchild as well as making it more likely we would oversimplify or misinterpret their meaning. As we re-address images, both literary and visual, of women who seem to stand only for a culture of commerce and display, I believe we will find them richer in meaning than is our tendency.

Kathleen Pyne's essay, 'Evolutionary Typology and the American Woman in the Work of Thomas Dewing,' initially pointed to a new direction in the potential meaning of these seemingly meaningless images. In this article and the following book-length study, Pyne argued that Thomas Wilmer Dewing's hazy, atmospheric paintings of lithe but indistinct women shown reading, playing instruments, or gazing contemplatively at some object, in largely empty interiors (or undefined outdoor spaces, which will not be discussed in this book) can be understood as reinforcements of an Emersonian and Spencerian view of evolution. Supporting her thesis with contemporary discussions of these issues both with and without these paintings in mind, Pyne suggested that Dewing intended these women as signposts of the cultural advancement achievable and achieved by Anglo-American upper-class society. Opposed to the Darwinian view of a somewhat random 'survival of the fittest,' Americans (particularly Anglo-Saxon New Englanders of the upper classes) preferred the possibilities of evolution through the study of and mastery over culture as represented in the fine arts.

Using examples such as Dewing's *A Reading* (1897) (Fig. 2.6), in which two women sit at a large, polished table, bare except for a book open before

one of the women and a decorative vase with a few flowers (which the other woman fingers), Pyne sees these women contemplating the beauty before them (the book, vase, flowers, and furniture) in a way which suggests their intellectual attainments. These women are not idlers but thinkers – a view reinforced by Dewing's statement that he only cared about his models' intelligence. This intelligence, Dewing felt, could be seen in their outward appearance, a point which Pyne considers as support for depicting their slim and attenuated bodies as rejections of the more animalistic world of the less cultured. The only aspect that muddies this reading, according to Pyne, is the tactility and desirability evident in the depictions of these women, which Pyne thinks echoes a Freudian narcissism that keeps these women aloof from their viewers and even more appealing to the male gaze.

Kathleen Pyne's scholarship on enculturation is an appealing step in a different direction in its allowance of both a meaning for American paintings of interiors beyond mere decorativeness and the suggestion that the women therein are in fact shown with an intellectual and societal purpose.[3] Yet I think her argument is a springboard to an even more complex view of these images than she allows. Despite Pyne's contribution of an intellectual life to the women of so-called decorative painting, these women are still depicted as general types, not individuals. Women as individuals are in that sense invisible in Gilded Age American painting, even though they are among its primary subjects.

Commodification, Signification, and the Feminine

Part of the problem we encounter in considering paintings like those by Dewing or texts like Henry James's 1904 novel *The Golden Bowl* is the tendency of scholars to accept, consciously or out of habit, the most commonly discussed tropes of historical periods regardless of the actual information presented them. The 'separate spheres' construct for the Gilded Age is particularly persuasive in its apparent tidiness – surely men and women lived as social constructions suggested they did, and thus we can interpret paintings and novels as if these constructions were fact. Both during the Gilded Age and by its scholars now, one of the most pervasive associations is that of the commodification and aestheticization of objects and surroundings with femininity in the nineteenth century. Rémy Saisselin explains this as the product of the situation in which the commodification of artworks sends them into the domestic realm, inseparable from the realm of the woman:

These aspects converge to form that phenomenon of the age, the ubiquity of the bibelot, attribute of the feminine, so much so that women and

luxury are part of the same general phenomenon of bibelotization. Woman
herself turns into a most expensive bibelot and yet is, at the same time,
a voracious consumer of luxury and accumulator of bibelots.[4]

Despite her aesthetic consumerism, woman does not, however, approach man
in the world of collecting valued art objects, but is supposed to stick to the
decoration of the home.

Henry James shows the tensions created by this normative yet not
necessarily workable construct in *The Golden Bowl*. In the novel, an American
widower and entrepreneur, Adam Verver, has decided to spend some of
his significant wealth traveling Europe and buying artworks he intends to
place in a new museum back in the States. On his travels, accompanied by
his daughter, they meet an American woman, Charlotte Stant, and an Italian
prince who have previously been lovers. The daughter, Maggie, falls in love
with and marries the Prince and also becomes best friends with Charlotte; so
to keep the happy foursome together, the father marries Charlotte. Naturally,
Charlotte and the Prince have an affair, which Maggie finds out about and
ends. The title of the novel comes from the way Maggie finds out about
Charlotte's and the Prince's past assignations: Charlotte had gone shopping
for a wedding present for Maggie and the Prince came along, in a sort of
Jamesian sexless tryst. Together, they found a beautiful golden bowl in an
antique shop. The bowl had a slight imperfection, a flaw, so they agreed
not to buy it. Later, Maggie finds and purchases the bowl, failing to see
the flaw. The bowl's imperfection and its previous assessment by Charlotte
and the Prince are eventually revealed by a friend, Fanny Assingham, and
the shopkeeper, later questioned, remembers the two who rejected it as a
romantic couple. The bowl comes to symbolize the relationship of Maggie
and the Prince, beautiful but fundamentally flawed in a way that Maggie
initially overlooks. Throughout, the novel emphasizes the division between
the purchasing done by Adam Verver and that done by his daughter Maggie
– he is carefully and surreptitiously acquiring museum pieces, while she
purchases a flawed bowl from a small shop of no known repute. Although
Adam Verver does the significant spending in the novel, the only two acts of
typical consumer purchasing are enacted or attempted by women: Maggie
and Charlotte Stant and their Golden Bowl. And the superior enculturation
of Charlotte and the Prince, at least initially, is also contrasted with that of
Maggie in her failure to see the flaw in the bowl.

Maggie fits into the standard equation of woman with decorativeness in
terms of her own appearance, as two lengthy descriptions of her clothing
and dressing preparations attest. Edwin Bowden overdetermines Maggie
as feminine art appreciator, going so far as to suggest that her architectonic
consciousness is a construct to help her hide from knowledge, rather than a
way of expressing it:

Dresses, museums, collections, and her own princely room where she can sit 'as if she had been carried there prepared, all attired and decorated, like some holy image in a procession,' all provide an escape from the cares and pains of life. … her images of pictures and medallions, porcelains, and pagodas, give her imaginatively the arts with which to insulate her sensibilities.[5]

This argument assumes that femininity and the arts coincide in Maggie as a space for avoidance of the world and intellectual activities within it.

Such interpretations maintain the standard constructs of gender-divided behavior, with its consequent limitation upon the idea of woman as active agent. To her credit, Kathleen D. McCarthy, in *Women's Culture: American Philanthropy and Art, 1830–1930*, questions the division of masculine and feminine roles in art discernment and patronage at least in America, where women were allied in popular mythology with intellect and art custodianship. Despite such characterizations, McCarthy finds that in reality women had limited access to such roles. Sarah Burns, looking at paintings of women in studio interiors, argues that the association of women with the art world was a double-edged sword:

At a time when commercial values seemed more and more to tarnish art's shining sanctity, the figure of its metaphorical consumption by elegant women sanitized or sublimated the circumstances of its consumption in the secular marketplace. At the same time, however, the almost exclusive identification of women with studio interiors reinforced the construction of the art world as feminine, passive, and dependent for its very existence on industrial and commercial sources of wealth, unseen and unmentioned, yet all-powerful.[6]

The duality of this construction of woman as symbol of art consumption warns us to be wary of any attempt to define it in just one simple direction. Yet most critics of *The Golden Bowl* have chosen to read the women as *embodying* these stereotypical feminine aspects, even when the critics' agendas are feminist, by relying upon binary concepts of gender that do not fit the text itself. Creating an essentialist interpretation of the characters and their behavior, critics have overlooked the fact that all of the characters, but particularly Maggie, subvert such binary codes. Such criticism results in a rather limited view of the intellectual capacity of the female characters, leading to a false view of the ending of the novel as a rather mundane 'girl wins boy away from other girl' scenario. James's women *do* fit the standard concept of femininity (passive, decorative, creative, adept with words, but not active in the non-domestic sphere) to a certain extent. Yet most critics of the text often fail to see the performative, non-polar gender aspect of James's characters, both male and female.[7]

In terms of our discussion of woman as mythical patron of the arts and woman as the ideal object to acquire, the most obvious examples of this in *The Golden Bowl* are Adam Verver and the Prince – the two men. In fact, the Prince in many ways is as traditionally feminine as Fanny Assingham and

Charlotte Stant. These are certainly the characters he gravitates to in terms of having interests in common. Like Charlotte, he is a decorative purchase of the Ververs, whose only role is to 'be' for them, to take care of all the tedious social demands upon them. As Maggie tells him before they are married, '"You're at any rate a part of his collection," she had explained – "one of the things that can only be got over here. You're a rarity, an object of beauty, an object of price."[8] Adam Verver, in thinking about the Prince, describes him as round, the sort of thing that one feels with one's hand, a passive object that 'liked all signs that things were well, but he cared less why they were.'[9] Even Charlotte recognizes that they share the role of passive 'wives' to their active 'husbands,' Adam and Maggie.

Some critics give the Prince a very active determining role in the text, citing for example the presentation of the first of the three books in the text as from his consciousness and therefore equal to Maggie's role in the last book. A close reading of the text will immediately reveal that although the first book may bear his name, in fact it is riddled with the primary conscious expressions of almost all the major characters. Maggie's book is much more her own. And although Maggie is desirous of the Prince in many husbandly ways, the very skilled way in which she manages the outcome of his rejection of Charlotte as the only one possible shows overtly her manipulation of him, an active role normally assigned only to masculine figures.

Charlotte, although described by the Prince as an accumulation of his possessions from whom is heard the occasional 'chink of metal,' is also described by him as so thoroughly experienced in life as to have the habit of 'not being afraid.'[10] This is not a typical description of a genteel and beautiful female object of the time. On their shopping trip to Bloomsbury, Charlotte and the Prince trade surprise over each other's knowledge, each seeming to expect the other to be less – and the one note of gender difference in that sequence is the Prince's:

When his companion, with the memory of other visits and other rambles, spoke of places he hadn't seen and things he didn't know, he actually felt again – as half the effect – just a shade humiliated. He might even have felt a trifle annoyed – if it hadn't been, on this spot, for his being, even more, interested.[11]

Charlotte, in the one segment told from her point of view, thinks about her abilities in 'arranging' in much the same way Adam Verver thinks about his in collecting: 'the proved private theory that materials to work with had been all she required and that there were none too precious for her to understand and use.'[12] This metaphor of labor subverts the reading of her 'arranging' as a purely feminine skill.

In one way or another, each of the major characters shows qualities traditionally connected with masculinity and femininity. Priscilla L. Walton notes this fact: 'In James's writings, the Feminine is frequently located in

female characters, but it is not restricted to them and is also often found in the plurality of writing and textual production. As a result of this, writing becomes a manifestation of the Feminine, or that which cannot be confined.'[13] Walton then gives Maggie the most power possible by suggesting that the second book of *The Golden Bowl* is Maggie's textual revision of the Masculine first book, the result of which is a 'multiplicit Feminine text' because Maggie has learned that knowledge is an illusion and has therefore endeavored to open up the narrative through absence and silence.

Many critics have associated the femininity of a text with the femininity of the author and specifically with authors like Henry James, whose works are largely delivered through feminine consciousness. But the relation of textuality and representation to femininity is not always the only option. David Lubin, in his appraisal of James and painter John Singer Sargent, offers a more fluid theory: 'To the extent that passive observation is stereotyped by our society as feminine, while instrumental activity is characterized as masculine, the act of portrayal as it is here defined might be regarded as an activity involving dually sexual, antithetically sexual, impulses.'[14] Rather than the author as feminine, we have the author as hermaphrodite, calling into question any assertions of each character as more or less an expression of the author's particular gender. I believe the push–pull of James's conceptualization of people and objects is structured significantly upon gender, albeit not always in as binary a fashion as most critics have argued.

Maggie nonetheless represents the culmination of all the characteristics of a desirable Gilded Age woman as far as that period was prepared to see gender. Initially, Adam Verver is presented as the possessor of both wealth and taste, and the intelligence to put both together successfully in collecting art objects for his museum. This collecting practiced by Verver includes not just the inanimate spoils of an increasingly indebted Europe, but also its animate spoils – the poignantly named Prince Amerigo, whose acquisition Verver believes reinforces his own sense of full enculturation:

> The aspirant to his daughter's hand showed somehow the great marks
> and signs, stood before him with the high authenticities, he had learned
> to look for in pieces of the first order. Adam Verver knew, by this
> time, knew thoroughly: no man in Europe or in America, he privately
> believed, was less capable, in such estimates, of vulgar mistakes.[15]

But Verver's mentality remains bourgeois – based on the skill he has acquired through self-education rather than some inherent superiority of birth. Charlotte and Amerigo both have the talent, but neither has the wealth to sustain their own position. And by the end of the novel, the once-smart Charlotte has been shown as stupid and replaced by the newly intellectual Maggie, in a sort of Spencerian evolutionary contest of self-culture that gives precedence to the wealthy Americans of a new era. Like Dewing's women, she can be James's

'heir of all ages' – wealthy, cultured, meditative, intellectual, and powerful. She supersedes the others, who have only a few of those characteristics or the illusion of them. Therefore Henry James can be seen to engage the issue of evolution in terms of self-culture. His heroine, and I think we can call her that, is the ideally self-cultured woman.

Class, Labor, and American Enculturation

Pyne's enculturation thesis is thus appealing in helping us to see representations of women that seem at first to fit the normative passive view as potentially more active. Yet I think her argument should be further nuanced. By arguing that paintings by turn-of-the-century American artists like Dewing show only the 'old money' American viewpoint, Pyne forgets that most of the images she discusses were publicly shown at the National Academy of Design, the Society of American Artists, and independent galleries, and often sold to the *newly* rich. Also, although it is true that Dewing came from upper-class New England stock, many of the other artists who depicted similar images did not. Pyne does argue that Dewing's paintings might be seen as propagandistic of his societal class and its cultural interests, and she does point out that he and others (Childe Hassam, for example) made their women resemble historically validated ideals of beauty (Grecian statuettes and Renaissance Venuses). But we must take the next step – Dewing was showing his own self-culturing abilities by painting these images with their historical references ('I know my history') and their facile painting of many different kinds of valuable artifacts ('I have taste, I can decorate an interior properly, I can dress a woman beautifully, and I can paint a vase or a piano to look as good as the best of the "real"'). Therefore these paintings do not just defend the identity of the racial and class group from which he comes, they also defend his work as an artist and the position of an artist within the broader society.[16] Throughout American history the artist's role has been contested, and artists have been alternately denigrated and supported as either craftspeople or 'gentleman/gentlewoman' artists. In the late nineteenth century, these poles were occupied and fought over, as for example between Thomas Eakins and William Merritt Chase (Eakins thought the best school for learning to paint was the operating room, and the best studio was a workplace devoid of decor, while Chase preferred travel to European museums and salons, and his studios were renowned for their bric-a-bracomania). Dewing places himself firmly in the Chase camp by arguing that society would be bettered by his images of contemplation of the arts, which would themselves be contemplated over and thus improve the viewer. By painting, Dewing was improving society. The same can obviously be argued for James, whose challenging novels full of extremely intelligent characters certainly show a utopian desire for self-culturing and 'civilizing'

to create a more advanced (if not necessarily happy) society.[17] James shares with Dewing and other visual artists of the Gilded Age a desire to create a whole aesthetic environment where beautiful people and beautiful objects engage each other thoughtfully. In *The Golden Bowl*, for example, moments of consciousness and relationships between people are described as pagodas, bowls, arches, and books – even one's thoughts are an architectural space, one's statements paintings, one's emotional offerings flowers. A complete environment is thus created inside a person and out – if they are tasteful and 'civilized' enough to comprehend it and, at least in terms of the American characters, willing to work hard to acquire that knowledge.

As Alan Trachtenberg points out in *The Incorporation of America: Culture and Society in the Gilded Age*, the division between labor and management/ ownership was fiercely fought during this time, with both sides valuing hard work as a concept but having different interpretations of it. The urban lower-class workers were often seen negatively by the middle and upper classes, as dangerous immigrants lacking the proper education and hygiene. Pyne's reading of these paintings reconfirms the values of the genteel, but does not adequately present the images as denigrations of the values of new immigrant laborers. Although the upwardly mobile might have seen these images in a public showing and thought of what they ought to strive for, equally many might have seen them apprehensively as a world perhaps already lost to them through racial origination or lack of leisure time and finances. The Anglicized women shown represented an already waning racial constituent in urban America, and many of the newly rich did not share the Protestant values depicted.

Trachtenberg notes that images of urban cities were rare during this time, and the urban outdoors was a contested site – the city streets with their mingling races and classes and potential for danger through crime were viewed as inappropriate for the genteel elite (particularly women, whose presence there might even call their virtue into question, as both Joy Kasson and John Kasson have pointed out). Although scholars have noted this contestation as resulting in the parks of Frederick Law Olmsted or the urban views of both The Ten (a group of ten American painters, largely Impressionists and including Chase, Dewing, Tarbell, Benson, De Camp, and Hassam, who depicted the urban spaces of the US as clean, open, and verdant, with the occasional strolling family) and The Eight (a group of eight American painters including Robert Henri who named themselves in contradistinction to The Ten as a younger generation whose more realist, 'Ashcan' paintings showed urban spaces that were dirty and crowded with working-class people), few have noted the correspondence between the increasing tensions of urbanism and the dramatic increase in domestic interior imagery during this time. These images function not just as Impressionist encapsulations of the life of the artist, but as claims staked for

an avoidance of the urban reality of the time. Dewing's and Chase's interiors are contemplated not just for moral and intellectual improvement but for their expression of an ideal, interior world that in many senses was what Jean-Christophe Agnew would call a 'House of Fiction.'[18]

That women were at the center of this dispute about changing societal ideals both symbolically and actually has been the source of much rich scholarship of late. But despite Pyne's important contribution of an intellectual life to the women of so-called decorative painting, these women are still most often depicted as general types, not individuals. Judy Sund, in writing about the imagery chosen for the World's Columbian Exposition, notes that men most often occurred as actual historical personages (such as Columbus) whereas women most often occurred as symbolic figures (for example, Columbia). This was the case despite the presence of an abundance of real women, both contemporary and historical, who could have been depicted. The many actual women at this time actively involved in society at every level, from the political to the cultural to the laboring, are rarely painted or sculpted by the artists of the time (and if they are it is often at their own commissioning, as in the case of Isabella Stewart Gardner). The generalized woman standing in for various cultural and societal ideals is much more the norm.[19]

The difficulty in reading the women in these paintings as individuals is enriched by discussions of class and gender intersection in two ways: first, the cultural evolution and learnedness of women was a contested topic of the time, and second, the increased rigidity of codes of manners in American society suggests an instability in ideas of identity that was particularly constricting for women. Sarah Burns writes, in her treatment of the gendered nature of critical reception of artists at the time, that many people, particularly but not exclusively male, argued publicly against the danger of women becoming *too* intellectual and cultured. These women showed the degeneration of American society, not the evolution of it to a higher plane. The US, it was argued, was founded on principles of ruggedness and hard work, and such women threatened the preferable masculinity with which these critics wished to associate America. An artistic counterpoint to Dewing and Chase's paintings are those of Winslow Homer, for instance, whom Burns has shown to propagandize the masculinity of the rough Maine landscape.[20] By situating his works in a treacherous yet defeatable outdoors, Homer could suggest an alternative to the city worker's increasing inactivity – a move that Burns argues is a masculinized escape. I would like to read this in contrast to the more commonly noted domestic escape of the home.

By depicting women in interiors, male nineteenth-century artists were risking the equation of their own world with that of women, and thus risking the potentially damaging label of effeminacy. Generalizing the women's

features, and arguing for their symbolization of higher ideals like evolution and morality, allowed the male artist to stay within his proper intellectual realm. The constant commentary these artists generated of their interest in technique over subject matter also established them as technicians and skilled artisans rather than dabblers, although the matter was often disputed by critics (particularly in Chase's case). Some critics even noted the comparatively less skillful humanization of the female figures in these works, as did one in a 1907 exhibition review of The Ten:

> Mr. E.C. Tarbell's 'New England Interior' should have interested the observer in the two women sewing, who are now treated almost as part of the furniture of the room. … Everything is done with admirable skill. But the old Dutchmen who did this first gave a touch of human identity and individuality to their figures, and in this Mr. Tarbell, with all his taste and knowledge, falls short.[21]

The consistent praise of technical skill – and here enculturation – does not omit the reviewer's awareness that the female figures therein are lacking in specificity. But perhaps, rather than falling short in this crucial area, Tarbell is making a choice to depict them as objects, in order to maintain a distinction between himself and them (one that their sewing has already begun).

John Kasson has rightly argued for a renewed study of etiquette as a way to uncover social practices and ideas, and his discussion of the mirror is particularly apt here. Kasson states that facial composure was a site of apprehension for the middle and upper classes, and that mirrors throughout the home allowed people to constantly check their appearance to maintain the proper public effect.[22] This, combined with Karen Halttunen's discussion of interior decorating as the publicizing of the private self, reveals the interiors of these paintings to new critiques.[23] For instance, Dewing's The Mirror (1907) showing a young woman sitting at a large gilded mirror, gazing into it, while behind her in a chair like her own is a vase with narcissus blooms, is read by Pyne as showing the contradiction between this woman's intellectual contemplation and Dewing's desire for her narcissistic unknowability. This painting can also be read as a depiction of the struggle this woman might have over the presentation of her identity in her face, which is entirely indistinct. The same effect occurs in several of Dewing's paintings, including The Spinet (1902, Smithsonian American Art Museum, Washington DC) (Fig. 4.1), which has been shown through autoradiographic analysis to have had its indistinctly reflecting female face in a mirror added after all other elements were fully painted in.[24] The later Lady in White (No. 1) (c. 1910, Smithsonian American Art Museum, Washington DC) (Fig. 4.2) is a not-uncommon example of a woman sitting in front of, but looking perpendicularly away from, a large cheval glass which does not even reflect her. Are Dewing's female sitters empty, a mere site for the location of social ideals, or in a state of flux between individuality and generality?

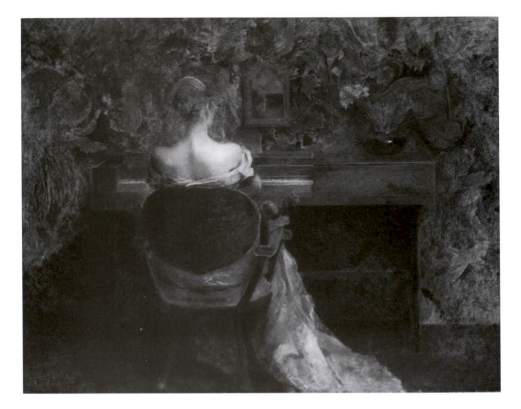

4.1 Thomas Wilmer Dewing (American, 1851–1938), *The Spinet*, 1902. Oil on wood, 15½" H × 20" W (39.5 × 50 cm). Smithsonian American Art Museum, Washington DC. Photo: Smithsonian American Art Museum, Washington DC/Art Resource, New York

Agency for the New Woman?

Wondering if the woman depicted might herself be struggling between cultural norms and individual desires leads us naturally to the possibility of a female viewer's subjective response to this type of depiction. Ruth E. Iskin's demand that we consider the female gaze and spectator as appropriate tools in analyzing French Impressionist paintings and visual culture is equally relevant here. Looking at the idea of the female subject in contemporaneous French images in terms of consumer culture, Iskin argues that 'by considering modern women's roles not only as passive icons that sell commodities but also as active producers, consumers and sellers … certain paintings by Manet and the Impressionists represent modern women's agency and inclusion rather than passivity and exclusion from the public spaces of modern Paris.'[25] Iskin and Sarah Burns have pointed out in several texts the error in understanding that all but the lowest classes of women were restricted

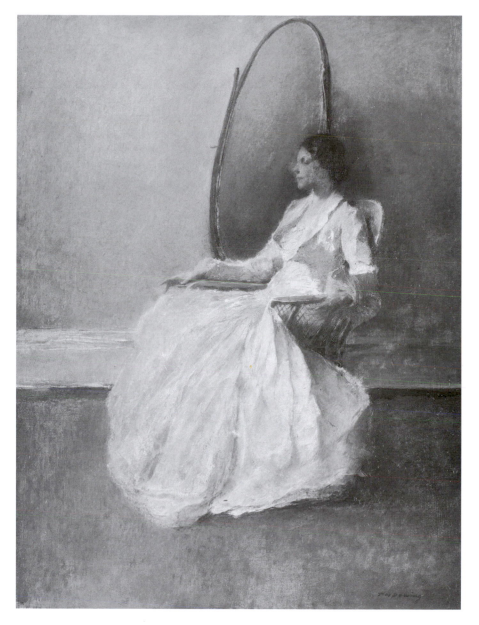

4.2 Thomas Wilmer Dewing (American, 1851–1938), *Lady in White (No. 1)*, c. 1910.
Oil on canvas, 26¼" H × 20¼" W (66.6 × 51.3 cm). Smithsonian American
Art Museum, Washington DC. Photo: Smithsonian American Art
Museum, Washington DC/Art Resource, New York

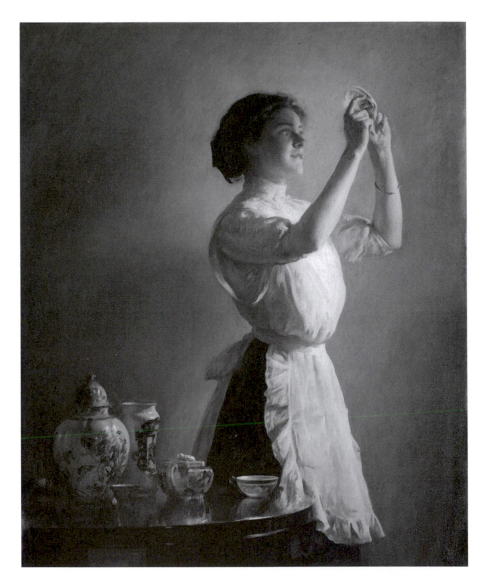

4.3 Joseph Rodefer De Camp (American, 1858–1923), *The Blue Cup*, 1909. Oil on canvas,
49⅞" H × 41⅛" W (126.7 × 104.8 cm). Museum of Fine Arts, Boston. Gift of Edwin S.
Webster, Lawrence J. Webster, and Mrs. Mary S. Sampson in memory of their father,
Frank G. Webster. 33.532. Photo: © 2010, Museum of Fine Arts, Boston

to the domestic or domesticated pastoral environments in this period, in both Europe and the US.[26] Applying that reading to our seemingly trapped American domestic angels is equally problematic. It is only if we agree with the normative tropes about the female subject's passivity that we read the images in that way. Rethinking the significant roles that women did play in selecting, purchasing, and placing the decorative elements of the home, as well as the growing numbers choosing to take cultural and other pursuits seriously and even professionally, requires us to invoke an active female viewer whose interpretation could differ widely from that reproduced in normative texts, both then and now. In Michel de Certeau's terms, we must note both the strategic spaces created by the holders of power and the tactical uses to which those without power put them.[27]

It is true that Dewing's women often seem more flaccid than, for example, Iskin's description of Mary Cassatt's *Woman with a Pearl Necklace in a Loge* (1879, Philadelphia Museum of Art), which 'represents a modern woman's agency in her performance of display. With elegant clothes and a sparkling presence, she is actively and pleasurably displaying herself, within the norms of bourgeois propriety.'[28] If we might read Dewing's woman as somewhat idiosyncratic, Pyne argues for a continuity of enculturational goals between somewhat earlier works such as Dewing's and later paintings like one of Childe Hassam's, *Tanagra* (discussed later in this chapter as Fig. 4.5). I offer that and other, similar contemporary paintings as a sign of the ever more contested depiction of the above concepts in a less rigidly stratified society after the turn of the century. Joseph R. De Camp's *The Blue Cup* (1909, Museum of Fine Arts, Boston) (Fig. 4.3) is usually discussed as an image of a maid stopping in her cleaning duties to observe the translucency of a fine cup. This painting could be showing an extreme level of enculturation, wherein even a servant is learning to tell the good china from the bad, presumably after much training from her mistress. But few if any scholars have noted the absence of any sign other than an apron for the understanding of this woman as a servant. She is not extravagantly dressed like the clearly bourgeois students of chinaware in William Paxton's paintings, but she is not in a uniform (as is Paxton's *The House Maid* of 1910, Corcoran Gallery of Art, Washington DC) (Fig. 4.4), and there are no other attributes of labor in the image (for instance a rag for polishing or a cupboard into which these articles are being placed). De Camp may in fact be signaling the acquisition of cultural discernment not among the servants of the upper classes but among the middle classes themselves. Katherine C. Grier informs us that popular culture in the nineteenth century showed a widespread awareness of the rhetorical statements possible in furnishings: 'Further, it is possible to think of users of this language of objects as being more or less successful in the act of communicating through their manipulation, to be "artifactually competent" just as they were linguistically competent.'[29] If such thought were part of widespread society, and it seems so from studies of the

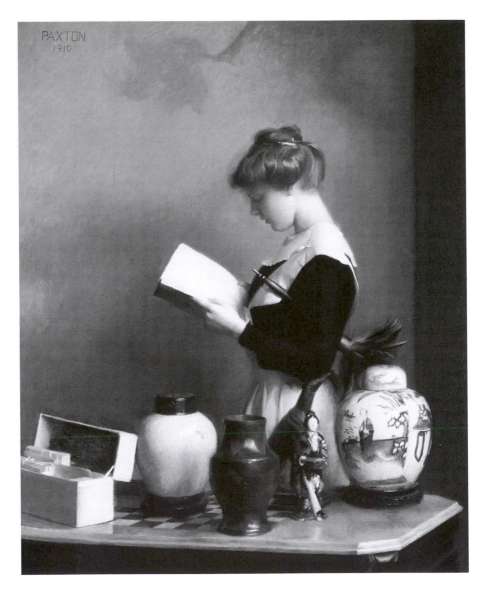

4.4 William McGregor Paxton (American, 1869–1941), *The House Maid*, 1910. Oil on canvas, 30¼″ H × 25⅛″ W (76.9 × 63.8 cm). Corcoran Gallery of Art, Washington DC. Museum Purchase, Gallery Fund, 16.9

increasing concern the wealthy of this period had that, through department store access to well-made clothing and imitation of certain manners, the middle classes were succeeding in blurring the distinctions between them, then perhaps paintings like De Camp's show the upwardly mobile arriving at some higher level.

And is it the new society of spectacle and consumerism that has helped with this shift in agency and empathy? Shawn Michelle Smith, persuasively attempting a similar revision of Theodore Dreiser's *Sister Carrie* (1900), believes so, arguing that the commodity begins to wield power over the viewer:

For while surveillance typically imagines an observer who exercises control over objects and bodies under view, a society of spectacle poses a viewer controlled by the objects that capture the gaze. … Dreiser's *Sister Carrie* offers new ways of reading the position and the relative power not only of woman-as-consumer and of woman-as-commodity but also of Woman as the object of the masculine gaze. Dreiser's text proposes that in these very positions women can attain a kind of ambiguous agency, a mobility with which they may stir, if not out of consumer culture, then perhaps out of the confines of patriarchal exchange.[30]

Unfortunately, as Smith points out, the same culture that allows Carrie to succeed in shedding her dependency nonetheless continues to carefully police racial and social boundaries many others could not so easily cross. As quickly as one could leave the working class for the middle class, one could choose to ignore the labor sources of all those commodities. But if the well-dressed white woman painted as the object of the gaze could reflect and make material the viewer's desire and subjectivity, she could not, as Carrie can, turn this self-as-mirror into a productive activity or draw a distinction between looking at and possessing it. The depicted figure can change or act in our imagination, but not in the painted scene itself, which freezes its subject in time and space.[31]

Childe Hassam's *Tanagra (The Builders, New York)* (1918, Smithsonian American Art Museum, Washington DC) (Fig. 4.5) shows a woman in a richly decorated interior, standing behind a polished wooden table that connects the fore- and middle grounds of the painting's tightly compressed composition and in front of an Asian folding screen whose colors are echoed in her loose, flowing drapery. She is holding a Greek statuette (the eponymous Tanagra) directly and somewhat stiffly with her right hand, while her left absent-mindedly skims the table. The woman gazes at the Tanagra somehow both intently and blankly, not unlike Degas's mannequin in his *Portrait of Henri Michel-Lévy* (Fig. 2.5). As the woman's drapery, hair, and alabaster skin echo Greek statuary, the comparison between the two figures is clear. However, the Tanagra is sharply outlined by the light coming through the window and contrasted with a view of tall city buildings – and men laboring on them – through a window directly behind it. Here the growth of the city and the

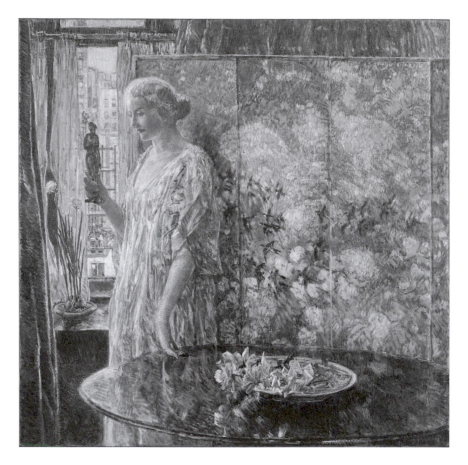

4.5 Childe Hassam (American, 1859–1935), *Tanagra (The Builders, New York)*, 1918. Oil on canvas, 58¾" H × 58¾" W (149.2 × 149 cm). Smithsonian American Art Museum, Washington DC. Photo: Smithsonian American Art Museum, Washington DC/Art Resource, New York

enculturation of the woman are equated by both Hassam and Pyne. Yet in this image the 'real' woman is almost completely subsumed by the decorative screen behind her, the backlit sculpture, and the dramatic exterior view. Perhaps in this case the image foretells not of the catching-up of woman to culture and class to class, but the meaninglessness of both in the rapidly growing urban exterior. Hassam's work during this period, and even earlier, had already started to show an Anglocentrism and ambivalent nostalgia for the past that competed with his previous progressive enthusiasm for new urbanism.[32] Women's and society's enculturation would in fact soon cease to be of interest as subject matter to the avant-garde painters of the US, as the Ashcan School's paintings of urban 'reality' and the experimental

abstractions of Georgia O'Keeffe, Stuart Davis, and Arthur Dove would cast a pall of outmodedness on the 'idealized' paintings of the Impressionists.

Yet while most canonical American painters of the early twentieth century dropped the subject of the genteel woman in a domestic interior, in literature the New Woman of the 1890s had introduced a new typology – one that might, at least according to its proponents, merge the best of the older trope and the new world. Critics of the New Woman – smoking, riding bicycles, wearing shorter dresses – sounded the alarm of the downfall of 'proper' femininity. Even Mary Cassatt expressed dismay at some of the more audacious (and presumably vulgar) habits of this younger generation. The New Woman's move to the public sphere in a bold and visible way obviously threatened the false but treasured binary of public and private that comforted its proponents that masculine and feminine could be easily determined along those lines. Seeing this new figure as combining the domestic individuality of the previous generation with the urban engagement of the new, Tamar Katz also finds her, in literature at any rate, 'as a way of reworking nineteenth-century versions of subjectivity' whose revision 'is crucial to literary experiment in the period and to modernist redefinitions of literature's authority.'[33] But as the literary avant-garde of the early twentieth century chose to highlight the New Woman's identity as a signifier of both the strengths and the weaknesses of a no-longer easily defined identity, American visual arts largely avoided the subject, shifting to an ever more complete excising of the feminine perspective.[34] We would see 80 years later, with Carol Duncan's and Griselda Pollock's help, the way the Museum of Modern Art in New York could create and reinforce a notion that avant-garde painting began in France and moved to the US only in the middle of the twentieth century, and that its subjects were first landscapes, then prostitutes, then prostitutes as landscapes – painted by men, for men, without a trace of the culture shaped and reflected by either female or American Impressionists or their female audience.

Notes

1. Charles Baudelaire, *The Painter of Modern Life and Other Essays*, ed. and trans. Jonathan Mayne (New York NY: Da Capo Press, reprinted from Phaidon's 1964 edition). See particularly T.J. Clark's *The Painting of Modern Life: Paris in the Art of Manet and His Followers* (Princeton NJ: Princeton University Press, 1984). Susan Sidlauskas's PhD dissertation ('A "Perspective of Feeling": The Expressive Interior in Nineteenth-Century Realist Painting,' University of Pennsylvania, 1989) did not focus specifically on women within domestic interiors, but it is a useful and comprehensive look at the role of the interior itself in both Realist painting and Impressionism (she includes in her study Degas, Chase, and Sargent, all of whom could be categorized at different points of their careers as one or the other).

2. Sidsel Maria Søndergaard presented this perspective in organizing the exhibition 'Women in Impressionism' for the Ny Carlsberg Glyptotek in 2007. The exhibition focused on French artists and subjects; however, Søndergaard points out in her introduction to the exhibition catalogue that, despite increasing feminist scholarly attempts to redress interpretations of these images, 'up until the present time, no appropriately balanced examination of the Impressionists' pictures of women – those created by both female and male artists – has formed the basis for a large-scale exhibition.'

See Sidsel Maria Søndergaard, *Women in Impressionism: From Mythical Feminine to Modern Woman* (exhibition catalogue, Milan: Skira, 2007), p. 12.

3. Reading the seemingly blank expression of the woman in Edouard Manet's *In the Conservatory* (1879, Nationalgalerie, Berlin), Søndergaard suggests that Manet may be ironically exaggerating a stereotypical view of femininity (*Women in Impressionism*, p. 21). I like this reading (and her linking of it to Jonathan Crary's reading (in *Suspensions of Perception: Attention, Spectacle, and Modern Culture* (Cambridge MA: MIT Press, 2000) of the woman as expressing, among other things, the self-control required of the modern visage); however, I think the American Impressionists rarely if ever used a Manet-like ironic critique in their works. More often, they are either earnest or overt in their expressions. It bears pointing out that the female sitter in the Manet painting is Mme. Guillemet (an American friend of Manet's who, with her French husband Jules, also pictured, owned a Parisian fashion house). Thus this is the portrait of a specific person, even if unidentified in the title – not a generalized female. I think we can and should still read this image as a type of modern genre scene, not a portrait, but that the Guillemets were well known in Paris would alter the Parisian audience's interpretations of it. I was struck that, although identified, the scholars who discuss this work fail to call her anything but Mme. Guillemet.

4. Rémy Saisselin, *The Bourgeois and the Bibelot* (New Brunswick NJ: Rutgers University Press), p. 53.

5. Edwin T. Bowden, *The Themes of Henry James: A System of Observation through the Visual Arts* (New Haven CT: Archon), p. 109.

6. Sarah Burns, 'The Price of Beauty: Art, Commerce, and the Late Nineteenth-Century American Studio Interior,' in *American Iconology: New Approaches to Nineteenth-Century Art and Literature*, ed. David C. Miller (New Haven CT: Yale University Press), p. 230.

7. Elizabeth Allen, despite an adept awareness of the confusions of James's novels between the woman as sign and her manipulation of that sign through awareness of it, proceeds with her argument on essentialist levels – the men in the book are depicted by her as always powerful over the women, and the women act only within the strictures of accepted stereotyping as the keepers of culture: 'Women signify and explain signification, their world is that of seeming.' See *A Woman's Place in the Novels of Henry James* (New York NY: St. Martin's Press, 1984), p. 182. The idea of women as coequal with the world of artifice and illusion is maintained and Allen feels the later Maggie who clearly understands the process of signification only maintains the old patriarchal system. Lisa Appignanesi does not align femininity strictly with women in the introduction to *Femininity and the Creative Imagination: A Study of Henry James, Robert Musil and Marcel Proust* (New York NY: Harper & Row, 1973), but in discussing *The Golden Bowl*, she focuses on femininity only in relation to Maggie and Charlotte. On the other hand, Patricia E. Johnson has persuasively questioned the binary focus on the gaze in relation to James's *Portrait of a Lady* in 'The Gendered Politics of the Gaze: Henry James and George Eliot,' in *Mosaic: A Journal for the Interdisciplinary Study of Literature*, vol. 30, no. 1 (March 1997), 39–55; Jessica Forbes attempts less successfully to counter Johnson's assessment that James, in the end, leaves protagonist Isabel Archer subject to the male gaze in her 'The Power of Looking: The Gaze in *The Portrait of a Lady*' (in *Henry James and the Visual Culture of Modernity*, Online publication of the University of Aarhus Department of English, 2006), pp. 34–43. An extremely useful text that attempts to read James more multivalently is the edited anthology *Henry James Against the Aesthetic Movement: Essays on the Middle and Late Fiction* (eds David G. Izzo and Daniel T. O'Hara, Jefferson, NC and London: MacFarland & Company, Inc., Publishers, 2006). This and other texts that address James's and his subjects' potential homosexuality still often reiterate binaristic interpretations of gender, sexuality, or both, and none addresses *The Golden Bowl* specifically in these terms.

8. Henry James, *The Golden Bowl* [1904] (New York NY: Penguin, 1983), p. 35.

9. James, *The Golden Bowl*, p. 120.

10. James, *The Golden Bowl*, pp. 58–9.

11. James, *The Golden Bowl*, p. 95.

12. James, *The Golden Bowl*, p. 192.

13. Priscilla L. Walton, *The Disruption of the Feminine in Henry James* (Toronto: University of Toronto Press, 1992), p. 32.

14. David M. Lubin, *Act of Portrayal: Eakins, Sargent, James* (New Haven CT: Yale University Press, 1993), p. 125.

15. James, *The Golden Bowl*, p. 121.

16. An argument of this type, about male artists and their representation of labor as a form of self-representation, forms the core of Tim Barringer's superb *Men at Work: Art and Labour in Victorian Britain* (New Haven CT: Yale University Press, 2005). Barringer says of Ford Madox Brown, for example: 'By remaining absent from the text but figuring himself through his own labour as an artist, Brown was able to circumvent the critique of intellectual labour as unmasculine and to assert his mastery over the whole social scene' (p. 80). Barringer also points out that Whistler's apparent effortlessness (like William Merritt Chase's) was hard-earned through a kind of labor not fully appreciated as such by his critics (most famously John Ruskin).

17. Alwyn Berland seems to support this idea in his reading of James in *Culture and Conduct in the Novels of Henry James* (Cambridge: Cambridge University Press, 1981), especially on page 2: 'Civilization, as James sees it, cannot re-make human nature, but it can shape its development and expression. Civilization cannot guard against raw egoism by cancelling it, but it can direct and discipline it through forms and manners, through ritual, through a shared ethic, and through art.'

18. Jean-Christophe Agnew, 'A House of Fiction: Domestic Interiors and the Commodity Aesthetic,' in Simon J. Bronner, ed., *Consuming Visions: Accumulation and Display of Goods in America 1880–1920* (New York NY: W.W. Norton, 1989). Susan Sidlauskas discusses the much more overtly unstable interior images that were made in this period in France in 'A "Perspective of Feeling,"' where she notes not just that the interior setting was becoming a more important and expressive element in modern painting but also that it was an important site for a psychological transition during the period: 'These pictorial strategies produced a relation between figures and their settings that seemed uneasy, active rather than passive, sometimes even adversarial. The interior was no longer a neutral vessel designed to contain or to protect (in fact its inability to do so became increasingly obvious as the century progressed) but a more animate entity, highly responsive to, even shaped by, the psychological currents that flowed within it' (p. 6). Although Sidlauskas sees ambivalence in the work of American expatriates John Singer Sargent and William Merritt Chase, I find her reading of Chase's *Hide and Seek* more anomalous in its tensions than typical of his work. Her more persuasive discussion of Edmund Tarbell and William Paxton focuses, as I will below, on works that are much later than those by the French and expatriate artists she considers. It would seem then that the trend toward seeing the interior space as a destabilizing one psychologically was a bit slower to pervade American Impressionist art. Sidlauskas herself makes this argument in pp. 209–10, where she also points out that the first artist to establish the genre of the empty interior is American Walter Gay – another expatriate.

19. See Martha Banta's book *Imaging American Women: Idea and Ideals in Cultural History* (New York NY: Columbia University Press, 1987).

20. Burns makes this argument in both *Inventing the Modern Artist* and 'Revitalizing the "Painted-Out" North: Winslow Homer, Manly Health, and New England Regionalism in Turn-of-the-Century America,' in *American Art*, vol. 9, no. 2 (Summer 1995), 21–37.

21. 'Art Proficiency in the Ten's Show,' *Evening Mail*, 21 March 1907, p. 5, as quoted in *The Art of Frank W. Benson: American Impressionist* (exhibition catalogue, Salem MA: Peabody Essex Museum, 2000), p. 68.

22. John F. Kasson, *Rudeness and Civility: Manners in Nineteenth-Century Urban America* (New York NY: Hill & Wang, 1990).

23. Karen Halttunen, 'From Parlor to Living Room: Domestic Space, Interior Decorations, and the Cult of Personality,' in *Consuming Visions: Accumulation and Display of Goods in America, 1880–1920* (New York NY: W.W. Norton, 1989), pp. 157–89.

24. Susan Hobbs, Yu-Tarng Cheng, and Jacqueline S. Olin, 'Thomas Wilmer Dewing: A Look Beneath the Surface,' in *Smithsonian Studies in American Art*, vol. 4, no. 34 (Summer–Autumn 1990), 62–85. Strikingly, the sitter is 'a fellow artist who lived nearby' (71).

25. Ruth E. Iskin, *Modern Women and Parisian Consumer Culture in Impressionist Painting* (New York NY: Cambridge University Press, 2007), p. 23.

26. Sarah Burns, 'Winslow Homer's Ambiguously New Women,' in *Off the Pedestal: New Women in the Art of Homer, Chase, and Sargent*, ed. Holly Pyne Connor (Newark NJ: Newark Museum, and New Brunswick NJ: Rutgers University Press, 2006).

27. Michel de Certeau, *The Practice of Everyday Life*, trans. Stephen Rendall (Berkeley CA: University of California Press, 1984).

28. Iskin, *Modern Women*, p. 32.

29. Katharine C. Grier, *Culture and Comfort: Parlor Making and Middle-Class Identity, 1850–1930* (Washington DC: Smithsonian Institution, 1997), p. 12.

30. Shawn Michelle Smith, *American Archives: Gender, Race, and Class in Visual Culture* (Princeton NJ: Princeton University Press, 1999), pp. 220–21.

31. Naturally this is not the case in new media art – video and animation – where a depicted subject can move, change, and act. But stasis is both the strength and the weakness of traditional art forms.

32. Elizabeth Broun makes this argument about Hassam's *The Hovel and the Skyscraper* (1904, private collection): 'His vantage point rises with the construction, but in this picture he balances progress and ambition with a new appreciation for what is being obliterated. His city scenes from the nineteenth century had looked eagerly forward without a backward glance, but ... Hassam perceptively frames a fleeting moment and introduces into his art a first note of nostalgia' (Elizabeth Broun, 'Childe Hassam's America,' in *American Art*, vol. 13, no. 3 (Autumn 1999), 32–57; at 42). Broun goes on to show Hassam's later turn toward Anglocentrism and Spencerian evolutionary theory in the context of the shifting racial tensions of this period, specifically as shown in *Tanagra (The Builders)*.

33. Tamar Katz, *Impressionist Subjects: Gender, Interiority, and Modern Fiction in England* (Urbana IL: University of Illinois Press, 2000), p. 45.

34. An obvious exception occurs in popular culture, where the Gibson Girl and other images of the New Woman did appear. For more on the New Woman in American culture, see *The American New Woman Revisited: A Reader, 1894–1930*, ed. Martha H. Patterson (New Brunswick NJ: Rutgers University Press, 2008).

Epilogue

Feminist materialist theory suggests that the studio, the gallery, the exhibition
catalogue are not separate, but form interdependent moments in the cultural
circuit of capitalist production and consumption. They are also overlapping sets
within the signifying system which collectively constitutes the discourse of art.
While the spaces of art have specific and local determinants and forms, they are,
furthermore, part of a continuum with other economic, social, ideological practices
which constitute the social formation as a whole. – Griselda Pollock[1]

William Merritt Chase's *A Friendly Call* and Mary Fairchild MacMonnies
Low's *Dans la nursery* are both seemingly mundane and typical late
nineteenth-century paintings of domestic interiors. Both depict women
taking up the tasks associated with the maintenance of bourgeois home life,
newly redefined by the Industrial Age. In both images, one of the primary
figures in the image is a female family member of the artist (Chase's wife
Alice and Fairchild's daughter Berthe), and the room depicted is within the
artist's own home. The rooms are decorated with a variety of furnishings,
including several paintings and textiles. Both images imply bourgeois life
and leisure, as well as implying the presence of the artist without actually
showing him or her.

Even some apparent differences can be read as similarities. The women
in each image are performing household duties, but these differ in apparent
laboriousness. In one case, we see servants at work in sewing and caring for
a child that is not their own. To twentieth-century eyes, such labor seems
more demanding at first than that engaged in by the women in *A Friendly
Call*, who are merely sitting and chatting. Yet a better understanding of late
nineteenth-century etiquette and the gendered division of labor alters this
view. The women chatting in what looks like a parlor are in fact doing work,
as their conversation could advance their husbands' businesses, or destroy
someone's reputation, or guarantee a daughter's successful marriage to
a social 'superior.' So in both paintings we see the feminized labor of the
bourgeois household, although in one case by paid servants and in the

other by unpaid housewives. Furthermore, these issues are not confined to the late nineteenth century, as the current plethora of 'mommy blogs' and television programs about nannies clearly show. That we still devalue labor, particularly in the domestic sphere, and perceive it as the duty of the XX chromosome bearer, makes these paintings more relevant to current social life than may at first be evident. The same may be said for social networking and the importance of domestic visual arrangements, both of which play a major part of Internet use, magazine sales, and television marketing.

None of the above similarities between Chase's and Fairchild's paintings is particularly surprising or illuminating, at least at first glance. Many such images were produced by other contemporary artists, and no strident, dogmatic statement issues from either of these two works to give the viewer pause. A closer inspection begins to unseat one's confidence in the ordinariness of the images, however. Should a viewer of the Chase painting begin to do some exploratory research, his or her interpretation of its space as a parlor is quickly contested. This is not Alice Chase's room, decorated and used by her to maintain the family's social standing and business success. It is William Chase's studio – a quite famous one at that, shown in contemporary journals as an exemplary 'summer studio' in Chase's grand style. How can this room be both a parlor and a man's workplace, if we understand parlors in the late nineteenth century to be a woman's 'workplace'?

A viewer of Fairchild's painting would not have the same delay in recognizing the room as a studio, since the skylight and easel provide simple and recognizable iconographic markers of the space's identity. But the title, and some of the painting's other subjects, do not allow the viewer to rest on this evidence. So, one wonders, is this a studio or a nursery? Is it both? The viewer's research would lead to another surprising finding: there are no other paintings like it, in which a woman artist of this time and stature depicts both her home life and her work life simultaneously. When the question of these domestic interiors as studios is raised, both paintings become much more complex.

Close readings of the studio paintings of Chase and Fairchild show that relying upon interpretations that depend on the rhetoric of separate spheres to explain late nineteenth-century art is fundamentally limiting. It is certainly true, as I showed in Chapter 1, that the strict division of masculine and feminine, of public and private, of domesticity and labor was a pervasive and powerful construct during this period. Overt violations of the boundaries of these dichotomies were often read as threatening to the moral and economic makeup of bourgeois society. We see this threat when suffrage is thought to destroy the sanctity of home and family and Oscar Wilde is imprisoned for homosexuality. However, we need to distinguish between the normative constructs that society appears to accept and reflect and the actual practices of individuals – as well as when those normative constructs only serve to

cause other practices and individuals to disappear, because of their race, class, or the type of labor they perform. *A Friendly Call* and *Dans la nursery* are two publicly displayed paintings by successful and well-known artists that defy the traditional understanding of late nineteenth-century society, gender roles, and art. That they do so subtly renders them no less subversive, merely more strategic – which is itself a requirement of negotiating social norms if one wishes to avoid social censure or othering.

In the twentieth and twenty-first centuries, women artists are more willing to show their own complexities openly because we have come to accept such representations more readily. Surely such change comes from people like Fairchild who lived and painted their lives with some awareness that they could not be confined by simple categorization. Each woman who made such a statement, in any field of endeavor, added to the eventually effective demand for more rights and greater societal freedom. We can only truly recuperate the valuable artistic legacies of the past if we can see people as individuals, rather than only as societal constructs of masculinity and femininity behaving according to normative values (to say nothing of limiting such a conversation even more fully by focusing on biological sex and its false binaries). In Griselda Pollock's words, 'The problem then, as now, is to find terms in which to analyse the *specificity* of women as subjects in a social and historical world without confirming that particularity as nothing more than difference; that is, that women are just women.'[2]

In the last decade, contemporary feminism, race theory, queer theory, disability studies, postcolonial theory, and communication studies have been aggressively challenging binary understandings of American culture.[3] As I have shown, accepting bifurcated constructions of gender has hurt the artistic and social lives of both women and men. If a work has 'feminine' qualities but was produced by a man, elaborate gymnastics are required to continue to see the man as a man. Chase was not entirely effeminate, but he was not entirely macho either; like all people, he felt and represented more than one facet of his identity. Scholars have either uncomfortably contrasted these qualities or avoided the issue altogether, rather than see him as performing a more multivalent self. In Chapter 2, I address Chase as both the member of a privileged, dominant class and race of men struggling to maintain their elevated status and appearance of powerful masculinity and as a man who painted pretty pictures, knew what his wife and children did all day because he was with them, and liked to play dress-up with them, himself, and his surroundings. Fairchild was able to create the work she did in part by leaving the US and in part because she was of a class that could afford servants to 'cover' her domestic responsibilities – her privilege in one area allowed her to stake claims in another that would not have been open to all women. Neither Chase's nor Fairchild's paintings totally fit the rhetoric of separate spheres, and they deserve to be considered more wholly.

American Impressionism deserves the same consideration of its unique qualities as these individual artists and their works. True, it is not French Impressionism, but it is not a poor copy either. Once we address these types of differences, rather than categorizing and then ignoring them, we will open up modern art history to more effective and complete understandings. Accepting this text as such an attempt, there may be other artists who can be addressed through these multiple lenses. There are in fact other artists, male and female, whose work is as revolutionary or complex as Fairchild's and Chase's, but whom we do not 'see,' because we have placed them in a category that they cannot escape on their own. For example, Alice Ravenel Huger Smith (1876–1958), a self-taught watercolorist from Charleston, South Carolina, devoted her life to documenting the low country rice plantations, the lives of slaves and former slaves, and the quickly fading life of the Antebellum South that she grew up in. Triply doomed as a southern woman artist using a 'lesser' medium than oil and depicting a nostalgic past during a time when the art world valued progress above all, Smith has received almost no art-historical attention despite the obvious quality of her work and the potential for reading it in terms of Southern social history, the role of memory in representation, or the metaphoric use of water as a medium in a water-driven economy. Yet, like Fairchild, Smith appears in brief entries in compendia of women artists and the occasional monographic reproduction-focused book, but rarely in critical texts where her work might be addressed fully in terms of meaning (John Michael Vlach's 2002 *The Planter's Prospect*, which devotes one of eight chapters to her, is the only one I have located).

There are more conventional paths that remain surprisingly untraveled as well. In my research, I learned something that was always evident but undiscussed: the paucity of women's painted representations of their studios. Part of the reason for the lack of discussion is that there were so many images by male artists of their studios that it was easy to see the whole field as flooded, rather than take note of just whom it was flooded by. This caused the false attribution of Fairchild's painting to her husband, because it seemed 'natural' to assume that he would represent his workspace, while she would not. Historians took for granted that the photographs of women's studios, combined with the few self-portraits, covered the issue of self-representation significantly, thereby ignoring the fact that studio paintings were a major and popular subject matter in the late nineteenth century.

Have we been similarly overlooking other subjects? Despite the clear hierarchization of representational subjects in terms of both normative art canons and the gendering of those canons, there are many genres that have not been considered. Certainly, vaginal flower paintings are an easy locus of feminist art criticism. But why has there been no feminist probing into the representation of landscapes? Although we have noted the tendency across art history to represent women as the human correlative of nature,

and the tendency to depict bourgeois women in 'domesticated' outdoor scenes like parks and gardens, where is the discussion of women artists painting landscape scenes?[4] The relative dearth of women artists compared to representations of women explains this in part, but only in part. In other words, we have said so much about so few women artists and so much more about the women in paintings, that we can scarcely say we have scratched the surface of understanding the role of gender in art or the role that gender has in canonizing one artist over another. In a sense, we only reaffirm the boundaries that we are trying to break down when we only write about O'Keeffe's vulva-flowers or Morisot's wet-nurse.[5]

As the above suggestions show, I focus here on one set of many sites and figures deserving reinterpretation in terms of gender and art. Using the studio as a locus for this particular reinterpretation has caused me to re-evaluate the importance of it, both as an actual space and as a representation, to our understanding of nineteenth-century art, art history, and culture. The radical difference between our understanding and study of men's studios and that of women's studios is therefore the most significant aspect of this study. Having realized that the most basic reason for that difference was our acceptance of the binary divisions of both space and subject matter in nineteenth-century art and culture, I have written a text that brings all of these issues together, rather than addressing them singly as historians have done in the past. In Linda Kerber's essay, 'Separate Spheres, Female Worlds, Woman's Place: The Rhetoric of Women's History,' she argues that if we continue to accept the concept and rhetoric of separate spheres, we are imposing 'a static model on dynamic relationships,' and that we rely on this model because we 'live in a world in which authority has traditionally validated itself by its distance from the feminine and from what is understood to be effeminate.' Rather than use the trope of separate spheres to communicate our understanding of gender more easily but inaccurately, Kerber calls for us to take the opportunities poststructuralist theories offer to tell a more complex story.[6] This book takes up that challenge, weaving histories of nineteenth-century culture and society together with analyses of both male and female artists' depictions of the studio, choosing to see all elements as multivalent.

Notes

1. Griselda Pollock, *Looking Back to the Future: Essays on Art, Life and Death* (Amsterdam: G & B Arts International, 2001), p. 79.

2. Pollock, *Looking Back*, p. 79.

3. See particularly *Beyond the Binary: Reconstructing Cultural Identity in a Multicultural Context*, ed. Timothy Powell (New Brunswick NJ: Rutgers University Press, 1999); Judith Butler, *Bodies That Matter: On the Discursive Limits of 'Sex'* (New York NY: Routledge, 1991); Werner Sollors, *Neither Black Nor White yet Both: Thematic Explorations of Interracial Literature* (Cambridge MA: Harvard University Press, 1999); and Cathy N. Davidson and Jessamyn Hatcher, eds, *No More Separate*

Spheres! A Next Wave American Studies Reader (Durham NC: Duke University Press, 2002). In art history, I am particularly fond of the collection of essays, including the introduction, that directly challenge simplistic binary histories while retaining an awareness of the role these constructs play in lived experience in Norma Broude and Mary D. Garrard's *Reclaiming Female Agency: Feminist Art History After Postmodernism* (Berkeley CA: University of California Press, 2005). Darcy Grimaldo Grigsby and Norma Broude take the issue head-on, but in terms of more canonical (Jacques-Louis David) or exceptional (Mary Cassatt) artists than I do here.

4. I had hoped that Stacy Alaimo's book *Undomesticated Ground: Recasting Nature as Feminist Space* might have led to more art-historical study of this area, but as at the time of writing that has not occurred (Ithaca NY: Cornell University Press, 2000).

5. Kathleen Adler and Tamar Garb pointed this out in 1986, speaking of the attention paid to Morisot, who at that time was still relatively unstudied compared to the body of work that now surrounds her: 'Indeed, it is because of her involvement with avant garde circles and her adherence to the conventions of picturing inscribed in these circles that she has remained relatively visible as an artist, even when most women artists, some extremely successful in their own time, have been all but forgotten. She poses few problems for traditional art history and is easily reincorporated into a tradition whose criteria for assessments of "quality" and "significance" remain unchanged, and whose writing remains unproblematically framed within what Derrida has called phallogocentric language.' In Denis Rouart, ed., *The Correspondence of Berthe Morisot with her Family and her Friends Manet, Puvis de Chavannes, Degas, Monet, Renoir, and Mallarmé* (trans. Betty W. Hubbard, London: Camden Press, 1986), p. 3.

6. Linda Kerber, 'Separate Spheres, Female Worlds, Woman's Place: The Rhetoric of Women's History,' in *Domestic Ideology and Domestic Work*, Part 1, in vol. 4 of *History of Women in the United States: Historical Articles on Women's Lives and Activities*, ed. Nancy F. Cott (Munich: K.G. Saur, 1992), pp. 173–203, esp. pp. 201–3. Patricia Zakreski's *Representing Female Artistic Labour, 1848–1890* (Burlington VT: Ashgate, 2006) is a particularly excellent move in this direction, showing the false dichotomy of separate spheres in Victorian women's lives, particularly in terms of craft artisanship, writing, and performing.

Bibliography

Abrams, Ann Uhry. 'Frozen Goddess: The Image of Woman in Turn-of-the-Century American Art.' In *Woman's Being, Woman's Place: Female Identity and Vocation in American History*. Ed. Mary Kelley. Boston MA: G.K. Hall & Co., 1977, pp. 93–108.

Adler, Kathleen, and Tamar Garb. *Berthe Morisot*. Ithaca NY: Cornell University Press, 1987.

Adler, Kathleen, Erica E. Hirshler, and H. Barbara Weinberg. *Americans in Paris 1860–1900*. Exhibition catalogue. London: National Gallery, 2006.

Agnew, Jean-Christophe. 'A House of Fiction: Domestic Interiors and the Commodity Aesthetic.' In *Consuming Visions: Accumulation and Display of Goods in America 1880–1920*. Ed. Simon J. Bronner. New York NY: W.W. Norton, 1989, pp. 133–56.

———. 'The Consuming Vision of Henry James.' In *The Culture of Consumption*. Ed. Richard Wightman Fox and T.J. Jackson Lears. New York NY: Pantheon, 1983, pp. 65–100.

Alaimo, Stacy. *Undomesticated Ground: Recasting Nature as Feminist Space*. Ithaca NY: Cornell University Press, 2000.

Allen, Elizabeth. *A Woman's Place in the Novels of Henry James*. New York NY: St. Martin's Press, 1984.

American Painters on the French Scene 1874–1914. Exhibition catalogue. New York NY: Beacon Hill Fine Art, 1996.

Americans in Paris 1850–1910: The Academy, the Salon, the Studio, and the Artist's Colony. Exhibition catalogue. Oklahoma City OK: Oklahoma City Museum of Art, 2003.

Appignanesi, Lisa. *Femininity and the Creative Imagination: A Study of Henry James, Robert Musil and Marcel Proust*. New York NY: Harper & Row, 1973.

The Artist's Studio in American Painting 1840–1983. Exhibition catalogue. Allentown PA: Allentown Art Museum, 1983.

The Art of Frank W. Benson: American Impressionist. Exhibition catalogue. Salem MA: Peabody Essex Museum, 2000.

Ashton, Dore. *Rosa Bonheur: A Life and a Legend*. New York NY: Viking, 1981.

Banta, Martha. *Imaging American Women: Idea and Ideals in Cultural History*. New York NY: Columbia University Press, 1987.

Barker, Deborah. *Aesthetics and Gender in American Literature: Portraits of the Woman Artist*. Lewisburg PA: Bucknell University Press, and London (UK): Associated University Presses, 2000.

Barringer, Tim. *Men at Work: Art and Labour in Victorian Britain*. New Haven CT: Yale University Press, 2005.

_____ and Elizabeth Prettejohn. *Frederic Leighton: Antiquity, Renaissance, Modernity*. New Haven CT: Yale University Press, 1999.

Barter, Judith A., et al. *Mary Cassatt: Modern Woman*. Exhibition catalogue. Chicago IL: Art Institute of Chicago, 1998.

Baudelaire, Charles. *The Painter of Modern Life and Other Essays*. Ed. and trans. Jonathan Mayne. New York NY: Da Capo Press, 1986, repr. from Phaidon's 1964 edn.

Baxandall, Michael. *Patterns of Intention: On the Historical Explanation of Pictures*. New Haven CT: Yale University Press, 1985.

Beaux, Cecilia. *Background with Figures*. Boston MA: Houghton Mifflin, 1930.

Bellony-Rewald, Alice, and Michael Peppiatt. *Imagination's Chamber: Artists and Their Studios*. Boston MA: Little, Brown, 1982.

Berland, Alwyn. *Culture and Conduct in the Novels of Henry James*. Cambridge: Cambridge University Press, 1981.

Betsky, Celia. 'In the Artist's Studio.' *Portfolio*, January–February 1982, 32–9.

Blaugrund, Annette. *The Tenth Street Studio Building: Artist-Entrepreneurs from the Hudson River School to the American Impressionists*. Southampton NY: Parrish Art Museum, 1997.

Boime, Albert. *The Academy and French Painting in the Nineteenth Century*. New Haven CT: Yale University Press, 1986.

_____ . 'The Case of Rosa Bonheur: Why Should a Woman Want to Be More Like a Man?' *Art History*, vol. 4, no. 4 (December 1981), 384–409.

Booker, Margaret Moore. *Nantucket Spirit: The Art and Life of Elizabeth Rebecca Coffin*. Nantucket MA: Mill Hill Press, 2001.

Bourguignon, Katherine M. 'Impressionist Giverny: American Painters in France.' *American Art Review*, vol. 20, no. 3 (2008), 100–13.

_____ , ed. *Impressionist Giverny: A Colony of Artists, 1885–1915*. Giverny: Musée d'Art Américain Giverny, 2007.

Bowden, Edwin T. *The Themes of Henry James: A System of Observation through the Visual Arts*. New Haven CT: Archon, 1969.

Brooks, Van Wyck. *The Confident Years: 1885–1915*. New York NY: E.P. Dutton, 1955.

Broude, Norma. 'Mary Cassatt: Modern Woman or the Cult of True Womanhood?' In *Reclaiming Female Agency: Feminist Art History After Postmodernism*. Eds Norma Broude and Mary D. Garrard. Berkeley CA: University of California Press, 2005, pp. 258–75.

_____ . *Impressionism: A Feminist Reading: The Gendering of Art, Science and Nature in the Nineteenth Century*. New York NY: Rizzoli, 1991.

Broun, Elizabeth. 'Childe Hassam's America.' *American Art*, vol. 13, no. 3 (Autumn 1999), 32–57.

Brown, Gillian. *Domestic Individualism: Imagining Self in Nineteenth-Century America*. Berkeley CA: University of California Press, 1990.

Bryant, Keith L. Jr. *William Merritt Chase: A Genteel Bohemian*. Columbia MO: University of Missouri Press, 1991.

Burns, Sarah. *Inventing the Modern Artist: Art and Culture in Gilded Age America*. New Haven CT: Yale University Press, 1996.

_____ . 'Revitalizing the "Painted-Out" North: Winslow Homer, Manly Health, and New England Regionalism in Turn-of-the-Century America.' *American Art*, vol. 9, no. 2 (Summer 1995), 21–37.

_____ . 'The Price of Beauty: Art, Commerce, and the Late Nineteenth-Century American Studio Interior.' In *American Iconology: New Approaches to Nineteenth-Century Art and Literature*. Ed. David C. Miller. New Haven CT: Yale University Press, 1993, pp. 208–38.

_____ . 'The "Earnest, Untiring Worker" and the Magician of the Brush: Gender Politics in the Criticism of Cecelia Beaux and John Singer Sargent.' *The Oxford Art Journal*, vol. 15, no. 1 (1992), 36–53.

Butler, Judith. *Excitable Speech: A Politics of the Performative*. New York NY: Routledge, 1997.

_____ . *Bodies That Matter: On the Discursive Limits of 'Sex'*. New York NY: Routledge, 1991.

_____ . 'Imitation and Gender Insubordination.' In *Inside/Out: Lesbian Theories, Gay Theories*. Ed. Diana Fuss. New York NY: Routledge, 1991, pp. 13–31.

_____ . *Gender Trouble: Feminism and the Subversion of Identity*. New York NY: Routledge, 1990.

Caffin, Charles H. *The Story of American Painting: The Evolution of Painting in America from Colonial Times to the Present* [1907]. New York NY: Johnson Reprint Corporation, 1970.

Campbell, Louise. 'Decoration, Display, Disguise: Leighton House Reconsidered.' In *Frederic Leighton: Antiquity, Renaissance, Modernity*. New Haven CT: Yale University Press, 1999, pp. 257–94.

Carr, Carolyn Kinder, and Sally Webster. 'Mary Cassatt and Mary Fairchild MacMonnies: The Search for Their 1893 Murals.' *American Art*, vol. 8, no. 1 (Winter 1994), 53–70.

Cass, David B. *In the Studio: The Making of Art in Nineteenth-Century France*. Exhibition catalogue. Williamstown MA: Sterling and Francine Clark Art Institute, 1981.

Cecilia Beaux: Portrait of an Artist. Exhibition catalogue. Philadelphia PA: Pennsylvania Academy of the Fine Arts, 1974.

Certeau, Michel de. *The Practice of Everyday Life*. Trans. Stephen Rendall. Berkeley CA: University of California Press, 1984.

Challons-Lipton, Siulolovao. *The Scandinavian Pupils of the Atelier Bonnat*. Lewiston NY: Edwin Mellen Press, 2001.

Chase, Vanessa. 'Edith Wharton, *The Decoration of Houses*, and Gender in Turn-of-the-Century America.' In *Architecture and Feminism*. Eds Debra L. Coleman, Elizabeth Ann Danze, and Carol Jane Henderson. New York NY: Princeton Architectural Press, 1996, pp. 130–60.

Cheney, Liana De Girolami, ed. *Essays on Women Artists: 'The Most Excellent'*. Lewiston NY: Edwin Mellen Press, 2003.

_____ with Alicia Craig Faxon and Kathleen Lucey Russo. *Self-Portraits by Women Painters*. Brookfield VT and Aldershot: Ashgate, 2000.

Cherry, Deborah. *Painting Women: Victorian Women Artists*. London: Routledge, 1993.

Chessman, Harriet. 'Mary Cassatt and the Maternal Body.' In *American Iconology: New Approaches to Nineteenth-Century Art and Literature*. Ed. David C. Miller. New Haven CT: Yale University Press, 1993, pp. 239–58.

Chopin, Kate. *The Awakening* [1899]. See Culley for 1994 Norton Critical Edition.

Cikovsky, Nicolai. *William Merritt Chase: Summers at Shinnecock 1891–1902*. Exhibition catalogue. Washington DC: National Gallery of Art, 1987.

Clark, T.J. *The Painting of Modern Life: Paris in the Art of Manet and His Followers*. Princeton NJ: Princeton University Press, 1984.

Clement, Clara Erskine. *Women in the Fine Arts: From the Seventh Century B.C. to the Twentieth Century A.D.* [1904]. New York NY: Hacker Art Books, 1974.

Clement, Russell T., et al. *The Women Impressionists: A Sourcebook*. Westport CT: Greenwood, 2000.

Cole, Helen. 'American Artists in Paris.' *Brush and Pencil*, vol. 4, no. 4 (July 1899), 199–202.

Coles, William A. *Alfred Stevens*. Exhibition catalogue. Ann Arbor MI: University of Michigan Museum of Art, 1977.

Conger-Kaneko, Josephine. 'The 'Effeminization' of the United States.' *The World's Work* (May 1906), 7521–4.

Connor, Holly Pyne, ed. *Off the Pedestal: New Women in the Art of Homer, Chase, and Sargent*. Newark NJ: Newark Museum, and New Brunswick NY: Rutgers University Press, 2006.

Cortissoz, Royal. 'Spring Art Exhibitions. The Society of American Artists.' *Harper's Weekly*, vol. 39 (April 1895), 318.

Cott, Nancy F., ed. *Domestic Ideology and Domestic Work*. Vol. 4 of the series *History of Women in the United States: Historical Articles on Women's Lives and Activities*. Munich: K.G. Saur, 1992.

Crary, Jonathan. *Suspensions of Perception: Attention, Spectacle, and Modern Culture*. Cambridge MA: MIT Press, 2000.

Culley, Margo, ed. *Kate Chopin's 'The Awakening': An Authoritative Text, Biographical and Historical Contexts, and Criticism*. New York NY: W.W. Norton, 1994.

Davidson, Cathy N., and Jessamyn Hatcher, eds. *No More Separate Spheres! A Next Wave American Studies Reader*. Durham NC: Duke University Press, 2002.

Degler, Carl N. *At Odds: Women and the Family in America from the Revolution to the Present*. New York NY: Oxford University Press, 1980.

Dirt and Domesticity: Constructions of the Feminine. Exhibition catalogue. New York NY: Whitney Museum of American Art, 1992.

Docherty, Linda J. 'Model-Families: The Domesticated Studio Pictures of William Merritt Chase and Edmund C. Tarbell.' In *Not at Home: The Suppression of Domesticity in Modern Art and Architecture*. Ed. Christopher Reed. London: Thames & Hudson, 1996, pp. 48–64.

Doezema, Marianne, and Elizabeth Milroy. *Reading American Art*. New Haven CT: Yale University Press, 1998.

Douglas, Ann. *Terrible Honesty: Mongrel Manhattan in the 1920s*. New York NY: Farrar, Straus & Giroux, 1995.

———. *The Feminization of American Culture*. New York NY: Alfred A. Knopf, 1977.

Downes, William Howe. 'William Merritt Chase, A Typical American Artist.' *The International Studio*, vol. 39, no. 154 (December 1909), 29–36.

Dudden, Faye E. *Serving Women: Household Service in Nineteenth-Century America*. Middletown CT: Wesleyan University Press, 1983.

Duranty, Louis Emile Edmond. *La nouvelle peinture à propos du groupe d'artistes qui expose dans les galeries du Durand-Ruel*. Paris: E. Dentu, 1876.

Duret, Théodore. *Histoire de Edouard Manet et de son oeuvre avec un catalogue des peintures et des pastels*. Paris: Bernheim-Juene, Editeurs d'Art, 1926.

Durkee, Mary. 'In the (Female) Artist's Studio: Urban Bohemia's Dangerous Spaces.' In *Auto-Poetica: Representations of the Creative Process in Nineteenth-Century British and American Fiction*. Oxford: Lexington, 2006, pp. 129–38.

Edelstein, T.J., ed. *Perspectives on Morisot*. New York NY: Hudson Hills Press, 1990.

Edwards, Lee M. *Domestic Bliss: Family Life in American Painting 1840–1910*. Exhibition catalogue. Yonkers NY: Hudson River Museum, 1986.

Eiland, William U., ed. *Crosscurrents in American Impressionism at the Turn of the Century*. Athens GA: Georgia Museum of Art, University of Georgia, 1996.

Erwin, John W. 'Henry James Circumvents Lessing and Derrida.' In *So Rich a Tapestry: The Sister Arts and Cultural Studies*. Ed. Ann Hurley and Kate Greenspan. Lewisburg PA: Bucknell University Press, 1995, pp. 125–35.

Faces of Impressionism: Portraits from American Collections. Exhibition catalogue. Baltimore MD: Baltimore Museum of Art, 1999.

Falk, Peter Hastings, ed. *The Annual Exhibition Record of the Art Institute of Chicago 1855–1950.* Madison CT: Sound View Press, 1990.

Filene, Peter G. *Him/Her/Self: Gender Identities in Modern America.* 3rd edn. Baltimore MD: Johns Hopkins University Press, 1998.

Fink, Lois Marie. *American Art at the Nineteenth-Century Paris Salons.* Cambridge: Cambridge University Press, 1990.

_____ and Joshua C. Taylor. *Academy: The Academic Tradition in American Art.* Exhibition catalogue. Washington DC: National Collection of Fine Arts, Smithsonian Institution Press, 1975.

Finkelstein, Christine E. 'Mary Fairchild MacMonnies Low.' Unpubl. master's thesis. New York NY: City College of New York, 1989.

Fischer, Diane P. *Paris 1900: The 'American School' at the Universal Exposition.* Exhibition catalogue. New Brunswick NJ: Montclair Art Museum and Rutgers University Press, 1999.

Flexner, James Thomas, et al. *The Shaping of Art and Architecture in Nineteenth-Century America.* New York NY: Metropolitan Museum of Art, 1972.

Forbes, Jessica. 'The Power of Looking: The Gaze in *The Portrait of a Lady*.' In *Henry James and the Visual Culture of Modernity*, online publication of the University of Aarhus Department of English, 2006, pp. 34–43.

Fortune, Brandon Brame. '"Not above Reproach": The Career of Lucy Lee-Robbins.' *American Art*, vol. 12, no. 1 (Spring 1998), 41–65.

Frascina, Francis, et al. *Modernity and Modernism: French Painting in the Nineteenth Century.* New Haven CT: Yale University Press, 1993.

Frederick William MacMonnies (1863–1937), Mary Fairchild MacMonnies (1858–1946): deux artistes américains à Giverny. Exhibition catalogue. Vernon (France): Musée Municipal Alphonse-Georges Poulain, 1988.

Gallati, Barbara Dayer. *William Merritt Chase.* New York NY: Harry N. Abrams, 1995.

Garb, Tamar. *Sisters of the Brush: Women's Artistic Culture in Late Nineteenth-Century Paris.* New Haven CT: Yale University Press, 1994.

_____ . 'L'Art Féminin': The Formation of a Critical Category in Late Nineteenth-Century France.' *Art History*, vol. 12, no. 1 (March 1989), 39–65.

Gaze, Delia, ed. *Dictionary of Women Artists.* London: Fitzroy Dearborn, 1997.

Gerdts, William H. *Monet's Giverny: An Impressionist Colony.* New York NY: Abbeville, 1993.

_____ . *Lasting Impressions: American Painters in France 1865–1915.* Exhibition catalogue. New York NY: Terra Foundation for the Arts, 1992.

_____ . *American Impressionism.* New York NY: Artabras, 1984.

Gere, Charlotte. *Nineteenth-Century Decoration: The Art of the Interior.* New York NY: Harry N. Abrams, 1989.

Greatorex, Eleanor. 'Mary Fairchild MacMonnies.' *Godey's Magazine*, vol. 126, no. 755 (May 1893), 630.

Green, Harvey. *The Light of the Home: An Intimate View of the Lives of Women in Victorian America.* New York NY: Pantheon, 1983.

Grier, Katherine C. *Culture and Comfort: Parlor Making and Middle-Class Identity, 1850–1930.* Washington DC: Smithsonian Institution, 1997. (Orig. publ. as *Culture and Comfort: People, Parlors, and Upholstery 1850–1930.* Amherst MA: University of Massachusetts Press, 1988.)

Griffin, Susan M. *The Historical Eye: The Texture of the Visual in Late James.* Boston MA: Northeastern University Press, 1991.

Halttunen, Karen. 'From Parlor to Living Room: Domestic Space, Interior Decorations, and the Cult of Personality.' In *Consuming Visions: Accumulation and Display of Goods in America, 1880–1920*. New York NY: W.W. Norton, 1989, pp. 157–89.

Handlin, David P. *The American Home: Architecture and Society, 1815–1915*. Boston MA: Little, Brown, 1979.

Hargrove, June, ed. *The French Academy: Classicism and Its Antagonists*. Newark DE: University of Delaware Press, 1990.

Harris, Neil. *The Artist in American Society: The Formative Years 1790–1860*. New York NY: George Braziller, 1966.

Harrison, Charles, and Paul Wood with Jason Gaiger, eds. *Art in Theory 1815–1900: An Anthology of Changing Ideas*. Oxford: Blackwell, 1998.

Havice, Christine. 'In a Class By Herself: Nineteenth-Century Images of the Woman Artist as Student.' *Woman's Art Journal*, Spring/Summer 1981, 35–40.

Helland, Janice. *The Studios of Frances and Margaret Macdonald*. Manchester: Manchester University Press, 1996.

Herbert, Robert L. *Impressionism: Art, Leisure, and Parisian Society*. New Haven CT: Yale University Press, 1988.

—— . 'Method and Meaning in Monet.' *Art in America*, vol. 67, no. 5 (September 1979), 90–108.

Hiesinger, Ulrich W. *Impressionism in America: The Ten American Painters*. New York NY: Prestel, 1991.

Higonnet, Anne. *Berthe Morisot's Images of Women*. Cambridge MA: Harvard University Press, 1992.

—— . *Berthe Morisot*. Berkeley CA: University of California Press, 1990.

—— . 'The Other Side of the Mirror.' In *Perspectives on Morisot*. Ed. T.J. Edelstein. New York NY: Hudson Hills Press, 1990, pp. 67–78.

Hills, Patricia. *John Singer Sargent*. Exhibition catalogue. New York NY: Whitney Museum of American Art, 1987.

—— . *Turn-of-the-Century America: Paintings, Graphics, Photographs 1890–1910*. Exhibition catalogue. New York NY: Whitney Museum of American Art, 1977.

Hirshler, Erica E. *A Studio of Her Own: Women Artists in Boston 1870–1940*. Boston MA: MFA, 2001.

Hobbs, Susan, Yu-tarng Cheng, and Jacqueline S. Olin. 'Thomas Wilmer Dewing: A Look Beneath the Surface.' *Smithsonian Studies in American Art*, vol. 4, no. 34 (Summer–Autumn, 1990), 62–85.

House, John. *Impressionism: Paint and Politics*. New Haven CT: Yale University Press, 2004.

Huber, Christine Jones. *The Pennsylvania Academy and Its Women*. Philadelphia PA: Pennsylvania Academy of the Fine Arts, 1974.

Hutton, John. 'Picking Fruit: Mary Cassatt's "Modern Woman" and the Woman's Building of 1893.' *Feminist Studies*, vol. 20, no. 2 (Summer 1994), 318–48.

In Pursuit of Beauty: Americans and the Aesthetic Movement. Exhibition catalogue. New York NY: Rizzoli, 1986.

An Interlude in Giverny. Exhibition catalogue. University Park PA: Palmer Museum of Art and Pennsylvania State University, and Giverny (France): Musée d'Art Américain Giverny, Terra Foundation for the Arts, 2000.

Iskin, Ruth E. *Modern Women and Parisian Consumer Culture in Impressionist Painting*. New York NY: Cambridge University Press, 2007.

James, Henry. *The Golden Bowl* [1904]. New York NY: Penguin, 1983.

Johnson, Patricia E. 'The Gendered Politics of the Gaze: Henry James and George Eliot.' *Mosaic: A Journal for the Interdisciplinary Study of Literature*, vol. 30, no. 1 (March 1997), 39–55.

Kasson, John F. *Rudeness and Civility: Manners in Nineteenth-Century Urban America.*
New York NY: Hill & Wang, 1990.

Katz, Esther, and Anita Rapone. *Women's Experience in America: An Historical
Anthology.* New Brunswick NJ: Transaction, 1980.

Katz, Tamar. *Impressionist Subjects: Gender, Interiority, and Modern Fiction in England.*
Urbana IL: University of Illinois Press, 2000.

Kelly, Francis, *The Studio and the Artist.* Newton Abbot: David & Charles, 1974.

Kessler, Marni Reva. *Sheer Presence: The Veil in Manet's Paris.* Minneapolis MN:
University of Minnesota Press, 2006.

Keyes, Donald D. *The Genteel Tradition.* Exhibition catalogue. Winter Park FL: Rollins
College, 1985.

Kimbrough, Sara Dodge. *Drawn From Life: The Story of Four American Artists whose
Friendship and Work began in Paris during the 1880s.* Jackson MS: University Press of
Mississippi, 1976.

Kimmel, Michael S. *Manhood in America: A Cultural History.* New York NY: Free Press, 1996.

———. 'Men's Responses to Feminism at the Turn of the Century.' *Gender & Society*
vol. 1, no. 3 (September 1987), 261–83.

Kirwin, Liza, with Joan Lord. *Artists in Their Studios: Images from the Smithsonian's
Archives of American Art.* New York NY: Collins Design, 2007.

Kofman, Sarah. 'The Narcissistic Woman: Freud and Girard.' In *French Feminist
Thought: A Reader.* Ed. Toril Moi. Oxford: Blackwell, 1987, pp. 210–26.

Konz, Louly Peacock. *Marie Bashkirtseff's Life in Self-Portraits (1858–1884): Woman as
Artist in Nineteenth-Century France.* Lewiston NY: Edwin Mellen Press, 2005.

———. 'Marie Bashkirtseff (1858–1884): The Self-Portraits, Journal, and Photographs
of a Young Artist.' PhD dissertation, University of North Carolina at Chapel Hill,
1997.

Langdale, Cecily. *Gwen John.* New Haven CT: Yale University Press, 1987.

Lears, T.J. Jackson. *No Place of Grace: Antimodernism and the Transformation of American
Culture 1880–1920.* New York NY: Pantheon, 1981.

———. 'Beyond Veblen: Rethinking Consumer Culture in America.' In *Consuming
Visions: Accumulation and Display of Goods in America 1880–1920.* Ed. Simon J.
Bronner. New York NY: W.W. Norton, 1989, pp. 133–56.

Lesser, Wendy. *His Other Half: Men Looking at Women Through Art.* Cambridge MA:
Harvard University Press, 1991.

Lethève, Jacques. *Daily Life of French Artists in the Nineteenth Century.* New York NY:
Praeger, 1972.

Levey, Michael. *The Painter Depicted: Painters as a Subject in Painting.* London: Thames
& Hudson, 1982.

Loftie, William John. *A Plea for Art in the House.* London: Macmillan, 1876.

Low, Will H. 'In an Old French Garden.' *Scribner's Magazine,* vol. 32 (July 1902), 3–16.

Lubin, David M. *Act of Portrayal: Eakins, Sargent, James.* New Haven CT: Yale
University Press, 1993.

Lynes, Russell. *The Art-Makers of Nineteenth-Century America.* New York NY:
Atheneum, 1970.

———. *The Tastemakers.* New York NY: Harper, 1954.

McCarthy, Kathleen D. *Women's Culture: American Philanthropy and Art, 1830–1930.*
Chicago IL: University of Chicago Press, 1991.

Mainardi, Patricia. *The End of the Salon: Art and the State in the Early Third Republic.*
Cambridge: Cambridge University Press, 1993.

Mancoff, Debra. N. *Mary Cassatt: Reflections of Women's Lives.* New York NY: Stewart,
Tabori, & Chang, 1998.

Manet, Julie. *Growing Up with the Impressionists: The Diary of Julie Manet*. Trans. Rosalind de Boland Roberts and Jane Roberts. London: Sotheby's, 1987.

Marsh, Margaret. 'Suburban Men and Masculine Domesticity, 1870–1915.' *American Quarterly*, vol. 40, no. 1 (March 1988), 165–86.

Martindale, Meredith. *Lilla Cabot Perry: An American Impressionist*. Washington DC: National Museum of Women in the Arts, 1990.

Mathews, Nancy Mowll, ed. *Cassatt and Her Circle: Selected Letters*. New York NY: Abbeville, 1984.

Milner, John. *The Studios of Paris: The Capital of Art in the Late Nineteenth Century*. New Haven CT: Yale University Press, 1988.

Morgan, H. Wayne. *New Muses: Art in American Culture 1865–1920*. Norman OK: University of Oklahoma Press, 1978.

Neil, J. Meredith. *Toward a National Taste: America's Quest for Aesthetic Independence*. Honolulu HI: University Press of Hawaii, 1975.

The New Painting: Impressionism 1874–1886. Exhibition catalogue. San Francisco CA: Fine Arts Museum of San Francisco, 1986.

Nochlin, Linda. *Representing Women*. London: Thames & Hudson, 1999.

———. *Women, Art, and Power*. New York NY: Harper & Row, 1988.

Nunn, Pamela Gerrish. *Problem Pictures: Women and Men in Victorian Painting*. England: Scolar, 1995.

———. *Victorian Women Artists*. London: Women's Press, 1987.

O'Leary, Elizabeth. *At Beck and Call: The Representation of Domestic Servants in Nineteenth-Century American Painting*. Washington DC: Smithsonian Institution Press, 1996.

Orienti, Sandra. *The Complete Paintings of Manet*. New York NY: Harry N. Abrams, 1967.

Orr, Clarissa Campbell, ed. *Women in the Victorian Art World*. Manchester: Manchester University Press, 1995.

Patterson, Martha H., ed. *The American New Woman Revisited: A Reader, 1894–1930*. New Brunswick NJ: Rutgers University Press, 2008.

Peck, James F., et al. *In the Studios of Paris: William Bouguereau and His American Students*. New Haven CT: Yale University Press, 2006.

Perry, Gill. *Women Artists and the Parisian Avant-Garde: Modernism and 'Feminine' Art, 1900 to the late 1920s*. Manchester: Manchester University Press, 1995.

Petit, Edith. 'Frederick MacMonnies, Portrait Painter.' *The International Studio*, 29 October 1906, 319–24.

Pevsner, Nikolaus. *Academies of Art, Past and Present*. London: Cambridge University Press, 1940.

Pisano, Ronald G. *William Merritt Chase: Portraits in Oil*, vol. 2. New Haven CT: Yale University Press, 2006.

———. *A Leading Spirit in American Art: William Merritt Chase 1849–1916*. Seattle WA: Henry Gallery Association, 1983.

———. *William Merritt Chase*. New York NY: Watson-Guptill, 1979.

———. *William Merritt Chase in the Company of Friends*. Exhibition catalogue. Southampton NY: Parrish Art Museum, 1979.

——— and Alicia Grant Longwell. *Photographs from the William Merritt Chase Archives at The Parrish Art Museum*. Southampton NY: Parrish Art Museum, 1992.

Pollock, Griselda. 'Louise Abbéma's *Lunch* and Alfred Stevens's *Studio*: Theatricality, Feminine Subjectivity and Space around Sarah Bernhardt, Paris, 1877–1888.' In *Local/Global: Women Artists in the Nineteenth Century*. Eds Deborah Cherry and Janice Helland. Burlington VT: Ashgate, 2006, 99–119.

_____ . *Looking Back to the Future: Essays on Art, Life and Death*. Amsterdam: G & B International, 2001.

_____ . *Differencing the Canon: Feminist Desire and the Writing of Art's Histories*. London: Routledge, 1999.

_____ . *Mary Cassatt: Painter of Modern Women*. London: Thames & Hudson, 1998.

_____ . *Vision and Difference: Femininity, Feminism, and Histories of Art*. London: Routledge, 1988.

_____ . and Roszika Parker, *Old Mistresses: Women, Art, and Ideology*. New York NY: Pantheon, 1981.

Powell, Timothy, ed. *Beyond the Binary: Reconstructing Cultural Identity in a Multicultural Context*. New Brunswick NJ: Rutgers University Press, 1999.

Pyne, Kathleen. 'Americans in Giverny: The Meaning of a Place.' In *Impressionist Giverny: A Colony of Artists, 1885–1915*. Ed. Katherine M. Bourguignon. Giverny (France): Musée d'Art Américain Giverny, 2007, pp. 45–55.

_____ . *Art and the Higher Life: Painting and Evolutionary Thought in Late Nineteenth-Century America*. Austin TX: University of Texas Press, 1996.

_____ . 'Evolutionary Typology and the American Woman in the Work of Thomas Dewing.' *American Art*, vol. 7, no. 4 (Fall 1993), 13–29.

Reed, Christopher, ed. *Not at Home: The Suppression of Domesticity in Modern Art and Architecture*. London: Thames & Hudson, 1996.

Reff, Theodore. 'The Pictures within Degas's Pictures.' *Metropolitan Museum Journal*, vol. 1 (1968), 125–66.

Rey, Jean Dominique. *Berthe Morisot*. Exhibition catalogue, trans. Shirley Jennings. Naefels (Switzerland): Bonfini Press, 1982.

Ringelberg, Kirstin. 'No Room of One's Own: Mary Fairchild MacMonnies Low, Berthe Morisot, and *The Awakening*.' *Prospects: An Annual of American Cultural Studies*, vol. 28 (2004), 127–54.

_____ . *Risking the Incoherence of Identity: Locating Gender in Late Nineteenth-Century Paintings of the Artist's Home Studio*. Ann Arbor MI: University of Michigan Press, 2001. (Orig. PhD dissertation, University of North Carolina at Chapel Hill, 2000.)

Roof, Katherine Metcalf. *The Life and Art of William Merritt Chase* [1917]. New York NY: Hacker Art Books, 1975.

Roth, Leland M. *The Architecture of McKim, Mead and White 1870–1920: A Building List*. New York NY: Garland, 1978.

Rouart, Denis, ed. *The Correspondence of Berthe Morisot with her Family and her Friends Manet, Puvis de Chavannes, Degas, Monet, Renoir, and Mallarmé*. Trans. Betty W. Hubbard. London: Camden Press, 1986.

Rousseau, Jean-Jacques. *Emile, or, Treatise on Education*. Trans. William H. Payne. New York NY: Prometheus, 2003.

_____ . *The Social Contract*. Trans. Maurice Cranston. New York NY: Penguin, 1968.

Rubinstein, Charlotte Streifer. *American Women Artists: From Early Indian Times to the Present*. Boston MA: G.K. Hall, 1982.

Saisselin, Rémy. *The Bourgeois and the Bibelot*. New Brunswick NJ: Rutgers University Press, 1984.

Schor, Naomi. *Reading in Detail: Aesthetics and the Feminine*. New York NY: Routledge, 1987.

Scott, William P. 'Morisot's Style and Technique.' In *Berthe Morisot: Impressionist*. Ed. Charles F. Stuckey and William P. Scott. Exhibition catalogue. New York NY: Hudson Hills, 1987, pp. 187–216.

Sellin, David. *Americans in Brittany and Normandy 1860–1910*. Exhibition catalogue. Phoenix AZ: Phoenix Art Museum, 1982.

Sharp, Kevin. 'The Americanization of Impressionism.' In *Masters of Light: Selections of American Impressionism from the Manoogian Collection*. Exhibition catalogue. Vero Beach FL: Vero Beach Museum of Art, 2006, pp. 9–18.

Sheriff, Mary D. *The Exceptional Woman: Elisabeth Vigée-Lebrun and the Cultural Politics of Art*. Chicago IL: University of Chicago Press, 1996.

Sidlauskas, Susan. *Body, Place, and Self in Nineteenth-Century Painting*. Cambridge: Cambridge University Press, 2000.

_____ . 'A "Perspective of Feeling": The Expressive Interior in Nineteenth-Century Realist Painting.' PhD dissertation, University of Pennsylvania, 1989

Smart, Mary. *A Flight with Fame: The Life and Art of Frederick MacMonnies (1863–1937)*. Madison CT: Sound View Press, 1996.

_____ . 'Sunshine and Shade: Mary Fairchild MacMonnies Low.' *Woman's Art Journal* vol. 4 (Fall 1983/Winter 1984), 20–25.

Smith, Shawn Michelle. *American Archives: Gender, Race, and Class in Visual Culture*. Princeton NJ: Princeton University Press, 1999.

Smith-Rosenberg, Carroll. *Disorderly Conduct: Visions of Gender in Victorian America*. New York NY: Alfred A. Knopf, 1985.

Sollors, Werner. *Neither Black Nor White yet Both: Thematic Explorations of Interracial Literature*. Cambridge MA: Harvard University Press, 1999.

Solomon-Godeau, Abigail. 'Male Trouble.' In *Constructing Masculinity*. Ed. Martin Berger, Brian Wallis, and Simon Watson. New York NY: Routledge, 1995, pp. 68–76.

Søndergaard, Sidsel Maria, ed. *Women in Impressionism: From Mythical Feminine to Modern Woman*. Exhibition catalogue. Milan: Skira, 2007.

Spacks, Patricia Meyer. *Gossip*. New York NY: Alfred A. Knopf, 1985.

Stevens, Hugh. *Henry James and Sexuality*. Cambridge: Cambridge University Press, 1998.

Strasser, Susan. *Never Done: A History of American Housework*. New York NY: Pantheon, 1982.

Sund, Judy. 'Columbus and Columbia in Chicago, 1893: Man of Genius Meets Generic Woman.' *The Art Bulletin*, vol. 75, no. 3 (September 1993), 443–66.

Swinth, Kirsten. *Painting Professionals: Women Artists and the Development of Modern American Art, 1870–1930*. Chapel Hill NC: University of North Carolina Press, 2001.

Tappert, Tara Leigh. *Cecilia Beaux and the Art of Portraiture*. Exhibition catalogue. Washington: Smithsonian Institution Press, and London: National Portrait Gallery, 1995.

Tosh, John. *A Man's Place: Masculinity and the Middle-Class Home in Victorian England*. New Haven CT: Yale University Press, 1999.

Toth, Emily. *Unveiling Kate Chopin*. Jackson MS: University Press of Mississippi, 1999.

_____ . *Kate Chopin*. Austin TX: University of Texas Press, 1993.

Trachtenberg, Alan. *The Incorporation of America: Culture and Society in the Gilded Age*. New York NY: Hill & Wang, 1982.

Van Hook, Bailey. *Angels of Art: Women and Art in American Society, 1876–1914*. University Park PA: Penn State University Press, 1996.

_____ . 'Decorative Images of American Women: The Aristocratic Aesthetic of the Late Nineteenth Century.' *Smithsonian Studies in American Art*, vol. 4, no. 1 (Winter 1990), 45–69.

Veblen, Thorstein. *The Theory of the Leisure Class: An Economic Study of Institutions* [1899]. New York NY: Modern Library, 1934.

Waller, Susan. *The Invention of the Model: Artists and Models in Paris, 1830–1870*. Burlington VT: Ashgate, 2006.

_____ . *Women Artists in the Modern Era: A Documentary History*. Metuchen NJ: Scarecrow Press, 1991

Walton, Priscilla L. *The Disruption of the Feminine in Henry James*. Toronto: University of Toronto Press, 1992.

Webster, Sally. *Eve's Daughter/Modern Woman: A Mural by Mary Cassatt*. Urbana IL: University of Illinois Press, 2004.

Weimann, Jeanne Madeline. *The Fair Women*. Chicago IL: Academy, 1981.

Weinberg, H. Barbara. 'American Women Painters in Paris 1860–1900.' *Fine Art Connoisseur*, vol. 3, no. 8 (September/October 2006), 51–7.

_____ et al. *American Impressionism and Realism: The Painting of Modern Life, 1885–1915*. Exhibition catalogue. New York NY: Metropolitan Museum of Art, 1994.

Weisberg, Gabriel P., and Jane R. Becker, eds. *Overcoming All Obstacles: The Women of the Académie Julian*. Exhibition catalogue. New York NY: Dahesh Museum, 1999.

West, Shearer. *Fin de Siècle*. Woodstock NY: Overlook Press, 1993.

Wharton, Edith, and Ogden Codman, Jr. *The Decoration of Houses* [1897]. New York NY: W.W. Norton, 1978.

White, Annie R. *Polite Society at Home and Abroad*. Chicago IL: Monarch, 1891.

Wichstrom, Anne. 'Asta Nørregaard: Aspects of Professionalism.' *Woman's Art Journal*, vol. 23, no. 1 (Spring–Summer 2002), 3–10.

Wigley, Mark. 'Untitled: The Housing of Gender.' In *Sexuality and Space*. Ed. Beatriz Colomina. Princeton NJ: Princeton Architectural Press, 1992, pp. 337–89.

Wildeblood, Joan. *The Polite World: A Guide to English Manners and Deportment from the Thirteenth to the Nineteenth Century*. New York NY: Oxford University Press, 1965.

Witzling, Mara R., ed. *Voicing Our Visions: Writings by Women Artists*. New York NY: Universe, 1991.

Woolf, Virginia. *A Room of One's Own*. New York NY: Harcourt, Brace, 1929.

Yeldham, Charlotte. *Women Artists in Nineteenth-Century France and England*. New York NY: Garland, 1984.

Zakon, Ronnie L. *The Artist and the Studio in the Eighteenth and Nineteenth Centuries*. Exhibition catalogue. Cleveland OH: Cleveland Museum of Art, 1978.

Zakreski, Patricia. *Representing Female Artistic Labour, 1848–1890*. Burlington VT: Ashgate, 2006.

Index

Page numbers in *italics* refer to figures.